Costa Rica

A Journey through Nature

Photographs & Text by
Adrian Hepworth

FIREFLY BOOKS

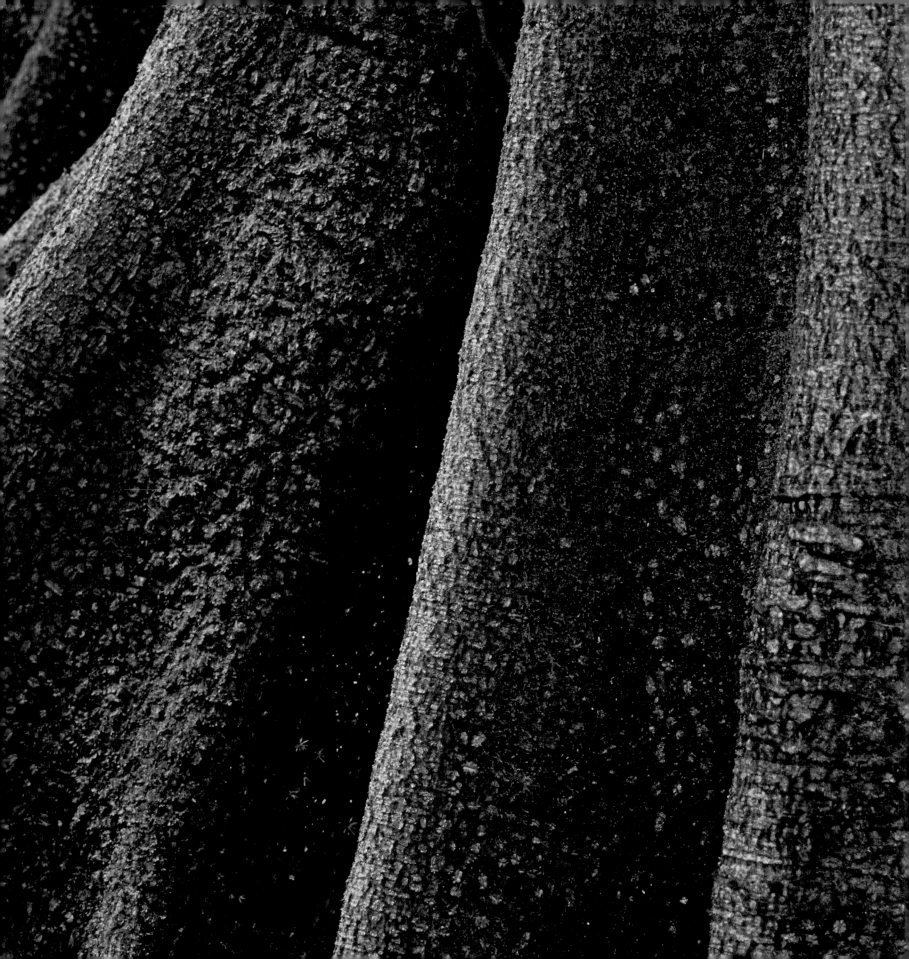

For Mum and Dad

at base camp.

A FIREFLY BOOK

Published by Firefly Books Ltd. 2008
Published by arrangement with Zona Tropical Publications

First printing

Publisher Cataloging-in-Publication Data (U.S.)
Hepworth, Adrian Paul, 1970-
 Costa Rica : a journey through nature / Adrian Hepworth.
[202] p. : col. photos. ; cm.
Summary: The extraordinary wildlife and landscapes of Costa
Rica. The stunning photographs and accompanying text take
the reader on a journey through the sublime beauty of
Costa Rica.
ISBN-13: 978-1-55407-431-0 ISBN-10: 1-55407-431-2
1. Costa Rica -- Pictorial works. 2. Costa Rica -- Description
and travel. 3. Natural history -- Costa Rica. I. Title.
917.2860/022/2 dc22 F1544.H479 2008

Library and Archives Canada Cataloguing in Publication
Hepworth, Adrian, 1970-
 Costa Rica : a journey through nature / Adrian Hepworth.
ISBN-13: 978-1-55407-431-0 ISBN-10: 1-55407-431-2
 1. Natural history--Costa Rica. I. Title.
F1544.H46 2008 508.7286 C2008-901140-6

Published in the United States by Published in Canada by
Firefly Books (U.S.) Inc. Firefly Books Ltd.
P.O. Box 1338, Ellicott Station 66 Leek Crescent
Buffalo, New York 14205 Richmond Hill, Ontario L4B 1H1

Printed in China

The publisher gratefully acknowledges the financial support
for our publishing program by the Government of Canada
through the Book Publishing Industry Development Program.

Front cover: Red-eyed tree frog in Tortuguero National Park.
Back cover: La Cangreja Waterfall in Rincón de la Vieja
National Park.
Page 2: Buttress roots in Braulio Carrillo National Park.
Right: Arenal Volcano at dawn.

Book design: Zona Creativa, S.A.
Designer: Gabriela Wattson
Developmental editor: Philip Davison
Copy editor: David Featherstone

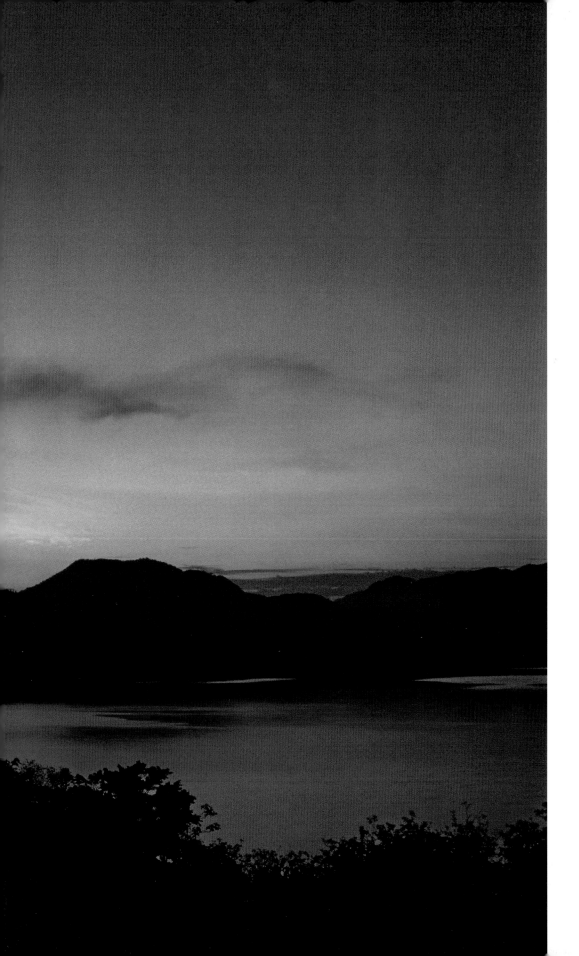

Contents

Introduction

I never imagined that the jaguar would come so close. It had appeared suddenly from the trees to the north, just a hundred yards away, casually trotting in my direction. The sun was still on the horizon, and I found myself downwind of the cat in a warm and humid Caribbean breeze. I was alone, deep inside Tortuguero National Park, miles from the nearest human habitation. The vultures around me had not yet seen the cat; they were busy feeding on the carcass of a green turtle killed during the night. Judging by the tracks in the sand, two medium-sized jaguars had attacked it just yards from the water. Surrounded by these tracks, I slowly sat down on the ground. I had waited eleven years for this encounter.

With not enough light to use a telephoto lens, I was forced to photograph the newcomer's approach with a standard 50 mm lens. It paused to smell the air before resuming its gait toward me. Some of the vultures noticed the movement and drifted nervously away from the carcass. The jaguar was close now, only twenty five paces from where I sat on the cool sand. It lifted its head one last time and finally saw what it was searching for. The trot became a run, the vultures scattered, and I began to question the sanity of my sitting next to a big cat's breakfast.

The result of this remarkable encounter can be seen on pages 154 and 155. Although coming face-to-face with a jaguar is an extremely rare occurrence, any tourist, researcher, or photographer who visits a national park or other protected wilderness in Costa Rica will return home with stories to tell. There is so much to see, so much to appreciate, and, inevitably, so much to preserve.

Despite its small size, Costa Rica is a remarkably diverse country. It has a total land area of 19,730 square miles (51,100 km²), or merely two-thirds the size of Scotland and just half the size of the state of Kentucky. Its land mass covers 0.03 percent of the Earth's terrestrial surface, yet it is home to about 8 percent of the world's recorded bird species, almost 5 percent of its mammals, and 3 percent of its reptiles and amphibians. Estimates suggest that Costa Rica also boasts between 2 and 4 percent of the world's vascular plant species and up to 360,000 species of insects (there are between about 5 and 30 million in the world).

Costa Rica ranks as one of the twenty most biodiverse countries in the world. This wealth of fauna and flora can largely be attributed to the wide variety of habitats and microclimates that exist throughout the country. Both the Pacific and Caribbean beaches are recognized as crucial turtle nesting sites. Where the rivers reach the sea, tidal mangroves provide important nursery sites for marine life and nesting locations for many waterbirds. The extensive network of freshwater canals that make up Tortuguero National Park provide secluded grazing for the endangered West Indian manatee. Birdwatchers flock to the internationally renowned seasonal marshes of Palo Verde and Caño Negro to view huge congregations of waterfowl. Within the borders of this small country, there are tropical dry forests, rainforests, and cloud forests, each with its own distinct flora and fauna. Finally, ascending the slopes of the higher peaks above the tree line is the unique ecosystem known as the paramo. At this elevation there are dwarf trees, shrubs, and bamboos mixed with other low-growing plants, all surviving in a very harsh environment.

A trip to Costa Rica is not complete without visiting at least one of the volcanoes that lie in various states of activity throughout the cordilleras. All manner of volcanic features can be experienced, including the constant eruptions and hot springs of Arenal Volcano, the smoking cone and crater lake of Poás Volcano, and the fumaroles and boiling hot mud pools surrounding Rincón de la Vieja Volcano.

Many of these wild areas lie within the nation's 102 government-managed national parks, biological reserves, and wildlife refuges, which cover an impressive 17 percent, or 3,436 square miles (8,900 km²), of the total land area in Costa Rica. In addition, there are over 140 private natural reserves that have helped to protect another 2 percent, or roughly 386 square miles (1,000 km²), of the national territory.

Costa Rica's world-famous network of national parks and reserves began in 1955 with the creation of small, government-protected areas around the craters of the Irazú and Turrialba Volcanoes. A few years later, in 1963, Cabo Blanco Nature Reserve was established on the southern tip of the Nicoya Peninsula. In 1969, a law was passed to control deforestation and create more protected areas. This law also established a small government department called the National Parks Service; most of today's national parks, reserves, and refuges were created during the decade that followed.

There can be no doubt that the creation and continued administration of what is now called the National System of Conservation Areas (Sistema Nacional de Areas de Conservación, or SINAC) has helped enormously in the preservation of the country's natural habitats. Surveys conducted by the Nature

Left: The endangered squirrel monkey.

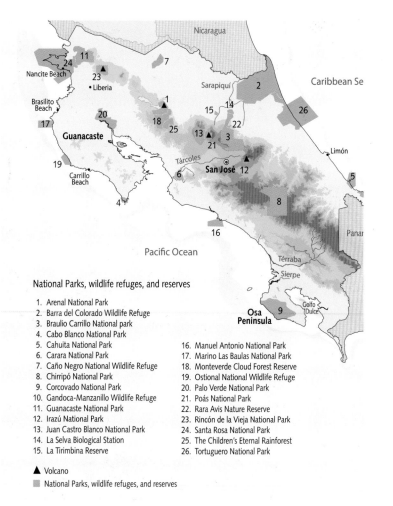

National Parks, wildlife refuges, and reserves

1. Arenal National Park
2. Barra del Colorado Wildlife Refuge
3. Braulio Carrillo National park
4. Cabo Blanco National Park
5. Cahuita National Park
6. Carara National Park
7. Caño Negro National Wildlife Refuge
8. Chirripó National Park
9. Corcovado National Park
10. Gandoca-Manzanillo Wildlife Refuge
11. Guanacaste National Park
12. Irazú National Park
13. Juan Castro Blanco National Park
14. La Selva Biological Station
15. La Tirimbina Reserve

16. Manuel Antonio National Park
17. Marino Las Baulas National Park
18. Monteverde Cloud Forest Reserve
19. Ostional National Wildlife Refuge
20. Palo Verde National Park
21. Poás National Park
22. Rara Avis Nature Reserve
23. Rincón de la Vieja National Park
24. Santa Rosa National Park
25. The Children's Eternal Rainforest
26. Tortuguero National Park

▲ Volcano

■ National Parks, wildlife refuges, and reserves

and the giant anteater are on the brink of extinction. In addition, global warming may at least partly explain why there have been no official sightings of the golden toad and many other cloud forest amphibian species since the late 1980s.

When the parks and reserves were established in the 1970s and 1980s, the National Parks Service designated protected status only to those areas that could be bought or that were donated. This has resulted in a patchwork of protected areas that in many cases have little or no connection with other protected areas. All too often, huge areas of industrial farmland or indiscriminate property development exacerbate this fragmentation. For many animals, there is a direct correlation between the size of a territory and the resources that territory can provide. Larger animals such as jaguars and pumas require a very large area within which to find food and, on occasion, a mate. If this area is significantly reduced, the inevitable result is declining populations. Territorial fragmentation also isolates populations, reducing genetic diversity and making the animals more vulnerable to disease. According to Randal García, the Director of Conservation at Costa Rica's National Institute of Biodiversity (INBio), up to 75 percent of the country's protected areas need to be enlarged and new biological corridors need to be created to connect the parks with neighboring protected areas. A number of corridors have already been created through both government and privately sponsored initiatives, but much work remains to keep these corridors ecologically viable and to protect them from property developers.

Most protected areas in Costa Rica suffer from a general lack of resources and financing. Many parks lack the necessary funding for equipment and staff. There are not enough rangers to patrol the parks and reserves and thereby effectively combat poaching, logging, wildlife trafficking, and industrial pollution.

Corcovado National Park on the Osa Peninsula, one of the few remaining areas of rainforest on Central America's Pacific coast, is considered an outstanding example of Costa Rica's park system. In 2004, however, a problem became apparent. Following years of continued cutbacks, the number of rangers available to patrol the 193-square-mile (500 km²) park had been reduced to just ten. The nearby Golfito Wildlife Refuge had no rangers at all. Hunting, mining, and logging had become rife in an area that has been described as one of the most biologically diverse places on Earth. In Corcovado, the rampant poaching of wild peccaries, the main food source of the jaguar, meant that Costa Rica's largest cat species was facing imminent extinction in the area.

Just when the situation appeared hopeless, a nonprofit organization called the Corcovado Foundation, founded by a group of local environmentally conscious hotel owners, began to work with MINAE in order

Conservancy and the Ministry of the Environment and Energy (Ministerio del Ambiente y Energía, or MINAE) demonstrate that Costa Ricans who have visited these areas are now more aware of conservation issues. Ecotourism in and around the parks and reserves creates business opportunities and employment for many local people, thus providing them a financial incentive to care for their natural heritage. Today, Costa Ricans appreciate the importance of nature conservation much more than they did twenty years ago.

Nevertheless, the entire system is now in desperate need of restructuring, and this requires additional resources and finances. Poaching and loss of habitat through deforestation and industrial pollution have already led animals such as the jabiru stork, green macaw, squirrel monkey, jaguar, puma, tapir, and manatee to become endangered or critically endangered species in Costa Rica. Worse still, the harpy eagle

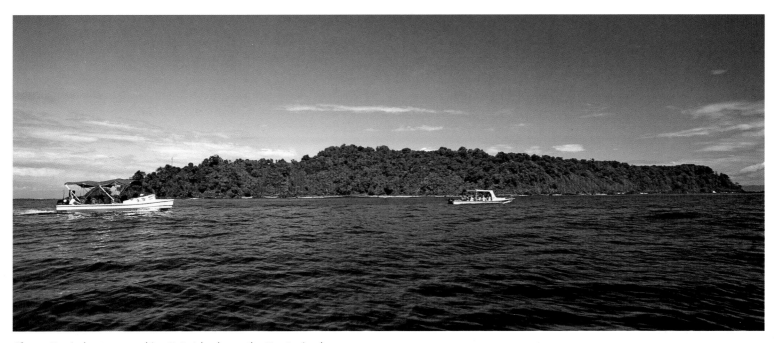

Above: Tourist boats approaching Caño Island, near the Osa Peninsula.

to lobby potential international sponsors for help. They eventually obtained an $8 million grant from the Gordon and Betty Moore Foundation via the Nature Conservancy. In early 2005, a total of sixty-seven new personnel were hired to guard and manage the protected areas on and around the Osa Peninsula for a period of almost three years. This action temporarily saved the natural resources of the peninsula from destruction. In late 2007, the government provided further good news by agreeing to pay the salaries of these new personnel for an indefinite period of time, thereby avoiding a return to the crisis of 2004. The work of the Corcovado Fundation is a fine example of how local people, local businesses, the government, and charities can pool their resources and produce real and effective results in the battle to conserve nature.

Conservation projects in other parts of Costa Rica have raised money to purchase plots of land that will link protected areas that are presently isolated. One such project is the Guanacaste Dry Forest Conservation Fund (headed by the world-famous ecologist Dr. Daniel Janzen), whose work has guaranteed the survival of an important biological corridor next to the Rincón de la Vieja Volcano. In addition, the Tropical Science Center is establishing two new biological corridors, the first between La Selva Biological Station in Sarapiquí and the Nicaraguan border, and the second between Monteverde and the Nicoya Peninsula. All of these corridors provide areas of protected rainforest through which animals can migrate in increased safety. Financial donations to these projects continue to be essential for their success. Ongoing nature-conservation efforts in Costa Rica must follow these examples if the areas that are already protected are to remain viable habitats for wildlife.

This book is presented as an introduction to the wildlife and wild areas of Costa Rica. The images and text are the product of my many trips around Costa Rica between 1993 and 2007. My sincere hope is that the book arouses more interest in the natural world around us and demonstrates once again how important it is to preserve this treasure for future generations.

Wildlife and landscape photography in the tropics is thrilling because of the sheer variety of subjects. It can, though, be incredibly challenging for both photographer and equipment. Torrential rainfall, gloom, humidity, and harsh sunlight must all be overcome, and weather conditions and wildlife sometimes seem to conspire against you. One good shot may require hours of crouching in mud surrounded by a swarm of mosquitoes. But the experiences are priceless: I will always remember sitting alone on the beach as that jaguar trotted toward me, having my hair sniffed by an inquisitive five-hundred-pound wild tapir, and accompanying giant sea turtles back to the surf as the sun appeared over the horizon. May such encounters never end.

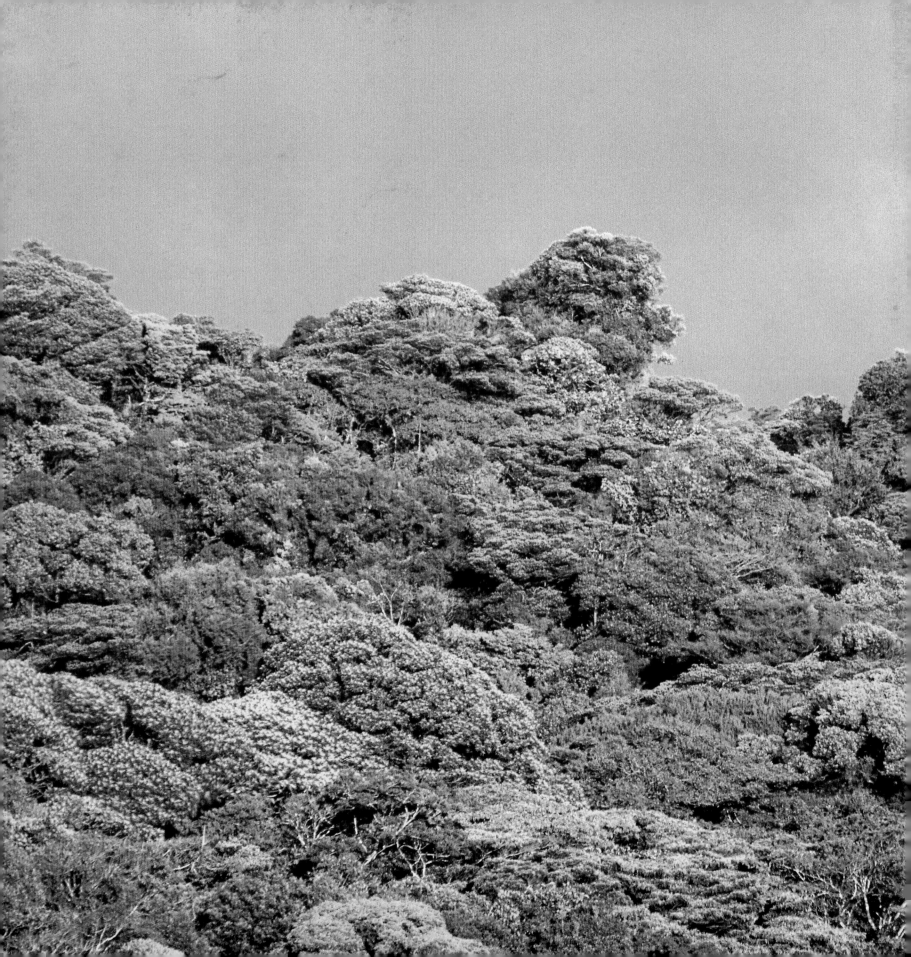

The Central Divide
Into the Clouds

The Central Divide runs the length of the country, separating the Pacific lowlands from the Caribbean lowlands. This extended range of highland terrain, composed of Costa Rica's active volcanoes and highest peaks, distinguishes the country from its less mountainous neighbors, Nicaragua and Panama, and adds an array of ecosystems that serve to increase the diversity of life found within its borders.

The stiflingly hot forests that cover the foothills of the Central Divide give way at higher elevations to cool, damp cloud forests. In these gloomy, mist-enshrouded regions, the temperature drops and the flora and fauna change dramatically. Covering the trees in a cloud forest are many forms of epiphyte—mosses, ferns, bromeliads, and vines. Epiphytes are plants that grow on the outside of other plants, taking advantage of a readily available platform. Giant tree ferns grow throughout the cloud forests, relics of a once-dominant vegetation predating the evolution of flowering plants. Inhabiting these misty realms are such exotic bird species as the resplendent quetzal and the three-wattled bellbird. Where the forests end above the timberline, a bare and treeless landscape of subalpine paramo surrounds Costa Rica's highest peaks.

The four cordilleras, or mountain ranges, of the Central Divide run from north to south. In the north, the Guanacaste Cordillera (featured in the chapter "Guanacaste: Life Under the Sun") consists of five volcanoes, including Rincón de la Vieja. Further south is the Tilarán Cordillera, the location of the Monteverde Cloud Forest Reserve (also known as the Monteverde Cloud Forest Biological Preserve). Here, too, stands Arenal, one of Costa Rica's youngest volcanoes and one of the world's most continuously active. In the Central Cordillera, Poás and Irazú Volcanoes—two prime tourist sights—tower above the capital, San José. The southernmost mountain range is the Talamanca Cordillera, where Costa Rica's highest mountain, Mount Chirripó, rises above the tree line.

This chapter highlights some of the wildlife and landscapes of the Tilarán, Central, and Talamanca Cordilleras.

Previous pages: Late afternoon sun bathes the Monteverde Cloud Forest Reserve.

Right: Sunset silhouettes giant tree ferns on the shores of Lake Arenal.

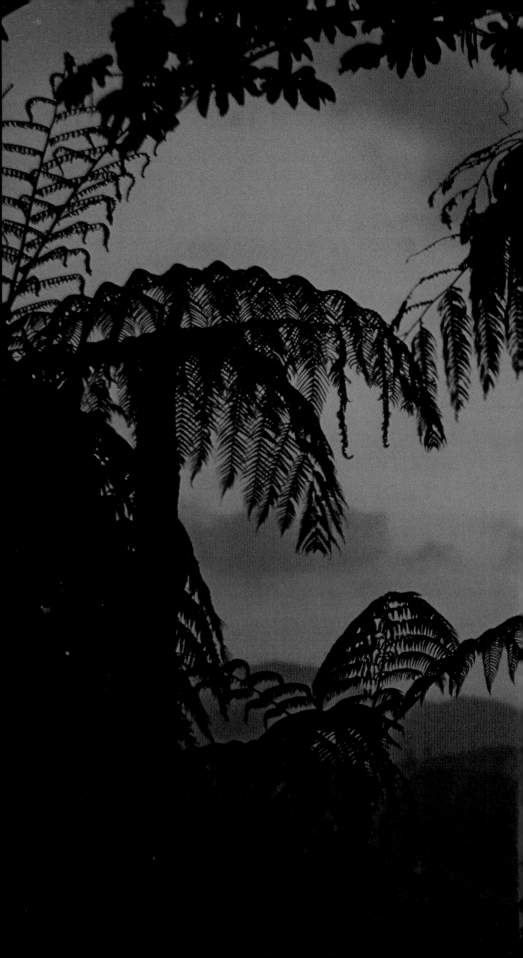

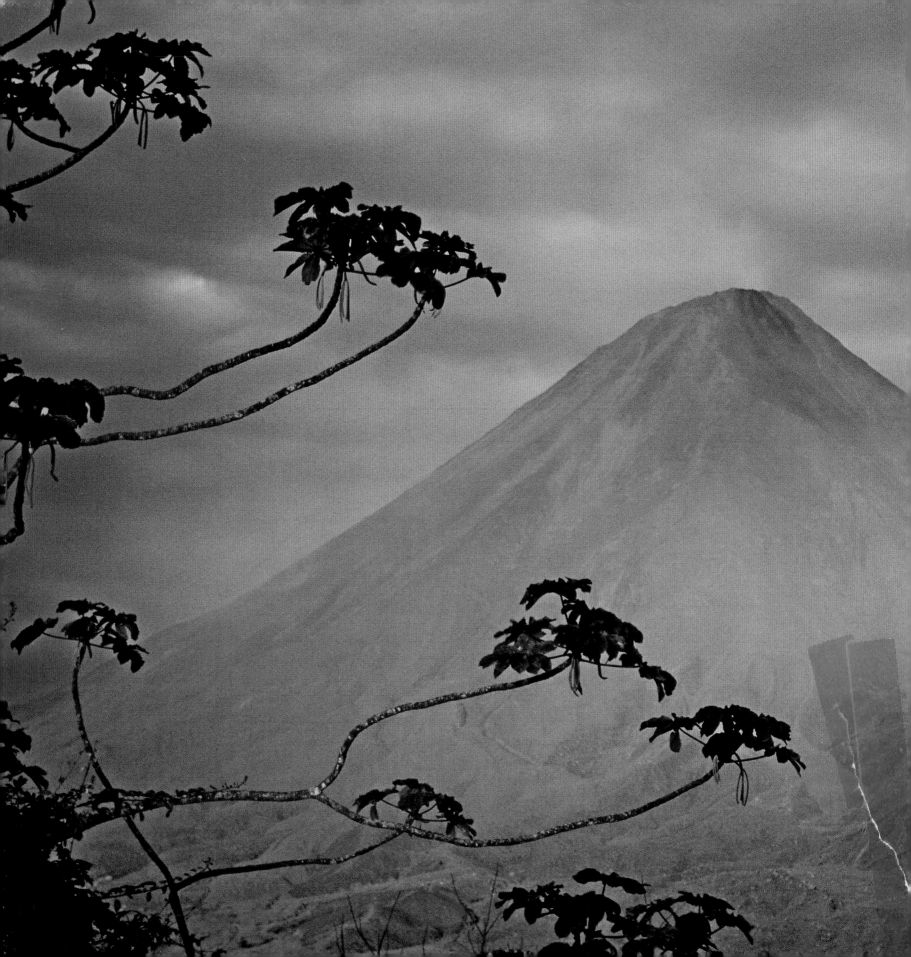

During the day, the ash-covered western slope of Arenal Volcano is an unremarkable gray. On a clear afternoon, however, the final few minutes of sunlight before dusk totally transform its appearance. The unexceptional gray color warms to an orange-brown and then red as the sun sinks to the horizon.

Left: The enormous smoldering cone of Arenal Volcano at dusk.

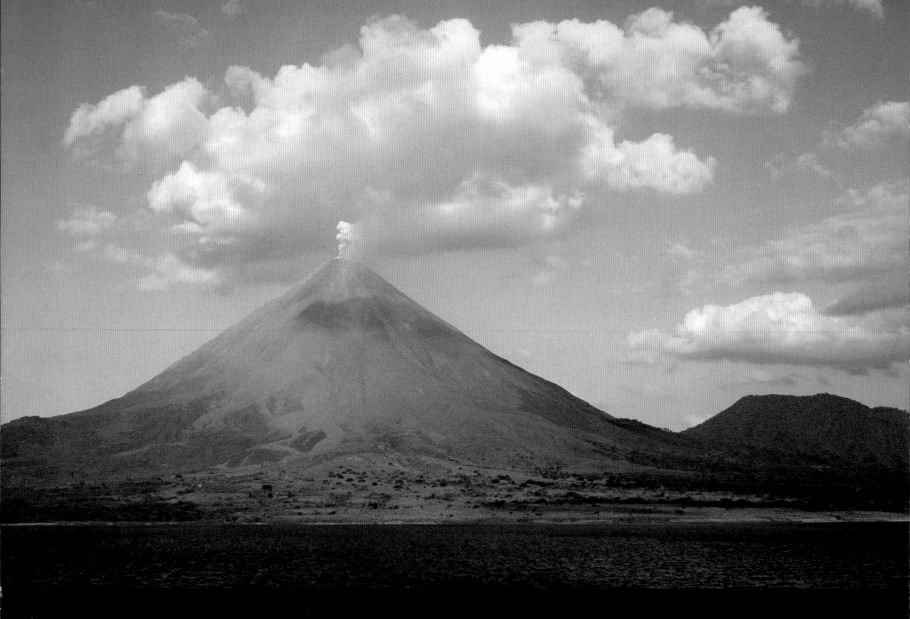

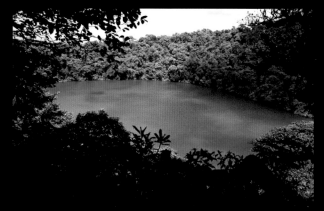

Rising dramatically out of the northern lowlands and dominating the surrounding landscape, Arenal (above) is the most active volcano in Costa Rica. The thunderous rumble of eruptions from this solitary volcano can be heard for miles, at times as frequently as every hour.

Arenal Volcano stands roughly 5,480 feet (1,670 m) high, and continues to grow at an average rate of roughly 14 feet (4.3 m) per year. It is relatively young in geological terms; its ear-liest eruptions are believed to have taken place between 7,000 and 4,000 years ago. Cerro Chato, the small hill next to Arenal, was also active during this period but became extinct around 3,500 years ago. Its crater is now a green lagoon surrounded by lush rainforest.

Above: Arenal Volcano in eruption, and its extinct neighbor, Cerro Chato.
Left: The lagoon inside the crater of Cerro Chato.

The energy released during volcanic activity is tremendous. Even a relatively small eruption such as this one (right), photographed at dawn, is capable of shooting red-hot lava many hundreds of feet into the air and sending an avalanche of car-sized boulders tumbling rapidly down the mountain's flanks.

Radiocarbon dating techniques indicate that Arenal was active in the early sixteenth century. There followed a period of relative dormancy until recent times. At 7:30 a.m. on July 29, 1968, Arenal's slumber came to a sudden and violent end. A series of enormous eruptions created three new craters. Rocks, ash, and lava shot out from these craters, destroying two small villages in the area. Since that event, Arenal has been constantly active. During the month of June 2007, the Volcanic and Seismological Observatory of Costa Rica detected more than 124 eruptions and 430 hours of earth tremors from the volcano. Although much of this activity is neither audible nor visible, it serves as a reminder of the power lying just beneath the Earth's surface.

Right: Arenal Volcano erupting at dawn.

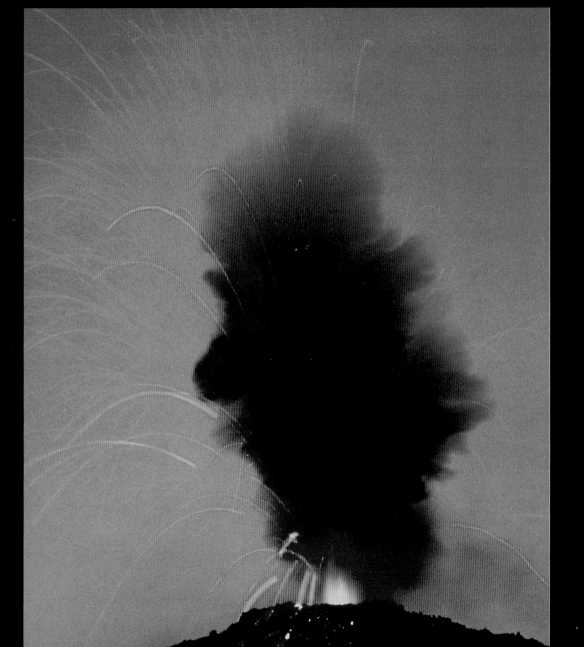

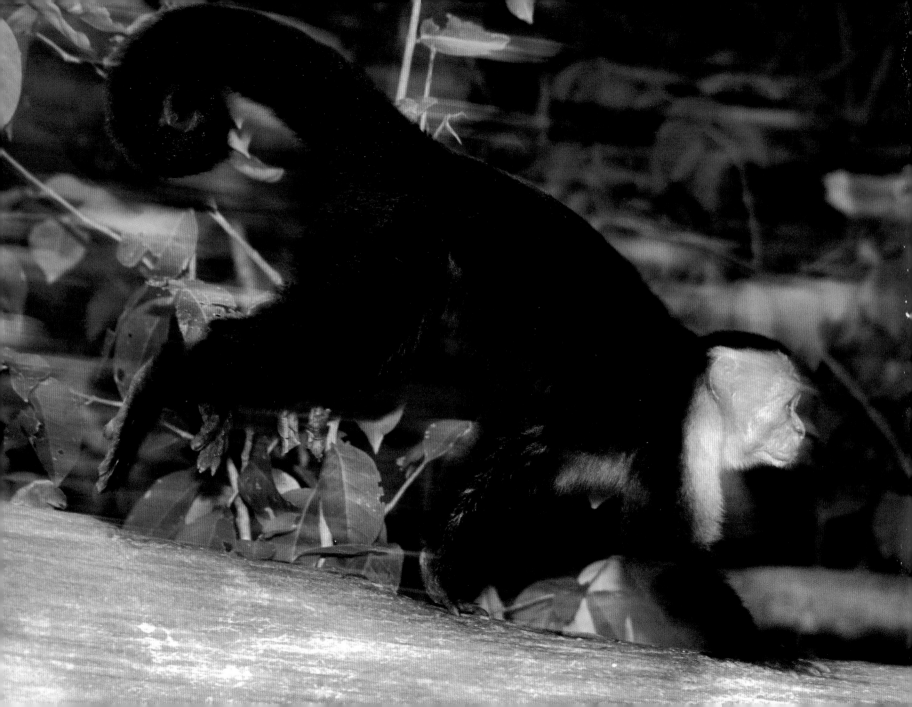

Protected rainforest at the base of the southern flank of Arenal Volcano marks the beginning of an important biological corridor linking Arenal National Park, the Monteverde Cloud Forest Reserve, and the Children's Eternal Rainforest.

Protected land corridors provide large mammals, such as the white-faced capuchin monkey (left), with more forest in which to forage without having to venture out into farmland or urban areas. The typical diet of this monkey consists of fruit and insects, and its versatile fingers enable it to pick food from branches, the underside of leaves, trunk hollows, and the forest floor. However, there are times when capuchin monkeys rely on speed and aggression to obtain food. They have been observed, on occasion, chasing and pouncing on squirrels, small birds, lizards, and crabs to supplement their diet.

A leaf katydid (below), standing motionless on the forest floor, may easily escape the attention of a foraging monkey. The katydid—a close relative of the cricket and the grasshopper—possesses an elaborate camouflage; its body not only mimics the color and shape of a fallen leaf, but also finer details such as leaf veins and patches of fungal growth. The name *katydid* derives from its similarity, if spoken quickly and repeatedly, to the sound of the insect's mating call.

Left: White-faced capuchin monkey.
Below: The resemblance of leaf katydids to fallen leaves is their main defense against predators.

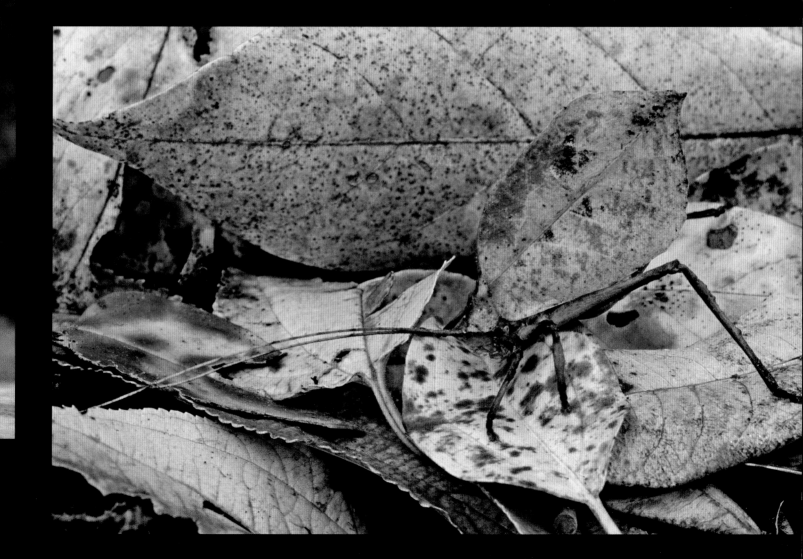

Snakes can be hard to find; many are camouflaged and remain relatively motionless. This not only makes these predators masters at ambushing prey, but also keeps them hidden from birds and mammals that feed upon them. But the hunter can become the hunted. Some snakes have evolved to become specialist feeders on other snakes.

The Central American coral snake (right), a distant relative of sea snakes, mambas, and cobras, is one of seventeen extremely venomous snake species found in Costa Rica. It lives on the ground, where it hunts among grasses and shrubs, leaf litter, hollow logs, and rocky crevices, catching snakes and, occasionally, lizards. Coral snakes bite and then hold on to their prey, injecting a powerful neurotoxin through two small fangs at the front of their upper jaw. Once paralyzed, the prey is swallowed headfirst and whole. The coral snake's brightly colored bands are believed to help deter predators, although it is not known exactly how. They may warn other animals of the snake's toxicity or cause surprise, and hence hesitation, in a predator when it first discovers the snake.

The shovel-toothed snake (below) mimics the true coral snake in both appearance and behavior, even though it belongs to a completely different family of snakes. This coral-mimic is not venomous, however, and looks slightly different: its eyes are much larger and have a light-colored iris, and the edges of its colored bands are less clearly defined.

Below: The shovel-toothed snake is a nonvenomous mimic of the true coral snake.
Right: Central American coral snake swallowing another snake that it has bitten and paralyzed.

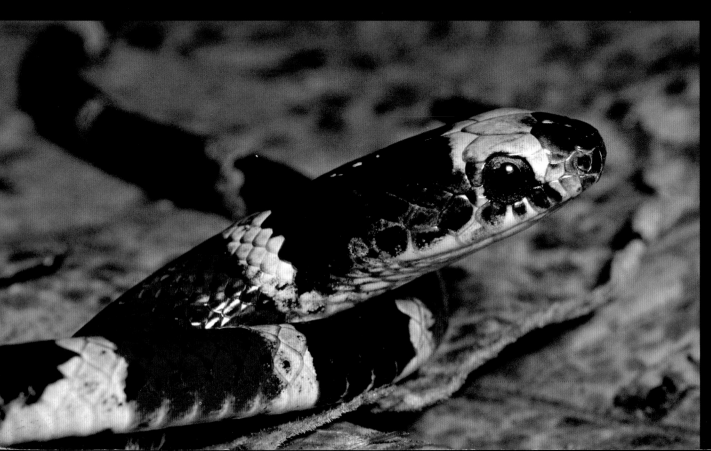

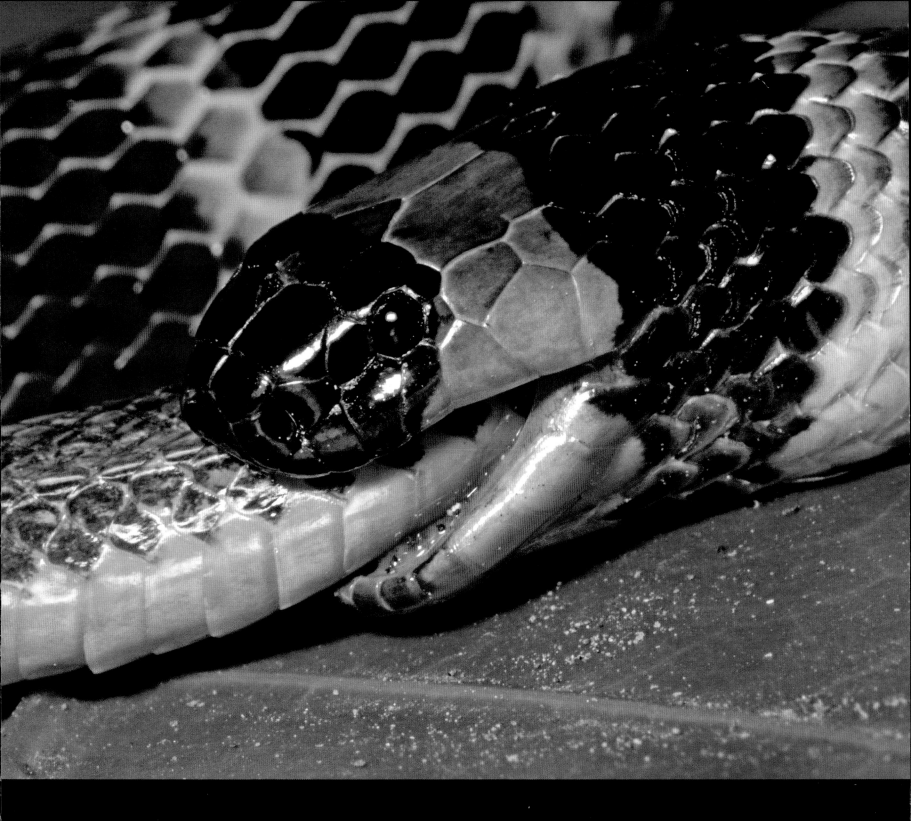

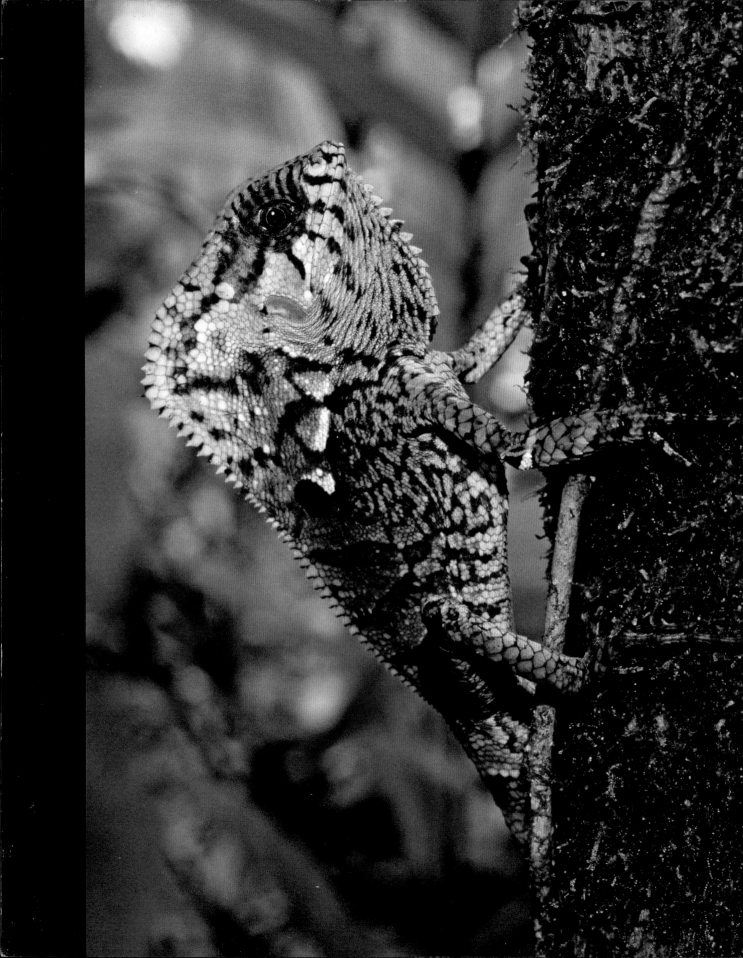

Camouflage is the first line of defense against preda-
tion for the helmeted iguana (left) and the automeris
moth (right). The iguana can change its skin tone to
match the trunk or branch that it is resting on, and the
moth appears much more like a dead leaf than a living
insect. Should these disguises fail to deceive a preda-
tor, each of these creatures has a secondary line of
defense. The helmeted iguana expands its head crest
and throat fan while at the same time lifting its body
away from the perch. Any potential predator is sud-
denly faced with prey that appears significantly larger
than first perceived. The automeris moth surprises its
predators by quickly flipping its forewings forward to
reveal two large eyespots on the hindwings. These
appear to belong to an animal much larger in size.
Predators such as lizards and small birds are often de-
terred by the sudden apparent change in the size of
their potential prey.

Left: Helmeted iguana adopting its puffed-up defen-
sive posture.
Right: When threatened by a predator, an automeris
moth will attempt to startle the animal by revealing
the large eyespots on its hind wings.

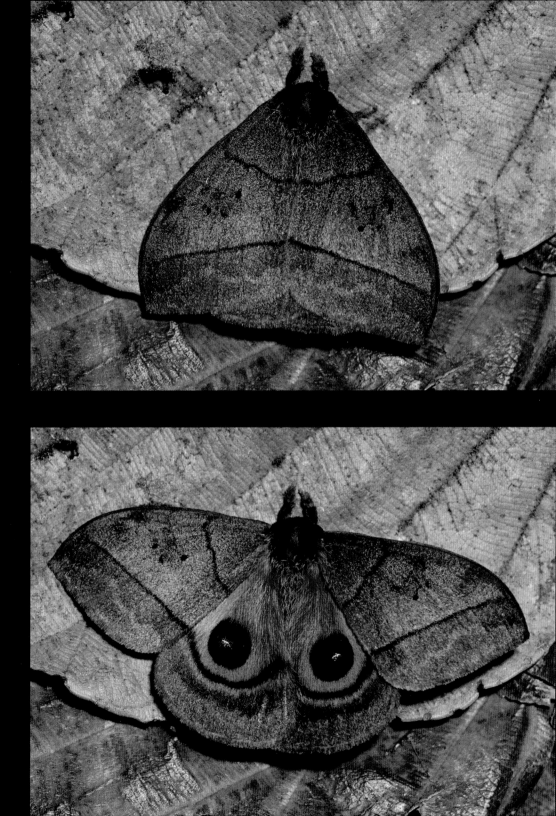

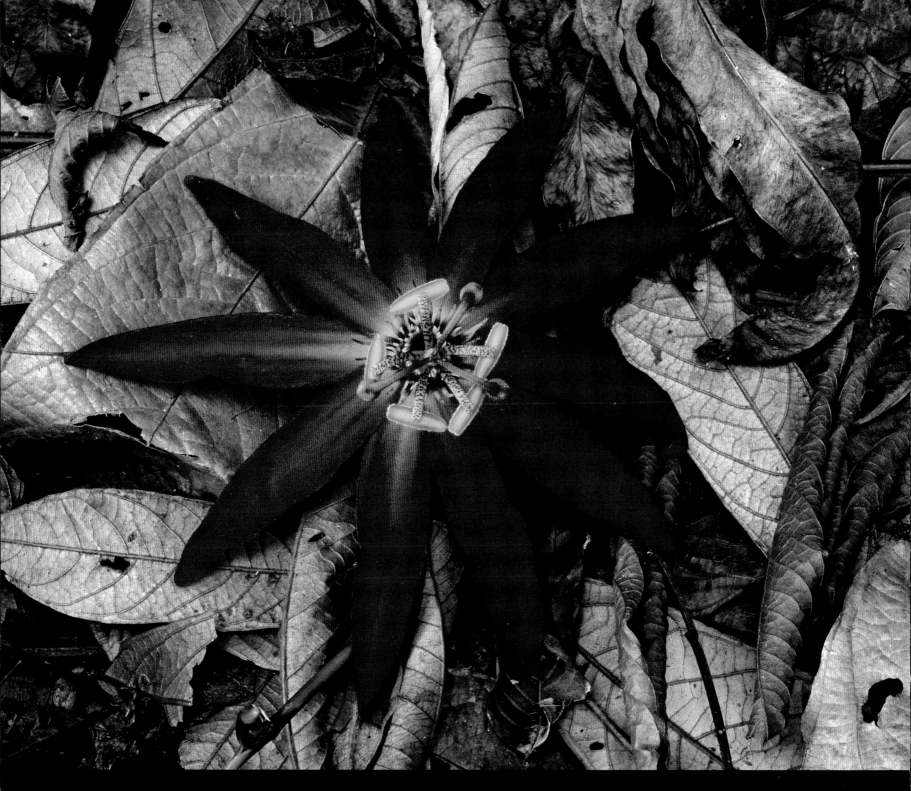

Sixteenth-century Christian missionaries arriving in Central and South America discovered a kind of plant that, to them, represented the crucifixion of Christ. It had five stamens, which symbolized the five wounds Christ received on the cross, and three styles, the three nails used to hold him there. It also had a corona, the circle of filaments in the center of the flower, representing the infamous crown of thorns. This group of beautifully elaborate flowers soon became known as passion flowers. More than fifty different species of passion flower have been recorded in Costa Rica. The most common is the bright red *Passiflora vitifolia* (left), which is pollinated by hummingbirds such as bronzy hermits and long-billed hermits. The main foliage of this plant typically grows up in the canopy, but it has flowering vines that often extend down to the forest floor.

Left: Passion flowers were so named by missionaries who thought they represented the crucifixion of Christ.
Below: Like passion flowers, *Gurania costaricensis* creates an explosion of color that attracts hummingbird pollinators.

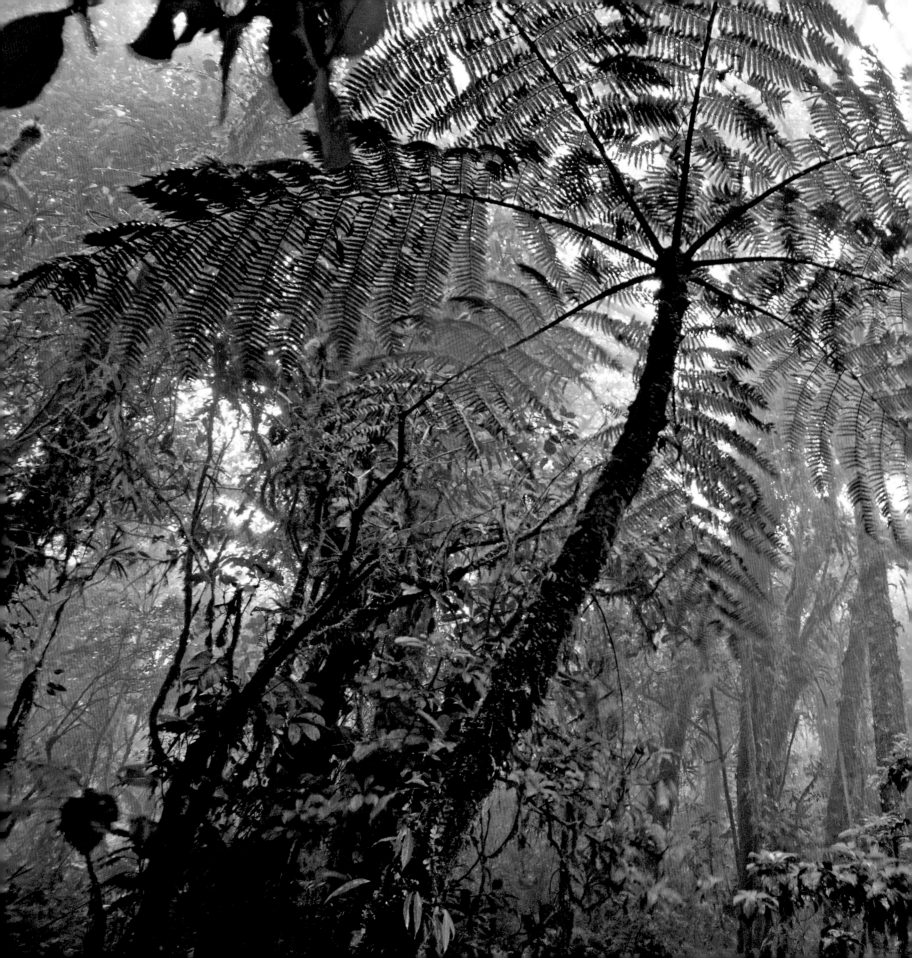

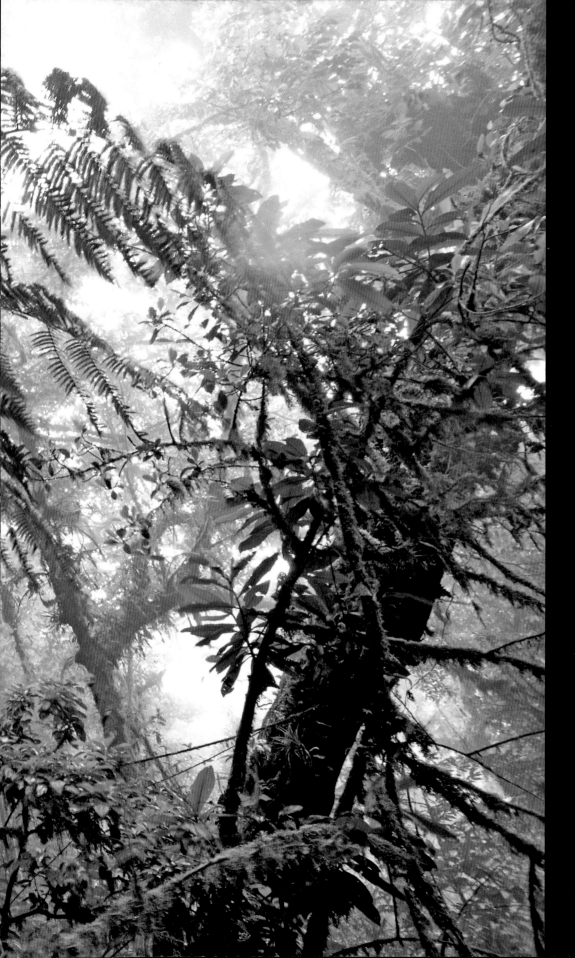

A persistent heavy layer of cloud lies over the Monte-verde Cloud Forest Reserve. It saturates the vegetation and causes water droplets to constantly drip and trickle down to the forest floor. The lower levels of the forest are dark and gloomy, and the low light level reduces the rate at which the plants can photosynthesize. Consequently, cloud forest plants grow more slowly than their counterparts in lowland rainforests. The sheltered and permanently moist cloud forest environment, however, offers perfect growing conditions for many plants, such as giant tree ferns (left). There are about two hundred different fern species that grow in the Monteverde Cloud Forest Reserve, some reaching 65 feet (20 m) in height.

Left: Giant tree fern in Monteverde Cloud Forest Reserve.

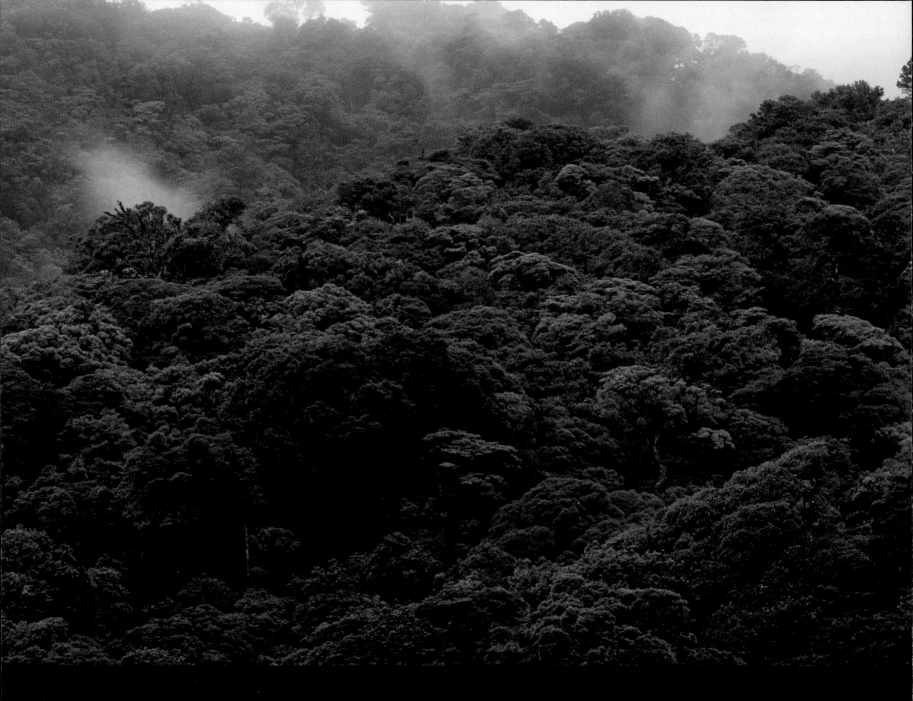

The original 1.3-square-mile (3.3 km²) Monteverde Cloud Forest Reserve was founded in 1972 by the scientist George Powell, his wife Harriet, and a resident Quaker named Wilford Guindon. The reserve now covers an area of 40.6 square miles (105 km²) and is home to more than 400 species of birds, more than 100 species of mammals, and over 120 species of reptiles and amphibians, while the number of recorded plant species exceeds 2,500.

Above: The canopy of the Monteverde Cloud Forest Reserve.

The high level of precipitation caused by an almost constant drifting of clouds through the canopy of the Monteverde Cloud Forest Reserve ensures that its rivers and waterfalls flow abundantly year-round.

Below: Waterfall in the Monteverde Cloud Forest Reserve.

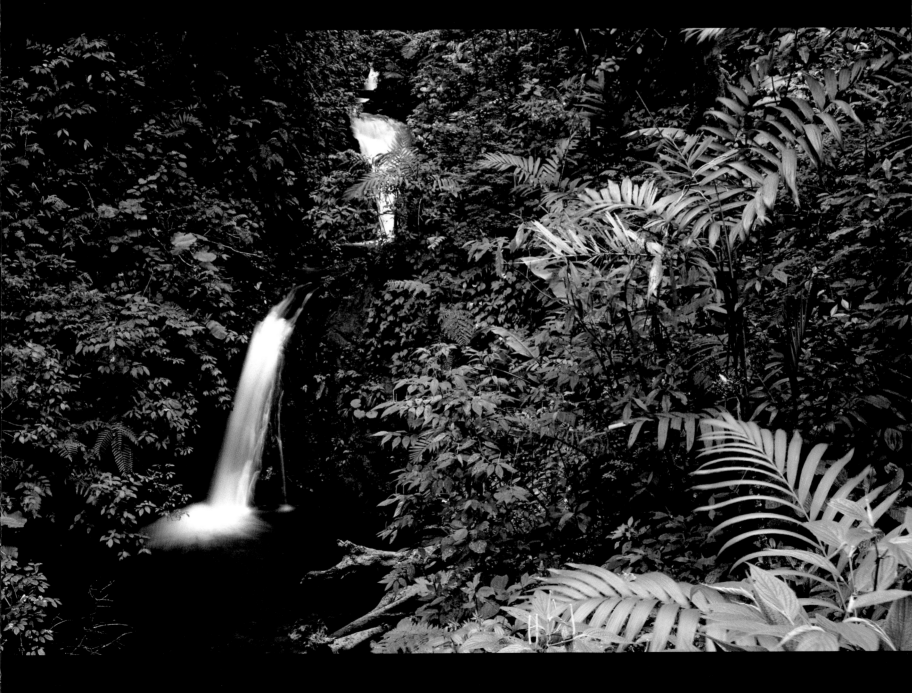

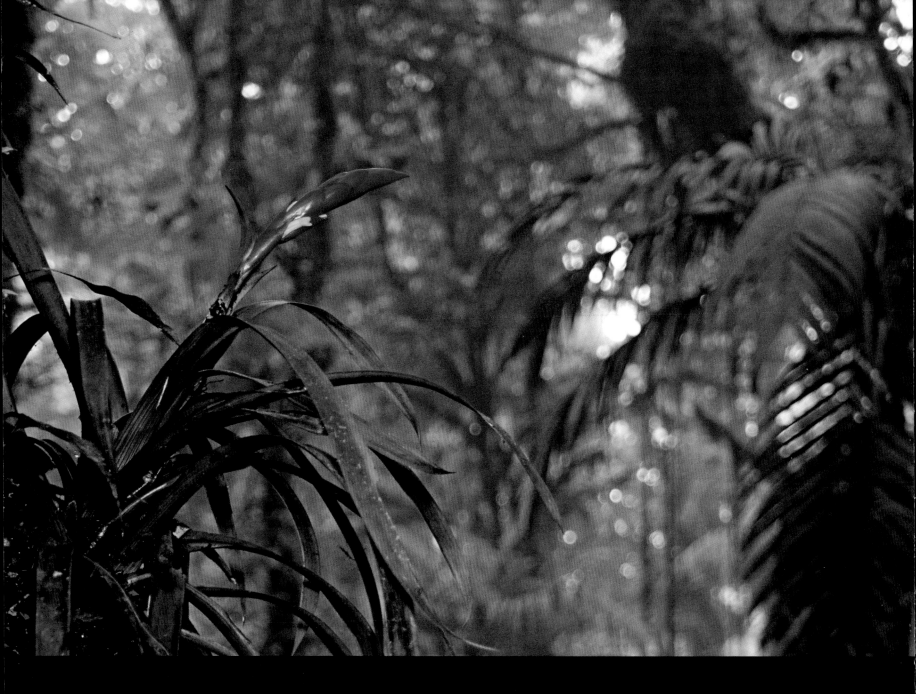

Above: The flowering stalk of a *Guzmania nica-raguensis* bromeliad in the Monteverde Cloud Forest Reserve.

Bromeliads grow in abundance on the trunks and branches of many cloud forest trees. These epiphytic adornments absorb nutrients from the water that accumulates between their leaves. The small body of water contained by the vaselike structure of the bromeliad is kept mineral rich by the insect excretion and detritus that continually fall from the canopy above. Numerous species of microorganisms thrive in these miniature ponds. Most mosquitoes and poison arrow frogs begin their lives here as larvae and tadpoles. Larger animals also benefit from this water source: mammals such as cats, monkeys, olingos, and squirrels drink from here, and small birds like the bananaquit (below) bathe in these bromeliad baths to remove dirt from their feathers.

Below: A water-filled bromeliad provides the perfect bath for a bananaquit to clean its wings.

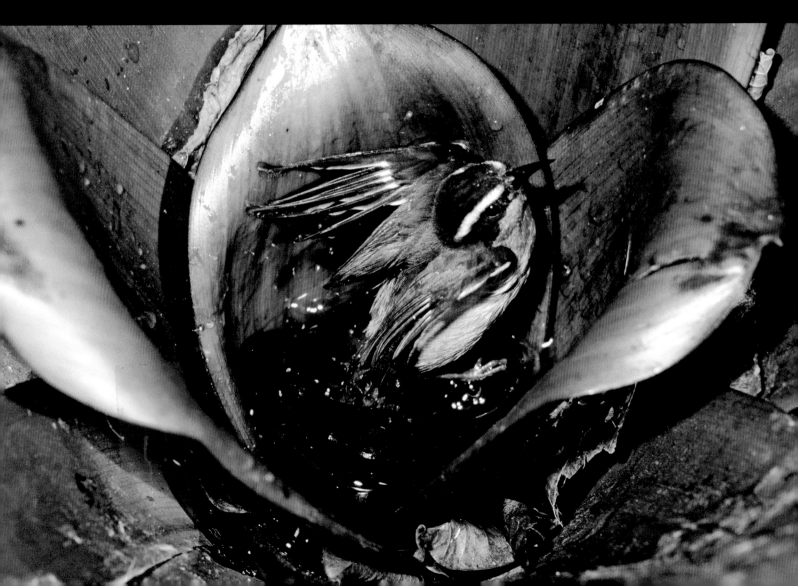

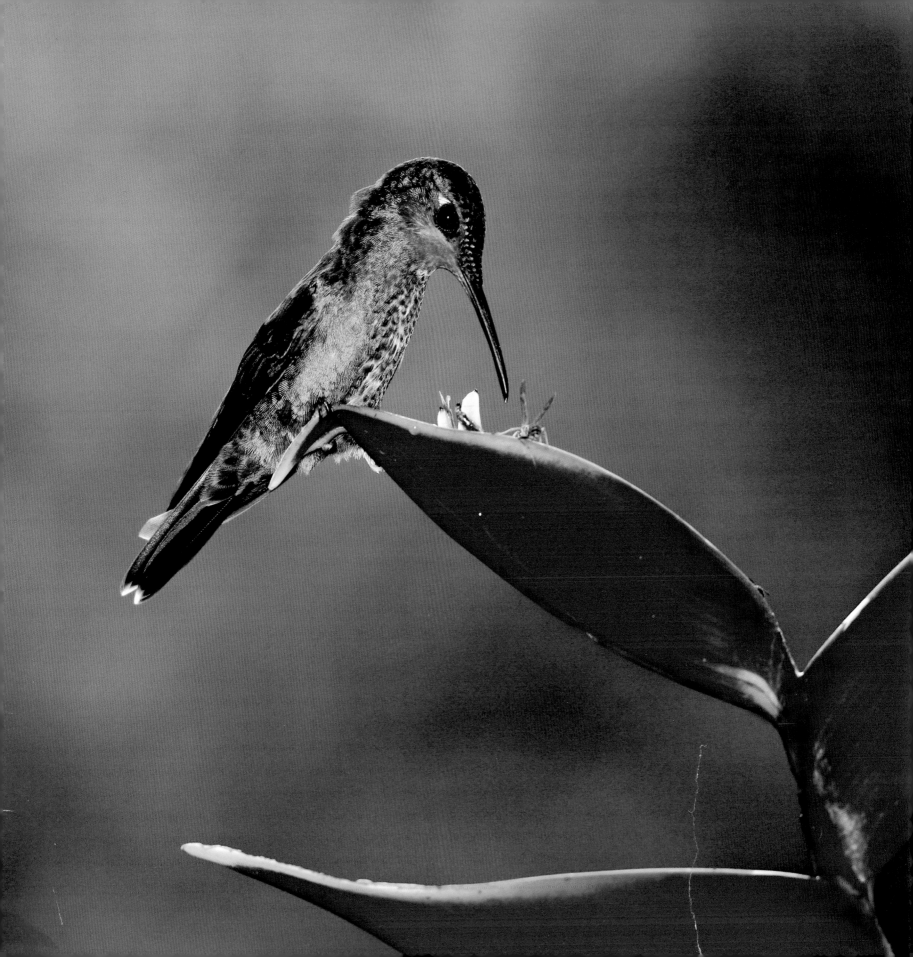

Cloud forests cover most of the mist-enshrouded higher elevations of Costa Rica's mountainous Central Divide. For part of the year, these are home to twenty species of hummingbird, almost half the total number of species found in Costa Rica. During the day, the abundance of flowers and insects within the dense vegetation provides a ready source of energy and protein for the hummingbirds. Being fast flyers with the ability to hover, hummingbirds require a frequent intake of high-energy food; the flowers provide this in the form of nectar. But as the cool of the cloud-forest day becomes the cold of the high-altitude night, hummingbirds enter a state of torpor to conserve energy. Their body temperature drops and is maintained at this low level until just before dawn, when the birds awaken and become fully active as the sun rises once more.

Heliconias, with their long broad leaves and distinctive flowers in shades of orange, yellow, and red, provide a valuable supply of nectar for a number of hummingbird species. Once a bird locates the food source, it hovers in front of the flower, probing with its beak and lapping the nectar with its tongue. While feeding, the green-crowned brilliant (left) prefers to perch on the heliconia flower rather than hover. The violet sabrewing (below), another common cloud forest species, is one of the largest hummingbirds found in Costa Rica, a veritable giant at 6 inches (15 cm) in length and weighing just over one third of an ounce (10 g).

Left: A green-crowned brilliant perching on a heliconia to feed.
Below: The violet sabrewing is one of the largest hummingbirds in Costa Rica.

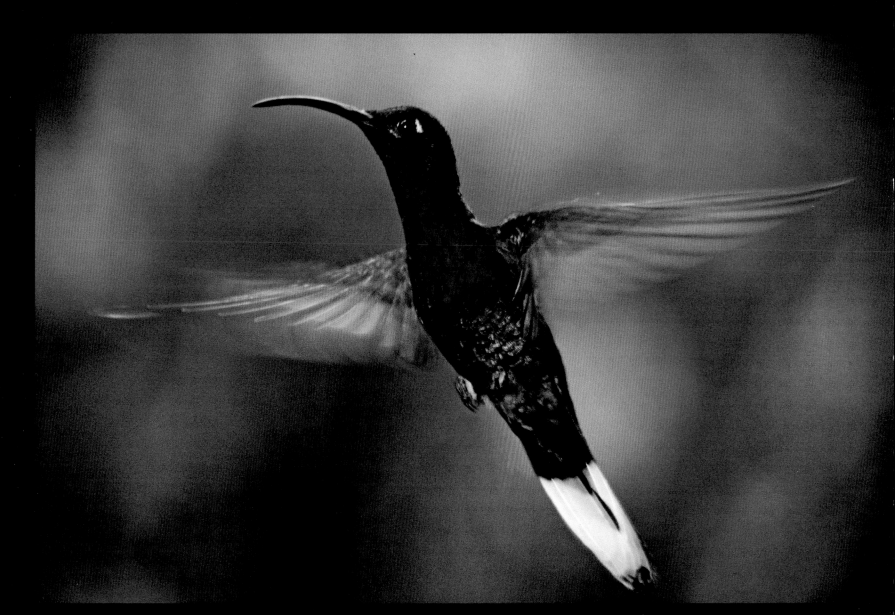

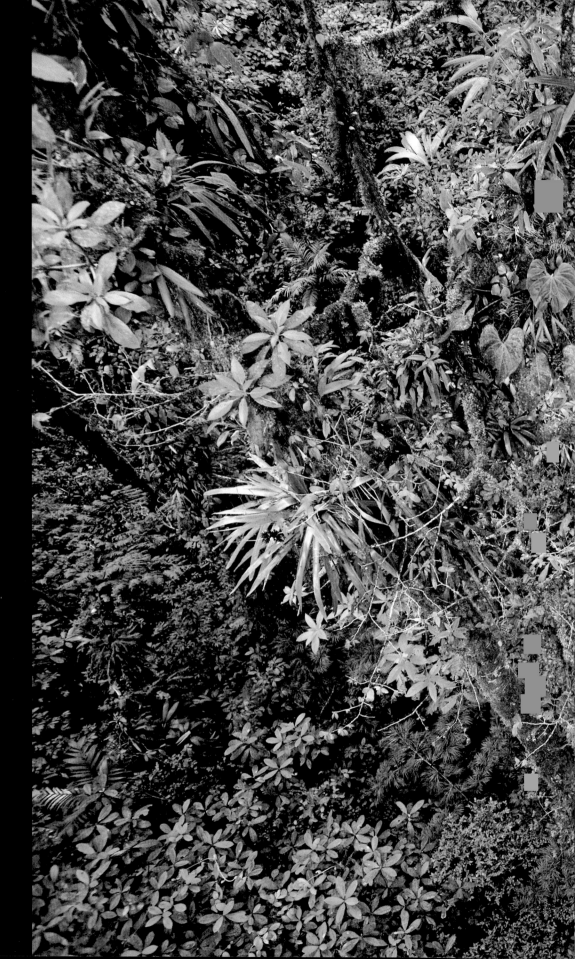

This photograph, taken from a suspended walkway, reveals the enormous variety of understory vegetation present in the Monteverde Cloud Forest Reserve.

In a tropical forest, trees of the same species seldom grow near each other. This is because seeds that fall and germinate at the base of a parent tree produce saplings that would have to compete with their already long-established parent for access to light and other resources. And these saplings face a second disadvantage in having to cope with attacks from pest species that the parent may be harboring in substantial numbers. For these reasons—and because of a number of other complex factors—there is a high diversity of tree species within a tropical forest.

The large distances separating individuals of the same species of tree indicate that the trees rely less on wind and more on mobile animals to effect seed dispersal and pollination; birds, bats, and flying insects, therefore, play a vital role in the pollination of cloud forest trees, as well as in the dispersal of their seeds.

Right: Bird's-eye view of the diverse plant life in the Monteverde Cloud Forest Reserve.

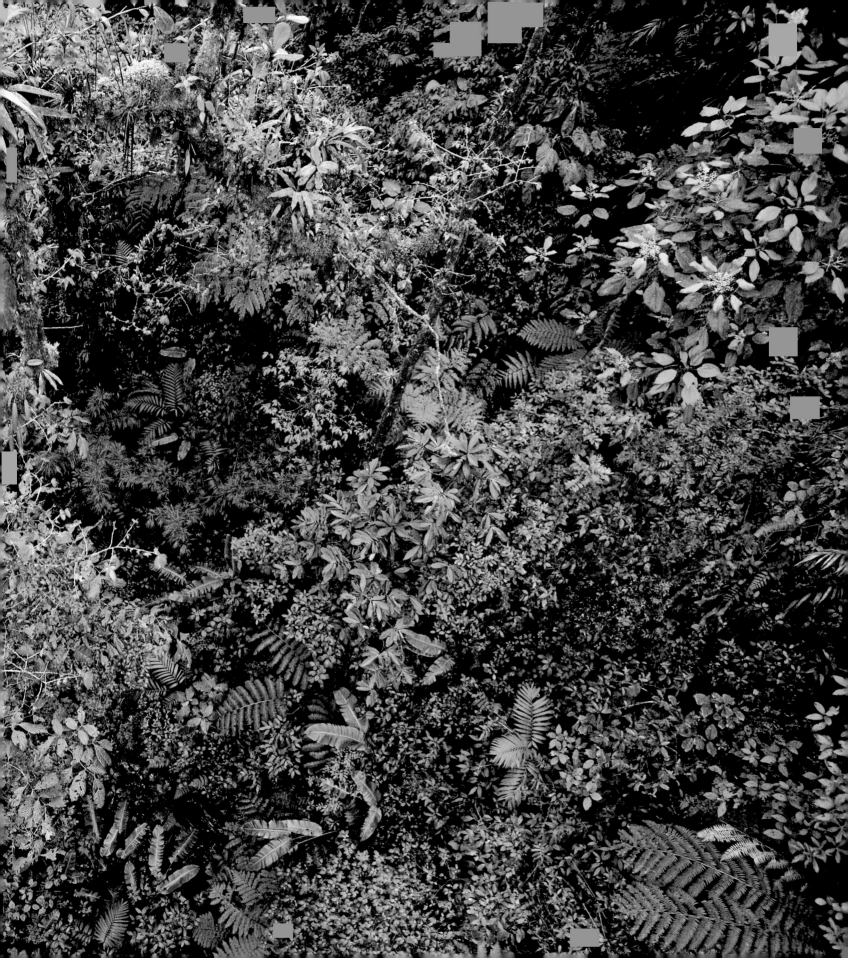

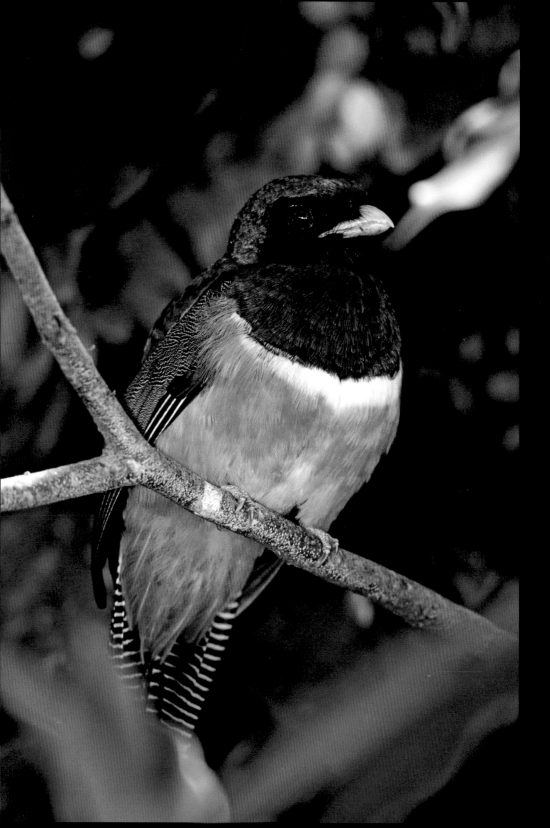

Trogons are without doubt some of the most beautiful birds in the neotropics. There are ten species of trogon in Costa Rica, eight of which have been recorded in the Monteverde area. Trogons are not always easy to see, however: they are quiet, normally solitary, birds that spend a lot of their time perched in the shade of the canopy.

The black-throated trogon (left) is Costa Rica's smallest trogon, but still measures an average of 9 inches (23 cm) from the top of its head to the end of its tail feathers. The resplendent quetzal (male, right) is the largest and most striking member of the trogon family. It was considered sacred by the Maya, and today it is the national bird of Guatemala. As part of its mating display, the male proudly flaunts its tail feathers—which can measure more than 36 inches (90 cm)—to attract the attention of females.

Left: Male black-throated trogon.
Right: The tail feathers of a male resplendent quetzal can grow to almost twice the length of its body.

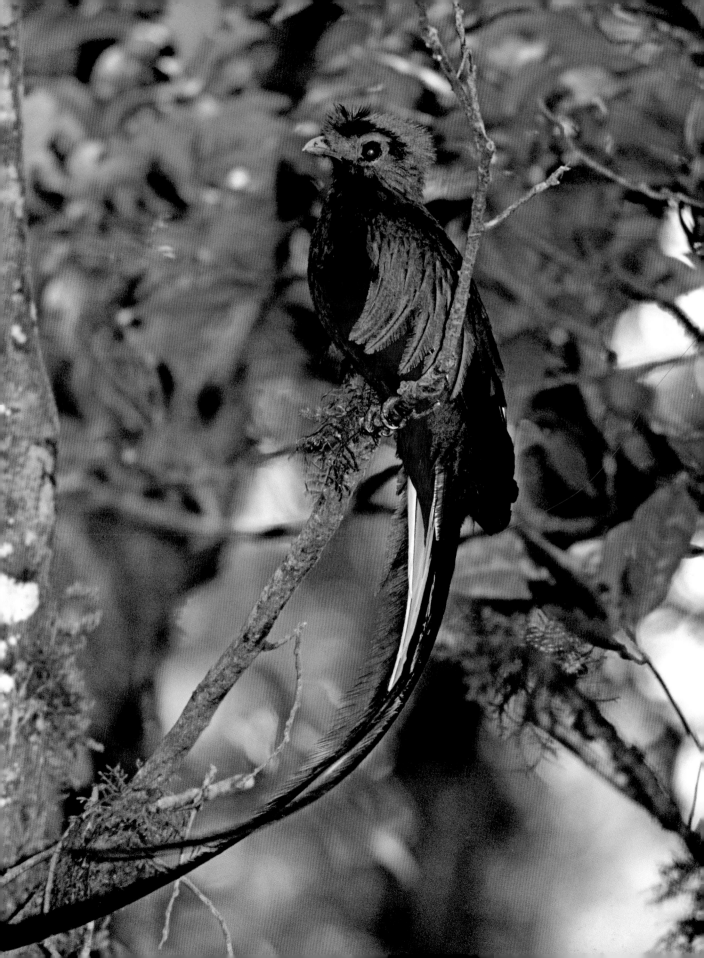

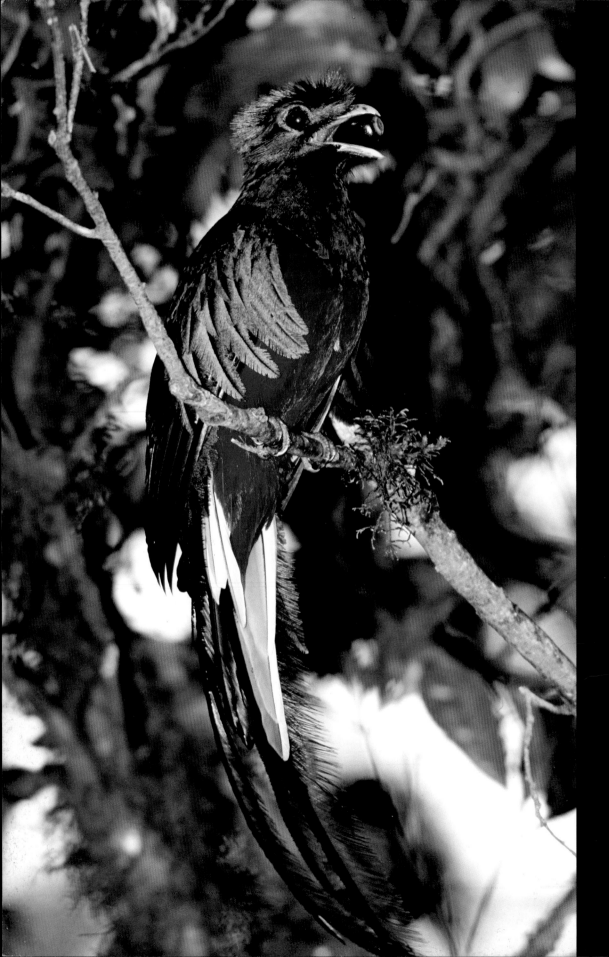

This male quetzal (left) is taking an *aguacatillo* fruit back to his nest to feed to his chicks. Small fruits such as the *aguacatillo* (literally, "little avocado") make up a large part of a quetzal's diet. Seeds that are too large to pass through the digestive tract are regurgitated once the fleshy fruit has been digested. Since this takes some time with larger fruits, the bird has usually traveled some distance by the time it ejects the seed, thus providing the tree with a very effective means of seed dispersal.

Left: Male quetzal with an *aguacatillo* fruit for its chicks.
Right: Female quetzal beginning to regurgitate a seed.

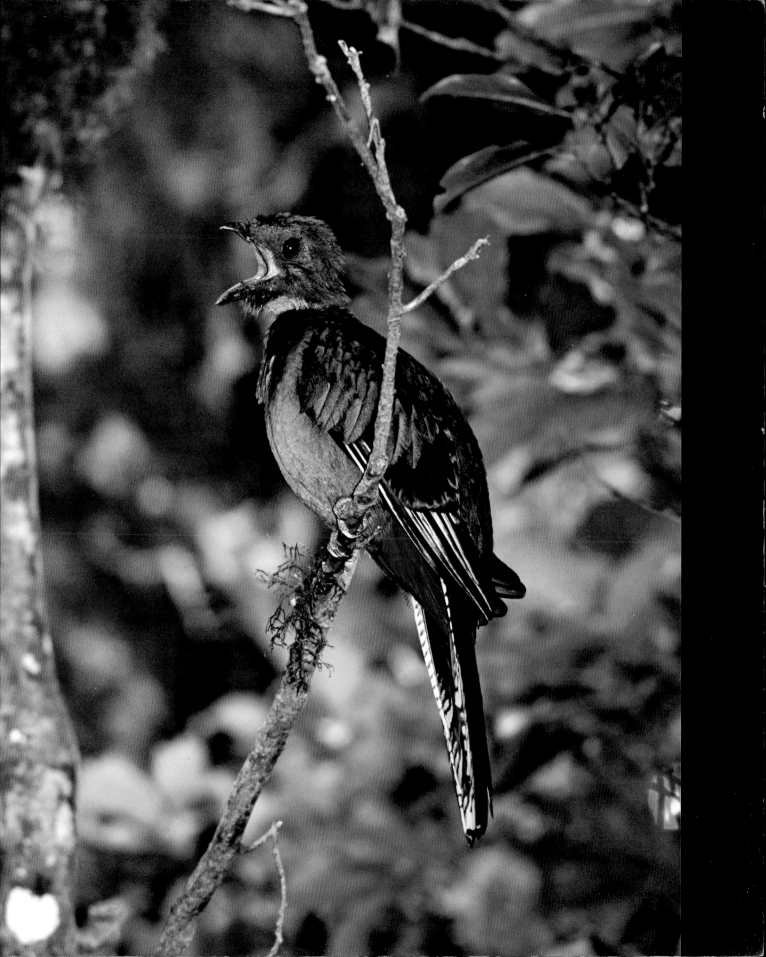

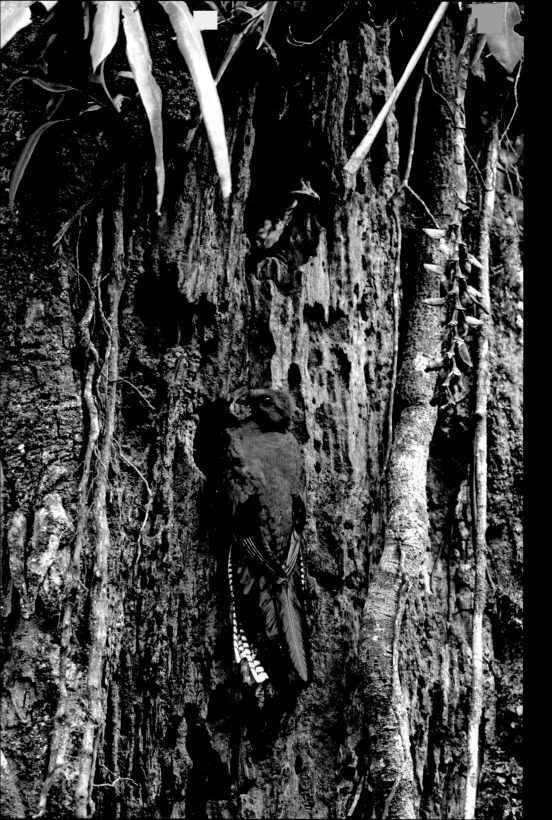

Both male and female quetzals participate in the care of their young. While the chicks are still in the nest, one of the pair will often stand guard on a nearby branch while the other searches for food in the forest. When an adult quetzal returns from foraging, it usually lands in a neighboring tree to survey the area for potential predators. When certain it is safe, it will fly onto the trunk that houses the nest. The female in the photograph on the left has just returned to the trunk and is making sure there are no predators nearby before she approaches her chick in the nest hole above her. The chicks, upon hearing the approach of an adult bird, appear in the entrance, eager to be fed. The male quetzal in the photographs on the right has arrived with an *aguacatillo* fruit, which one of his hungry chicks readily accepts.

Quetzals breed in highland cloud forest, then migrate to lowland forest at other times of the year because of the food that is available there. For many populations, however, the destruction of large areas of lowland rainforest in Central America has broken this cycle. As a result, the resplendent quetzal has become an endangered species.

Left: Female quetzal watching for potential predators before she approaches her nest hole.
Right: Male quetzal feeding an *aguacatillo* fruit to one of its chicks.

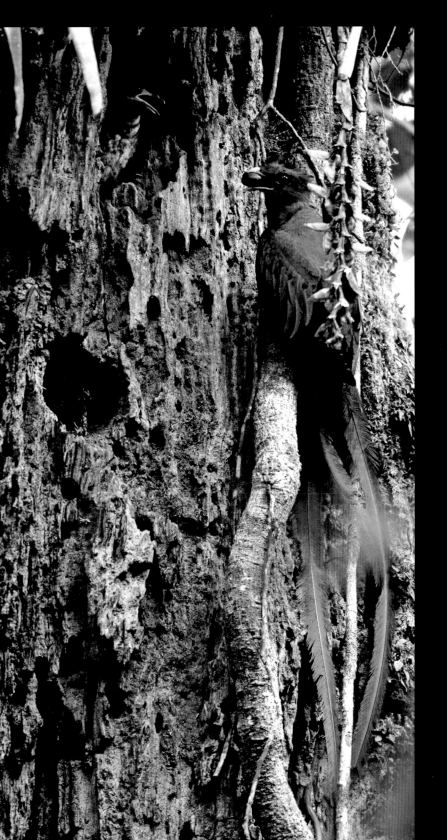
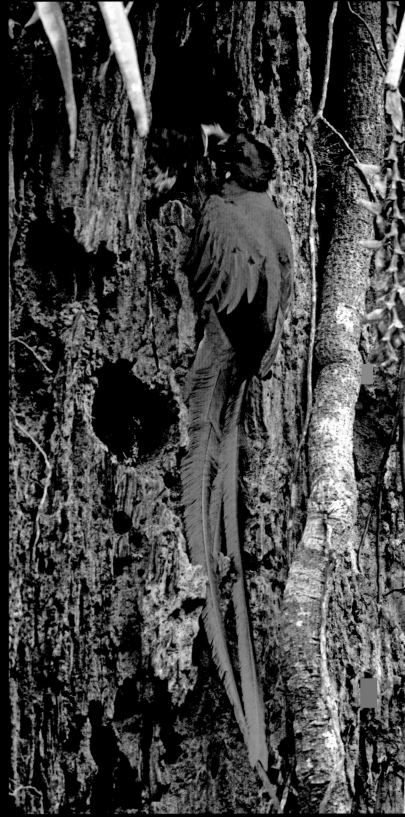

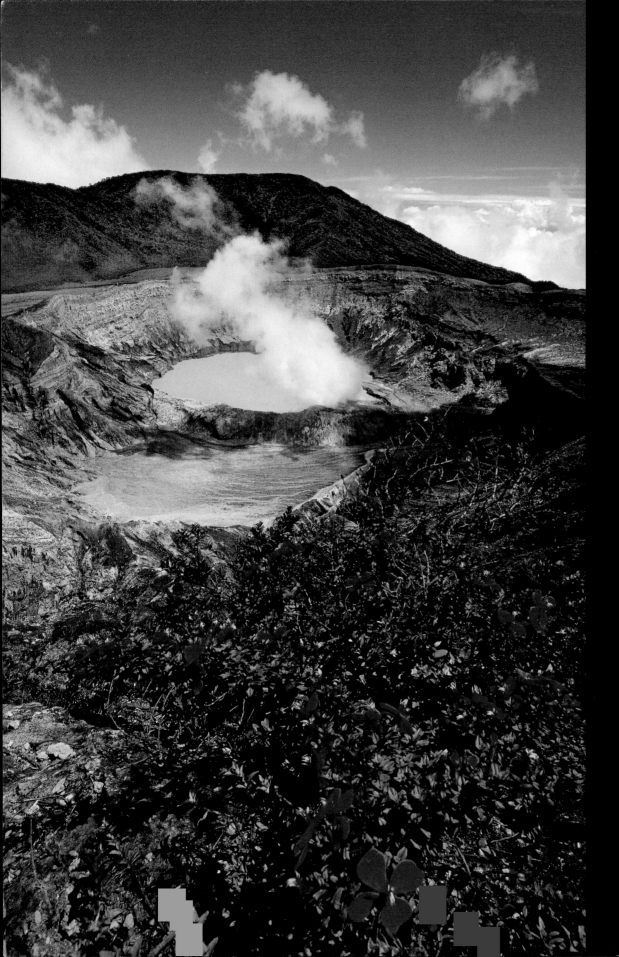

The active crater of Poás Volcano (left) has a diameter of 0.8 miles (1.3 km), making it one of the widest in the world. Unlike many active volcanoes, Poás can be observed and photographed safely from a viewing platform on its very rim. As proof of its active state, Poás periodically releases gases with a sound like the high-pitched hiss of pressure valves, and emits a rotten-egg smell out over the rim.

In the center of the volcano is a sulfur-rich acid lagoon. This is nothing less than an acid bath, at times registering a pH value of zero. During the dry season, evaporation causes the level of the lagoon to drop, re-sulting in a surge of hydrogen chloride emissions. This leads, in turn, to increased acid-rain precipitation in the area. Poás also releases up to five hundred tons of carbon dioxide into the atmosphere every day, many times more than the daily emissions produced by all the road traffic in the city of San José.

Left: The bloom of this plant, appropriately named "melastoma of the volcanoes," is common around the crater rim of Poás Volcano.

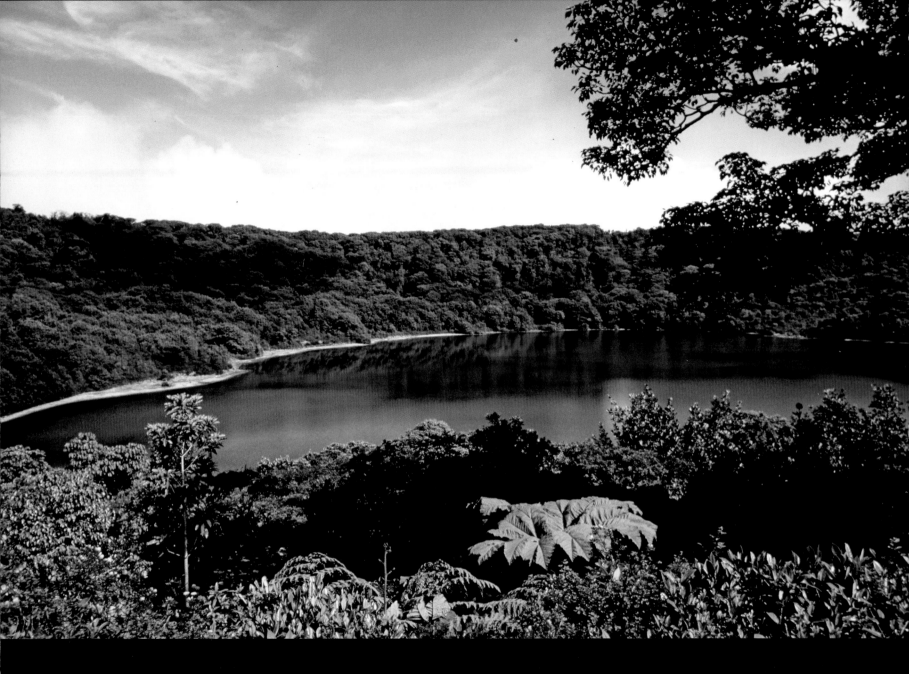

Poás Volcano has three craters, two of which are now extinct. In one of these extinct craters, at the end of a trail from the principal crater to the southeast, lies Botos Lagoon (above). Differing from the insidious-looking lagoon of the main crater, Botos is a picturesque lagoon formed entirely from rainwater and surrounded by an elfin cloud forest. The trees here are stunted in growth, to only a few yards in height, due to the battering they take from the strong winds that bluster over the Central Divide. The understory of the diminutive canopy is a dense network of moss-covered trunks and tangled branches, thickened for wind resistance. In contrast to the wind-exposed crater, there is an eerie silence under the shelter of the canopy. The high altitude and the forest's proximity to an active crater create very harsh conditions. The result is a relative scarcity of wildlife that further heightens the uncanny sense of calm. The most commonly seen animals here are birds, and species such as the collared redstart, the ruddy-capped nightingale-thrush, and the flame-throated warbler flit through the dark undergrowth.

Above: Botos Lagoon fills one of Poás Volcano's two extinct craters.

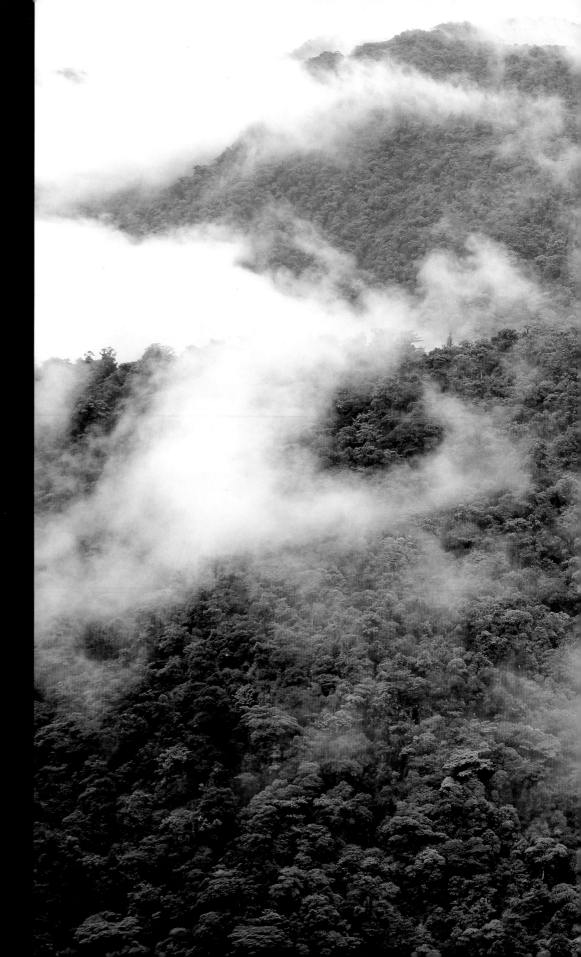

The majority of the sprawling, mountainous wilderness of Braulio Carrillo National Park (right), on the Central Cordillera, is uncharted and undisturbed. Its 181 square miles (470 km²) encompass the largest range of elevations of any national park in the country. The park extends from the cloud-forest-enveloped Barva Volcano, towering 9,500 feet (2,900 m) above sea level, to the lowland rainforest at the park's northern boundary, where the terrain descends to an elevation of just 115 feet (35 m). The world-famous La Selva Biological Station is located at this northern boundary. Braulio Carrillo National Park receives an average of nearly 15 feet (4.5 m) of rainfall per year, which keeps the richly forested slopes teeming with life. More than 5,000 species of vascular plants grow in this protected area, along with over 120 mammal species and 500 species of bird. Snakes, poison arrow frogs, and a multitude of bizarre and beautiful insect species add to the numbers, in an impressive display of biodiversity.

Right: Clouds drifting over the forest canopy in Braulio Carrillo National Park.

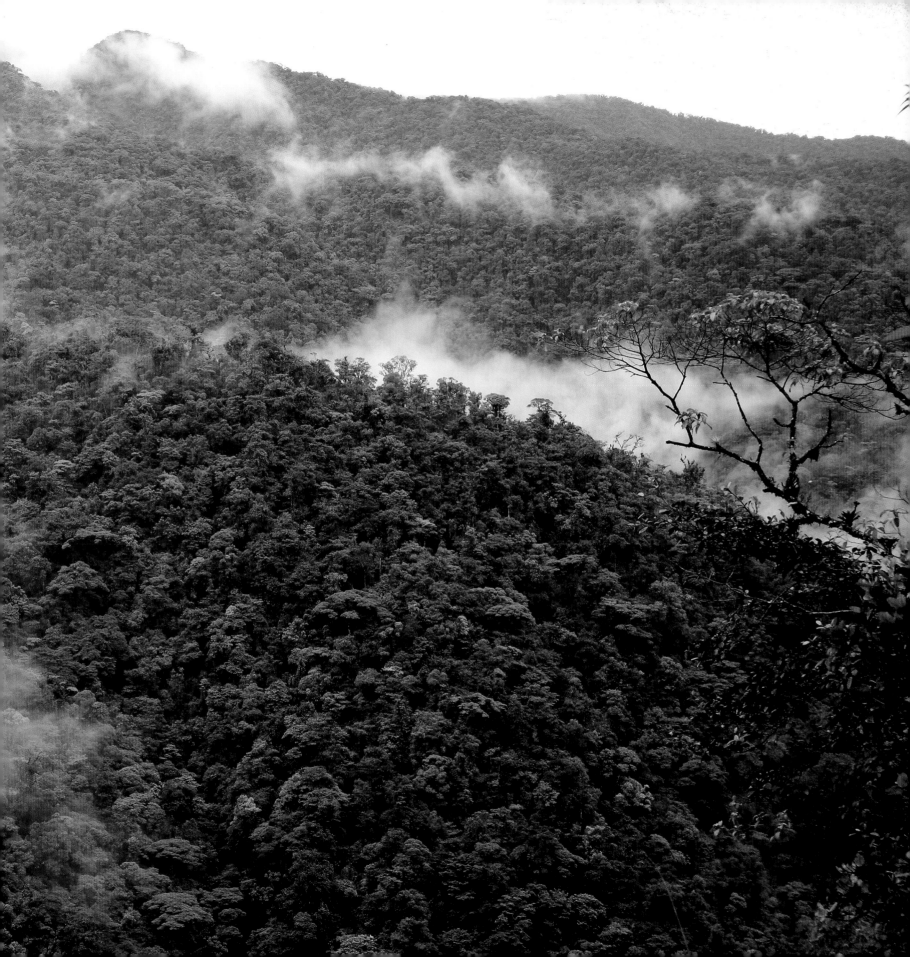

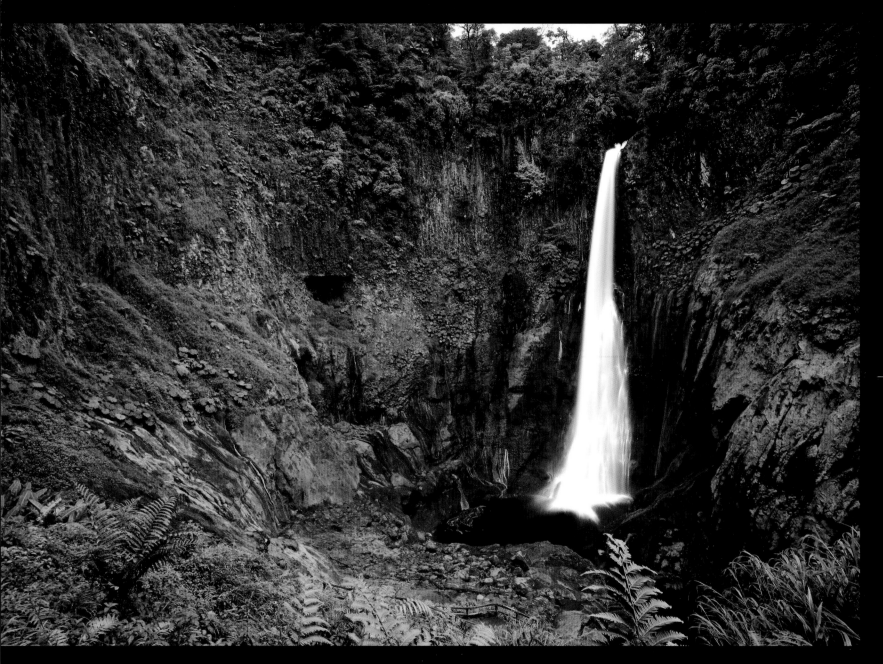

Deep inside the rainforest on the edge of Juan Castro Blanco National Park, the Del Toro Waterfall is surrounded by what seems like a prehistoric scene. In Costa Rica, it is second to none in terms of beauty and splendor. Its waters spill over the edge of a now extinct volcano and plunge four hundred feet (122 m) into the crater.

Above: The magnificent Del Toro Waterfall.

Orchids comprise the most diverse family of flowering plants on Earth, with twenty thousand or more species found worldwide. Roughly 7 percent of these orchid species grow naturally in Costa Rica, in habitats ranging from the hot and sultry coastal plains to the cold and damp highlands. The flowers, whose rich variety of shape and form make them so appealing, range from the size of a pinhead up to 10 inches (25 cm) across.

While the majority of Costa Rica's orchids grow as epiphytes in the forest canopies, the star orchid (*Epidendrum radicans*), shown above, is an exception. This terrestrial orchid is commonly found growing on open ground in Braulio Carrillo National Park.

Orchids are masters of sexual deception and use a number of guises to attract the attention of pollinating insects. The color and shape of the star orchid are thought to mimic the nectar-rich flowers of other plants.

In this way, the orchid, which contains no nectar, lures butterflies that inadvertently become pollinators with no reward in kind.

Above: *Epidendrum radicans* is one of about 1,400 orchid species that grow in Costa Rica.

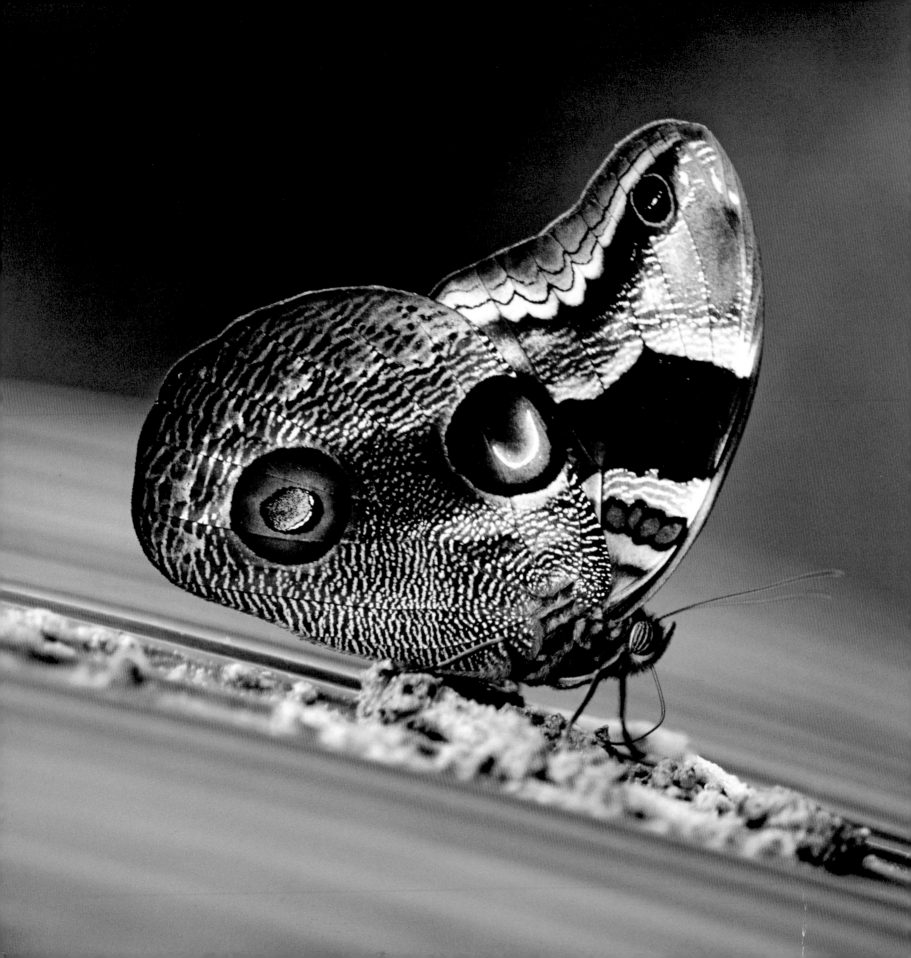

Owl butterflies (left) are easily identified by the large eyespots on the underside of their wings. These spots resemble the eyes of a bird of prey and will deter many animals from getting too close. When a bird such as the rufous motmot (right) does attack, it may be tricked into snapping at the false "eye" in the mistaken belief that this is the butterfly's head. The butterfly has a good chance of escaping with just a ripped wing, instead of damage to its head or abdomen.

Owl butterflies prefer to eat decomposing fruit, though they will sometimes feed on nitrogen-rich bird droppings, which are crucial in providing essential minerals that aid the butterflies' reproductive process.

The rufous motmot is the largest species of motmot in Costa Rica; it grows to an average of 18 inches (46 cm). It has two very long tail feathers that form small triangles at their ends. Curiously, when the bird is still young, a gap develops along the quill of these feathers just above the triangles. This physical peculiarity is seen in all but one species of motmot in Costa Rica, and no one has yet provided a satisfactory explanation for it.

Left: Eyespots on the wings of an owl butterfly help to draw a predator's attack away from the insect's body.
Right: The rufous motmot is the largest motmot species in Costa Rica.

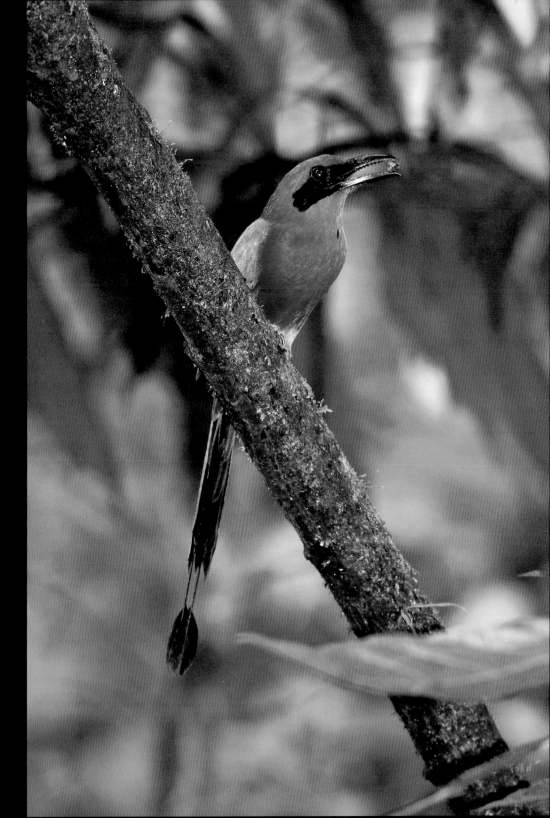

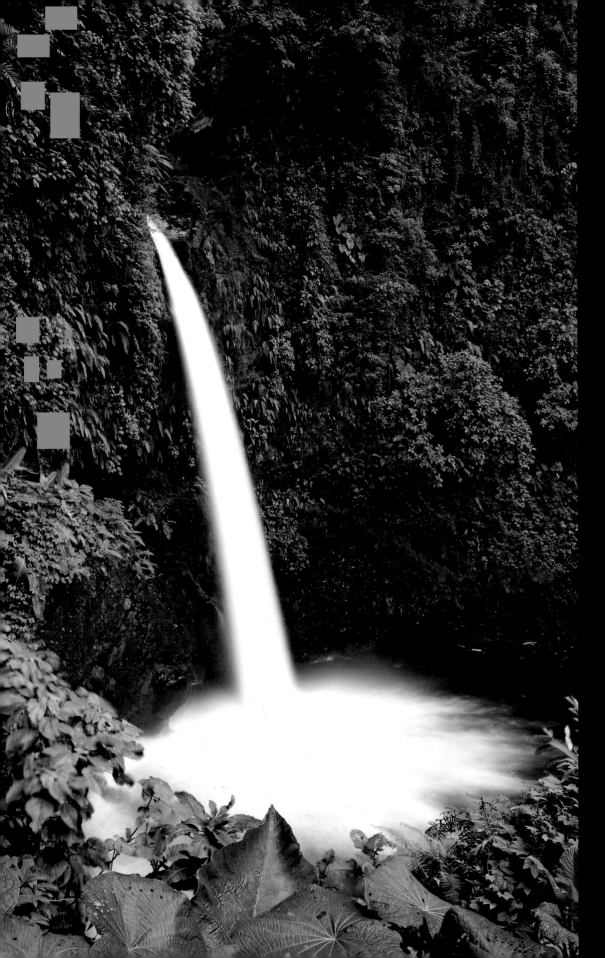

The valley of the La Paz River stretches across the western boundary of Braulio Carrillo National Park. Lush rainforests—at middle and upper elevations—blanket the mountain slopes. As the river descends through the mountains, it plunges over a series of magnificent waterfalls. The La Paz Waterfall (left) is by far the most famous of these.

This rainforest stream (right) was photographed at the end of a dry spell in Braulio Carrillo National Park. After heavy rainfall the following day, the entire streambed was submerged with a torrential cascade of water, fallen foliage, and logs.

Left: The splendid La Paz Waterfall.
Right: Rainforest stream in Braulio Carrillo National Park.

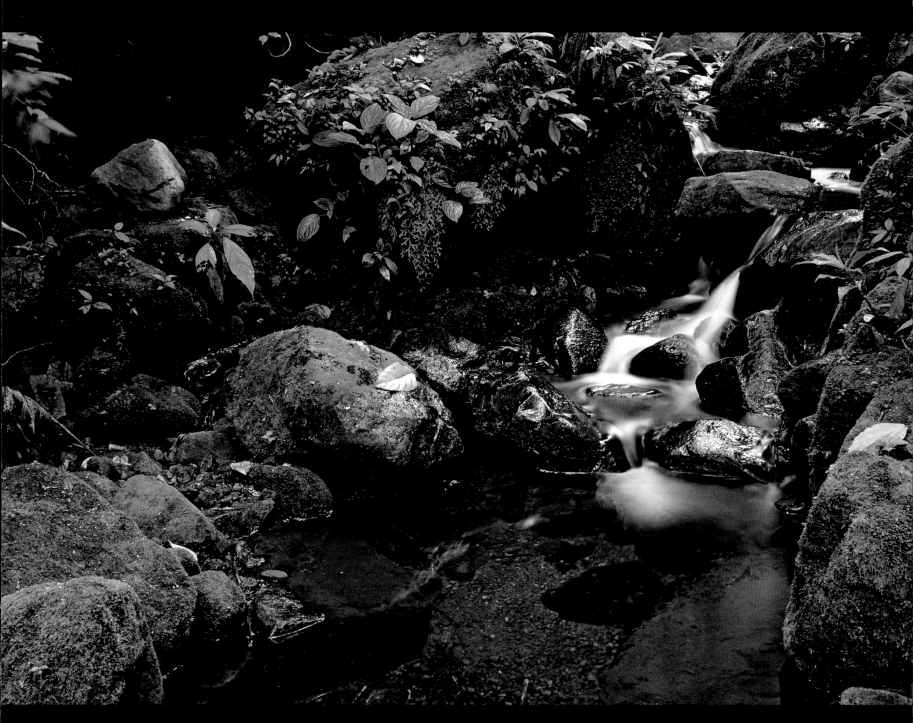

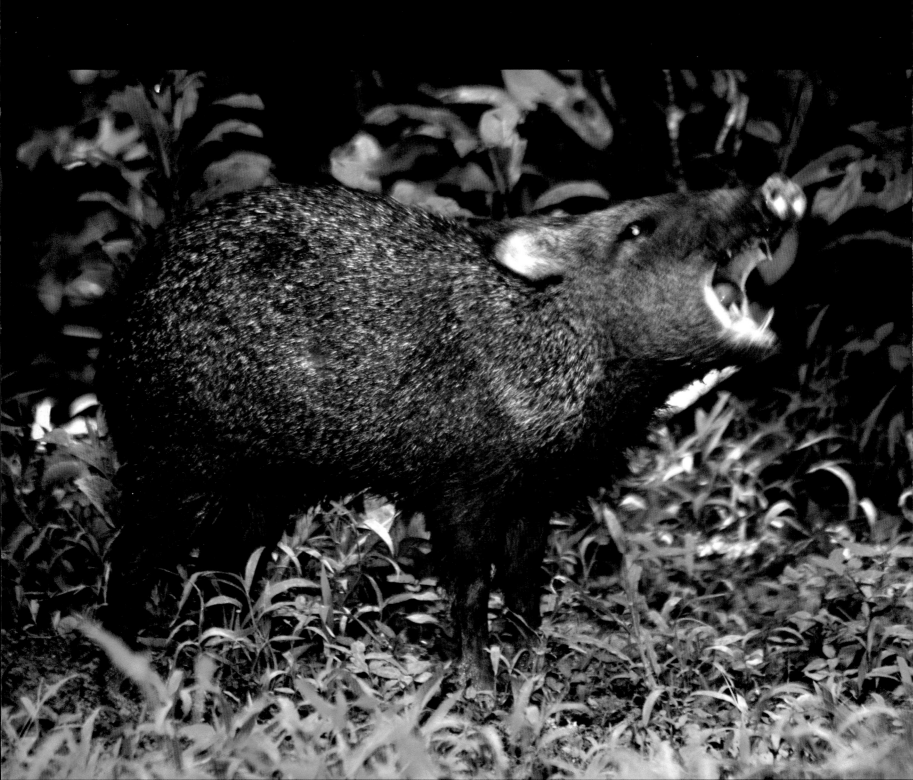

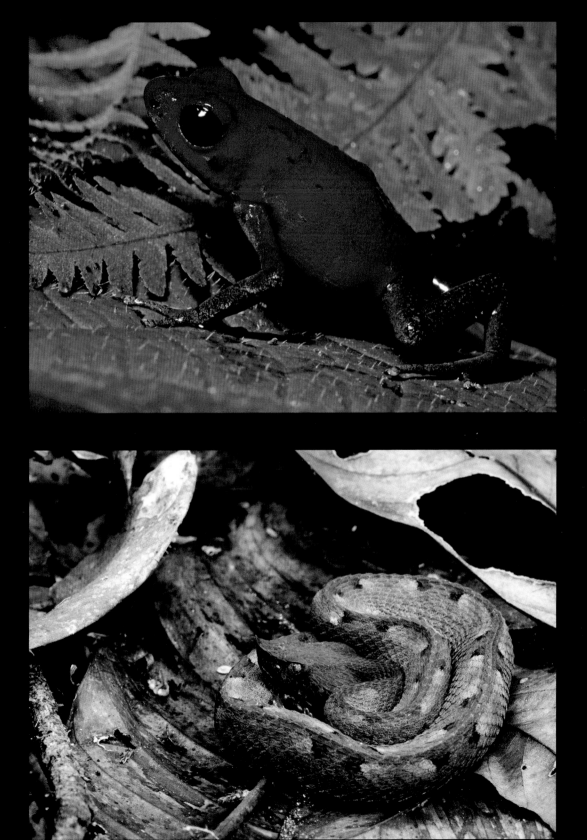

The tropical rainforest is a highly competitive environment. The species that live there survive partly because they have developed sufficiently effective defenses against their predators. The collared peccary (left) has very acute senses of hearing and smell that help it detect the stealthy approach of its large feline predators. If surprised and cornered, however, the peccary can deliver a vicious bite with its enlarged canine teeth.

In nature, vivid, attractive, contrasting colors tend to be an indication that the organism sporting them should, for whatever reason, be avoided. The bright colors of poison arrow frogs such as *Dendrobates pumilio* (top right) provide just such a warning. Secretions from the skin of these vibrant little amphibians are extremely toxic. Any small animal ingesting one of these frogs will become painfully ill, with a high likelihood of death. Poison arrow frogs, however, do encounter predators such as the Central American bullfrog that are immune to their toxins. To escape these animals, they use their long, powerful hind legs to leap quickly away into the undergrowth.

Immobility and camouflage are other highly effective ways of avoiding predators. The hog-nosed pit viper (bottom right) relies on both of these strategies to hide from the birds of prey and large mammals that might attack it. Even if it is detected, however, the viper may not be in danger; many animals would be wary of getting too close for fear of receiving its potentially deadly bite.

Left: Collared peccary eating peach-palm fruit.
Top right: *Dendrobates pumilio*, also known as the "blue jeans" poison arrow frog.
Bottom right: The hog-nosed pit viper has an upturned snout that clearly distinguishes it from other vipers.

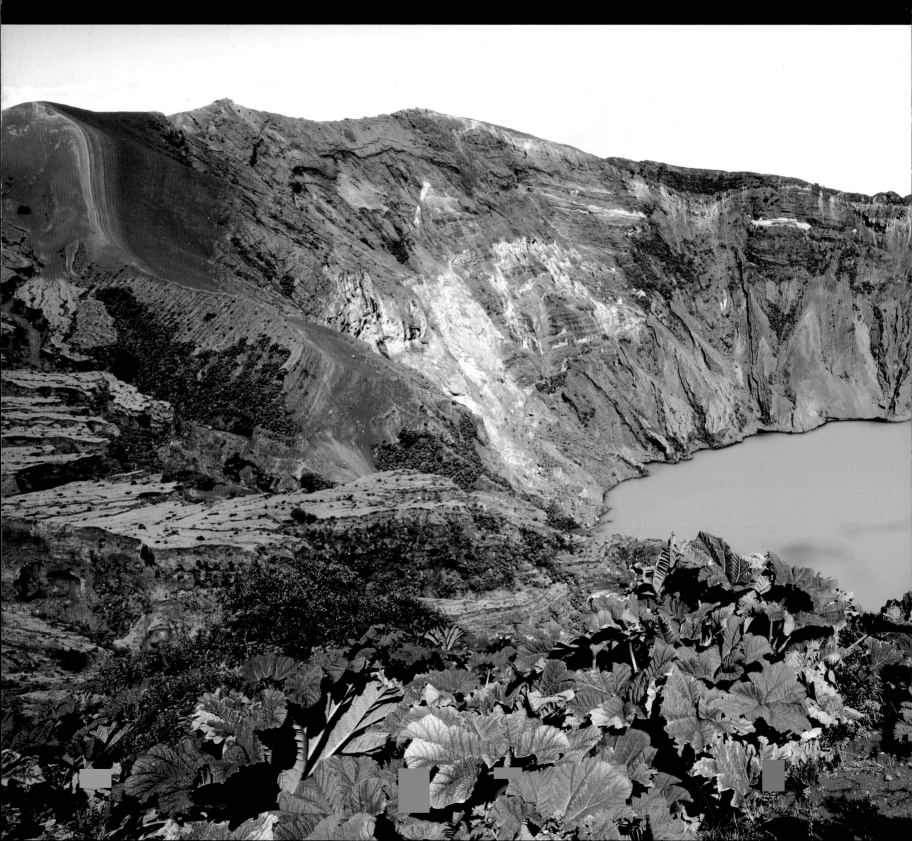

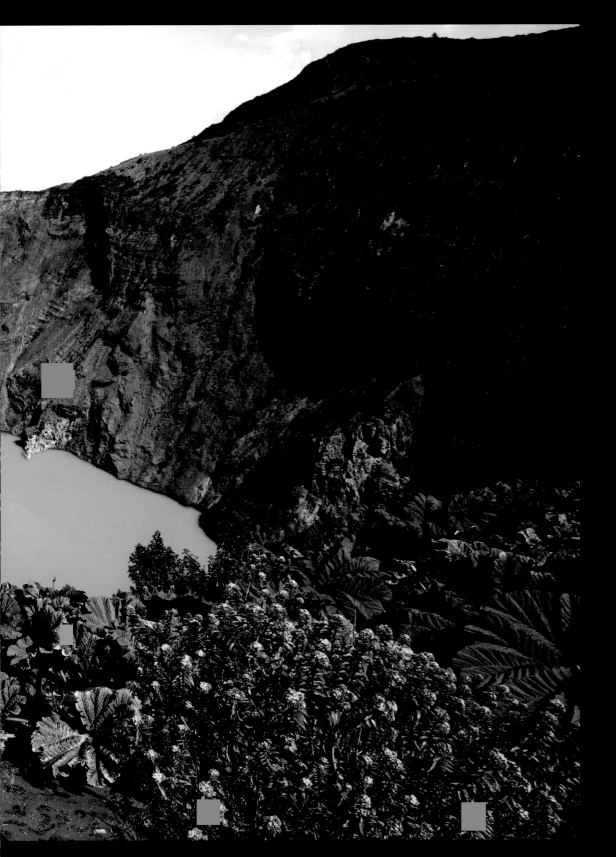

Irazú is the highest volcano in Costa Rica. It stands at 11,260 feet (3,432 m) above sea level and overlooks San José from the east. Visitors to the summit are greeted by a windswept moonscape of craters and gray volcanic ash. The largest of Irazú's three craters (left) has an impressive diameter of 3,445 feet (1,050 m) and contains a bright green lagoon of mildly alkaline water.

Despite its calm appearance, Irazú is an active volcano. On March 12, 1963, during a visit by President John F. Kennedy, Irazú erupted powerfully, blanketing large areas of San José with ash. More recently, in 1994, a small hydrothermal explosion on the volcano's northern slope destroyed large areas of forest and temporarily buried sections of the nearby Sucio River. Since then, Irazú has once again become quiet. The only visible sign of volcanic activity today is steam and gases issuing from some of the fumaroles.

Left: The principal crater of Irazú Volcano is over half a mile (1 km) in diameter.

The carved terrain of peaks and lake-filled valleys in Chirripó National Park, located in the Talamanca Mountains, is the result of glacial action that occurred as the last permanent ice melted approximately ten thousand years ago. The Talamanca mountain range arose as a consequence of two tectonic plates converging. The geologically heavier Cocos Plate of the Pacific Ocean has been sliding beneath the lighter Caribbean Plate for millions of years, and the resulting underwater volcanic eruptions initially formed a series of islands. Eventually, around three million years ago, the land bridge that is now Costa Rica and Panama became complete. This allowed migrations of many species between the previously isolated continents of North and South America. Since their formation, these mountains have risen to almost 13,000 feet (4,000 m).

The tallest peak in Costa Rica is Mount Chirripó. With a recorded height of 12,532 feet (3,820 m), it is one of the highest mountains in Central America, exceeded by only a handful of volcanoes in Guatemala. On a relatively cloudless day, both the Caribbean and Pacific coastlines are visible from its summit.

Right: Las Morenas Lakes, as seen early one morning from the summit of Mount Chirripó.

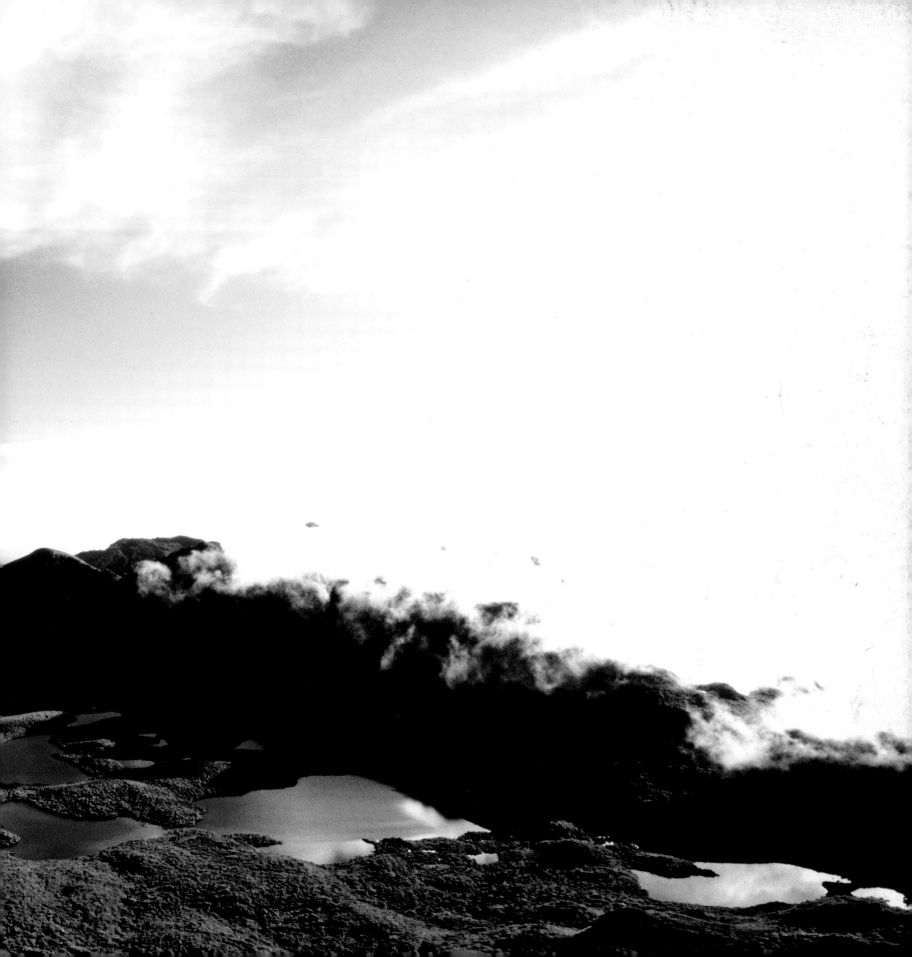

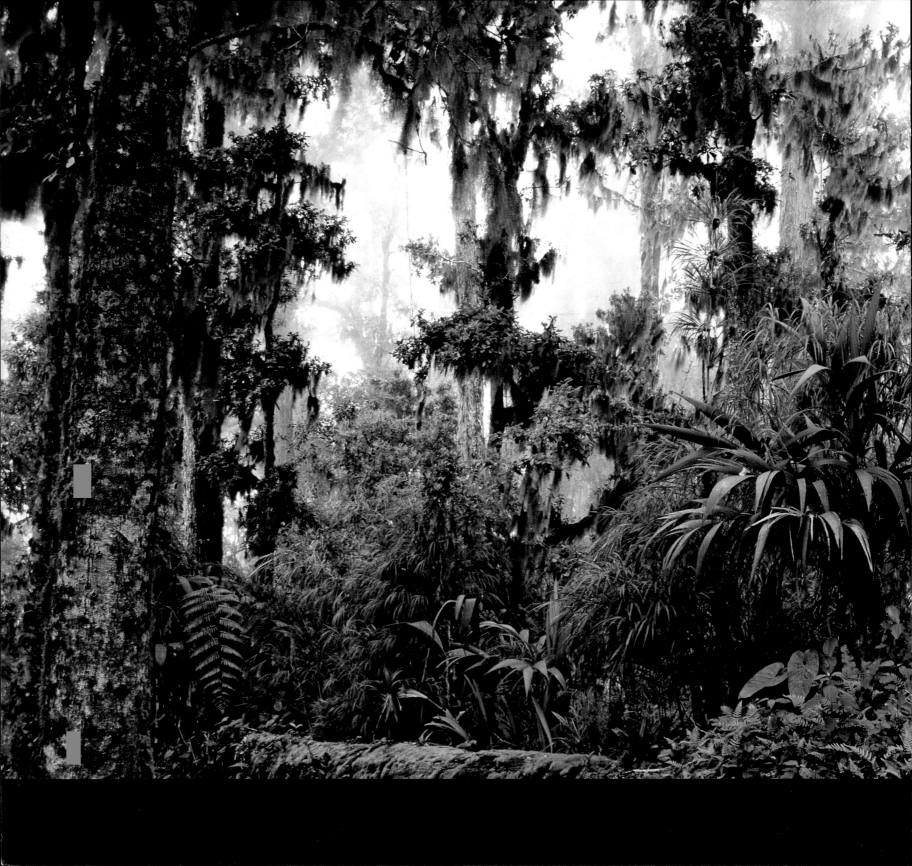

The scenery and vegetation surrounding the steep and winding trail that leads toward Mount Chirripó gradually changes as one ascends the slope. After a few miles, the coffee plantations and pastureland eventually surrender to natural wilderness as rainforest envelops the path. Higher still, a cloud forest of ancient trees appears, draped with moss and lichen (left). Here there are some enormous oak trees (above), towering up to 130 feet (40 m) above an understory that grows thick with bamboo. Few large mammal species appear at this elevation, and reptiles are scarce. There are many birds active in the canopy, however, including the flame-throated warbler, the volcano hummingbird, and, of course, that prize of the cloud forest, the resplendent quetzal.

Left and above: Cloud forest on the trail to Mount Chirripó.

The treeless, windswept paramo that surrounds the summit of Mount Chirripó offers an environment unlike anywhere else in Costa Rica. Strong winds and heavy rainfall constantly erode the soil and, on any given day, the temperature ranges from an average low of 41 degrees Fahrenheit (5 degrees Celsius) to an average high of 59 degrees Fahrenheit (15 degrees Celsius). No trees, and only the hardiest of plants, such as this *Castilleja* shrub (right), can survive under these conditions.

Unlike at lower elevations in Costa Rica, only a handful of birds, such as the delightfully named volcano junco and slaty flowerpiercer, inhabit the paramo. Insects are also rarely encountered. Because of this, the paramo is a strangely quiet place. Rainfall, water babbling in a nearby stream, or the distant howl of a coyote replace the more familiar calls of birds and insects.

Right: The *Castilleja* shrub is one of the few hardy plants that flower in the paramo.
Below: Paramo in Chirripó National Park.

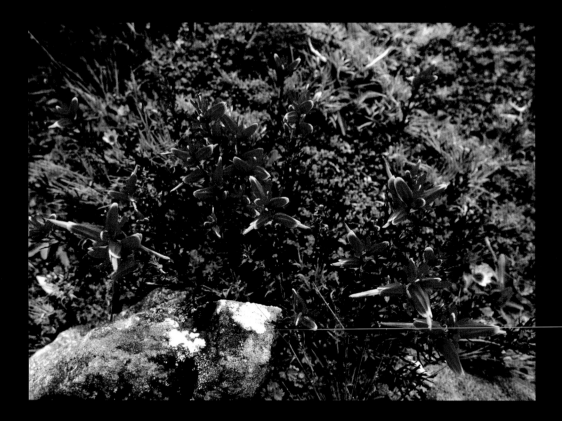

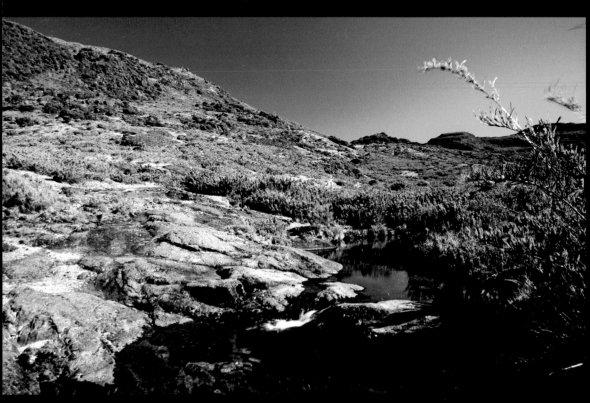

Probably the most characteristic, and certainly most photographed, feature of Chirripó National Park is a cluster of enormous rock pinnacles called Los Crestones (right). This rock formation sits majestically on the mountainside overlooking the visitor station. In the late afternoon on a clear day, for a few precious minutes before the sun drops below the cloud layer, this impressive sculpture is bathed in a glorious golden light.

Right: Los Crestones, Chirripó National Park.

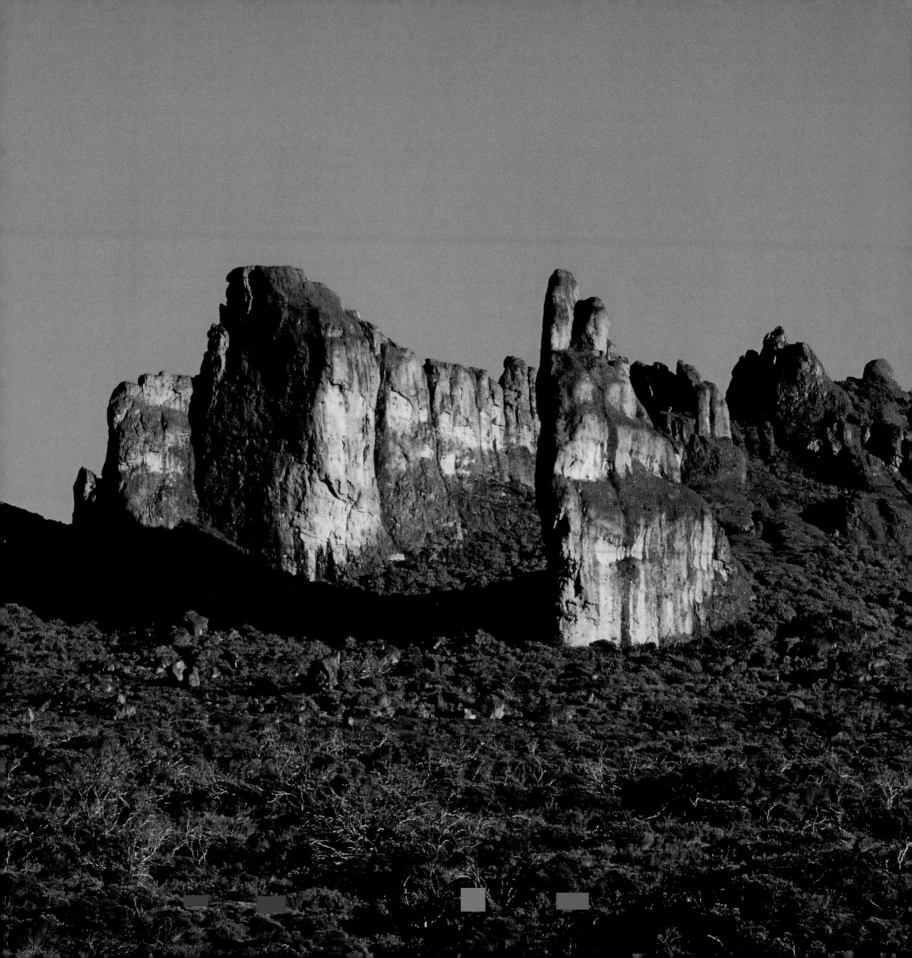

The mountains of Chirripó National Park rise up until their peaks vanish into the clouds. Looking down, entire valleys can disappear in an instant, and then reappear from behind enormous cloud banks. In the early hours, bitingly cold high winds that accompany the clouds challenge even the most enthusiastic hikers.

Above: Lake Chirripó appearing through the dawn mist.

Above: The sun slowly dropping below the cloud layer at dusk, as viewed from Los Crestones in Chir-

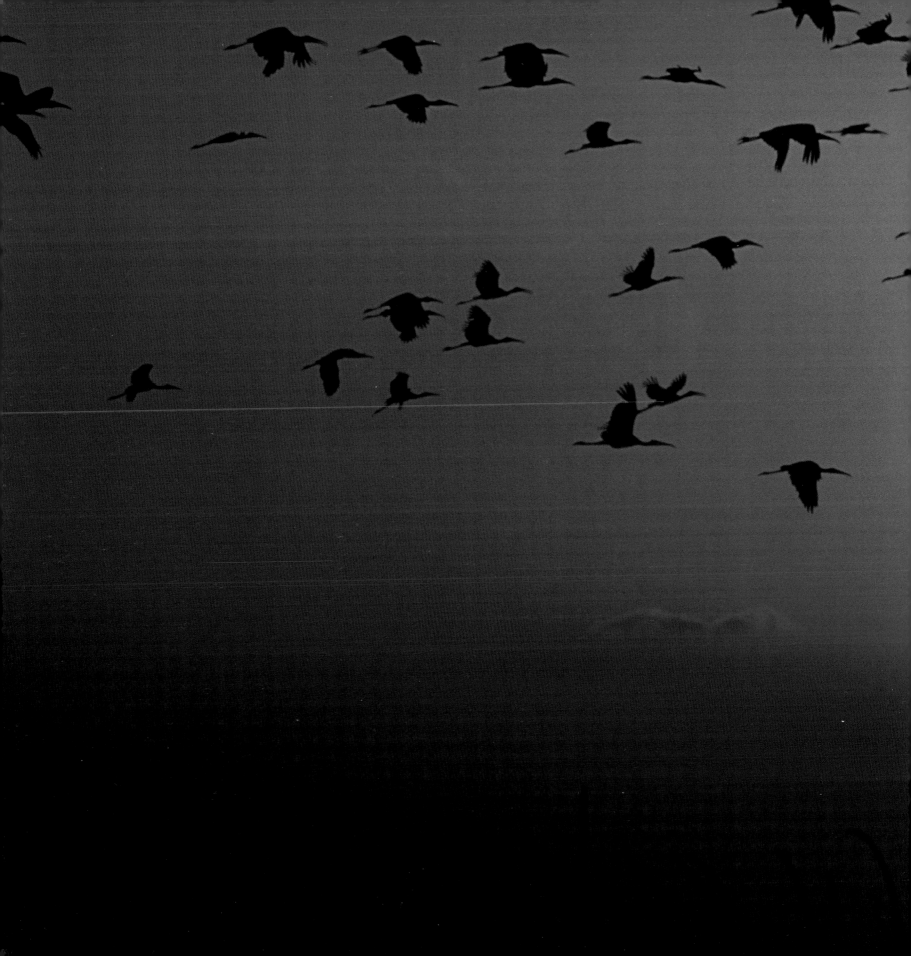

Guanacaste
Life Under the Sun

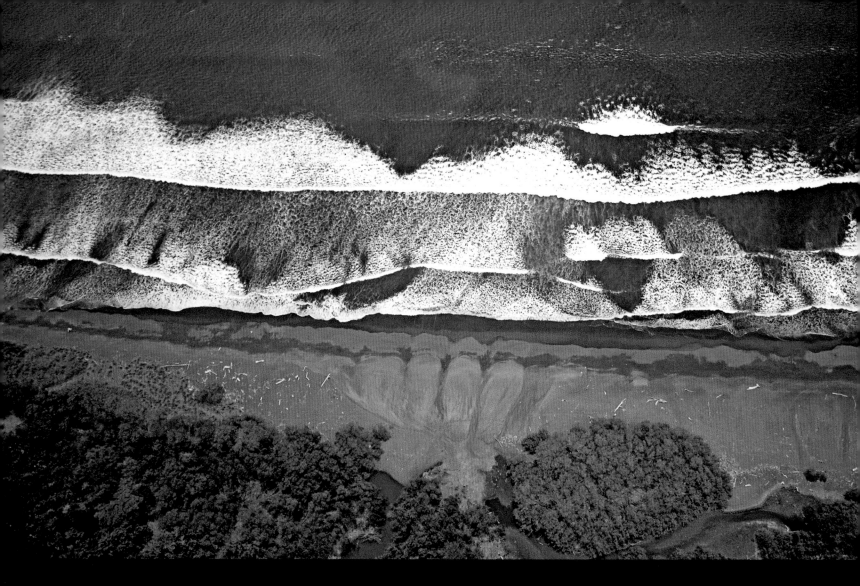

The lowlands of Costa Rica's northwestern region have a climate distinctly different from that of the rest of the country. For five months of the year, from December to the end of April, there is very little rain, and the midday temperatures often exceed 86 degrees Fahrenheit (30 degrees Celsius). In contrast to the denser rainforest typical of the southern Pacific and Caribbean coasts, the beaches of the Nicoya Peninsula, in the northwest of Costa Rica, are bordered by tropical dry forest and mangroves. The winding coastline forms

many small inlets and bays. Some of the bays are now developed tourist destinations, but many others are protected within the boundaries of the Guanacaste, Santa Rosa, and Las Baulas National Parks; the Tamarindo, Ostional, and Curú Wildlife Refuges; and the Cabo Blanco Biological Reserve. The coastal waters of this region are the site of migrating humpback whales and home to the yellow-bellied sea snake. Above the surf, frigate birds and brown pelicans sail on the wind, looking for fish. Thousands of marine turtles nest on

the beaches during certain months of the year. Their nests attract large numbers of wood storks, plovers, caracaras, and black vultures, all looking for an easy meal of turtle eggs or hatchlings.

Previous spread: Wood storks flying back to their roos as the sun sets over Palo Verde National Park.
Above: Waves breaking on Carrillo Beach.
Right: At daybreak, brown pelicans patrol the shallows of Ostional Beach for shoals of fish.

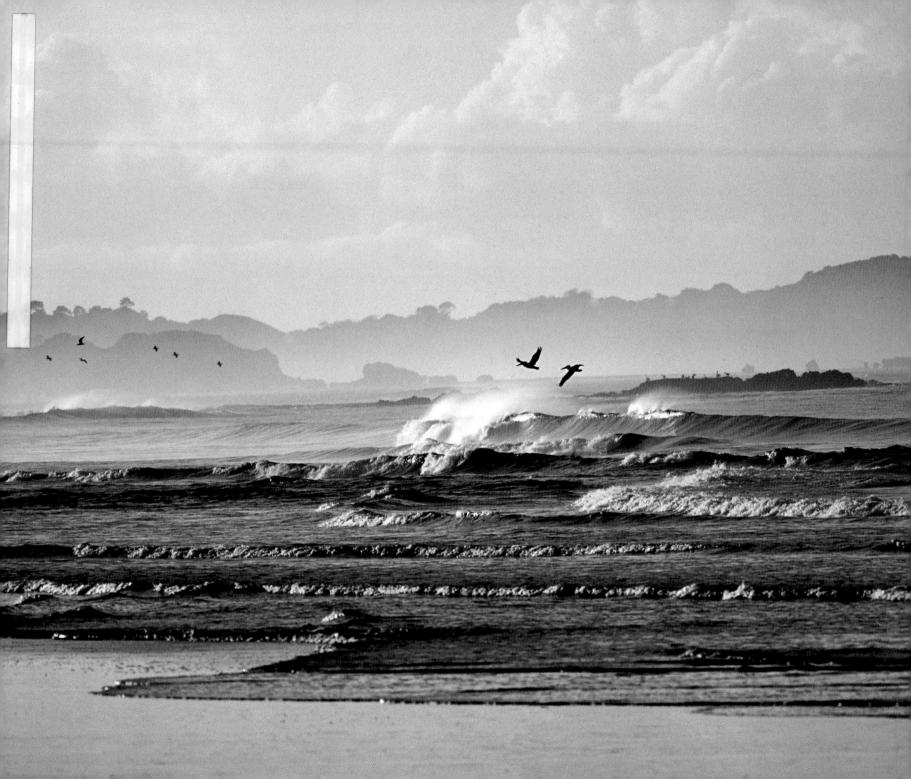

Sandy beaches are inhospitable places for most small animals, but painted ghost crabs (below) are very much at home here. They dig burrows in the sand, often up to 3 feet (1 m) deep, that serve as a refuge from predators and the midday sun. Their main sources of food are microscopic algae that grow on the surface of sand grains, and they separate the two by filtering the sand through their mouths and discarding the "processed" grains. Despite their terrestrial lifestyle, these crabs are marine organisms and breathe using gills that must be kept moist. From time to time, a crab will dart in and out of the breaking surf to immerse its gills in water.

Below: Painted ghost crab at the mouth of its burrow on Brasilito Beach.

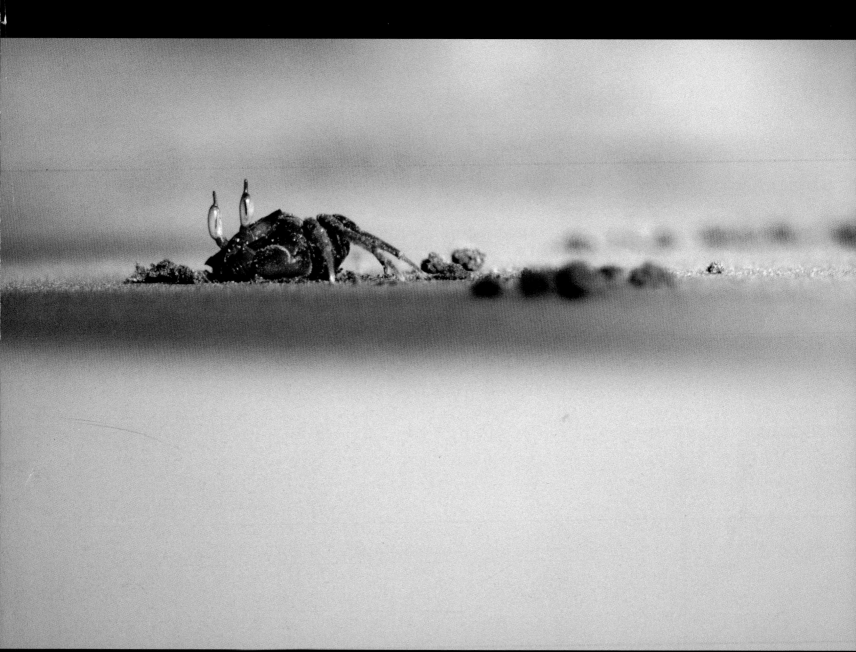

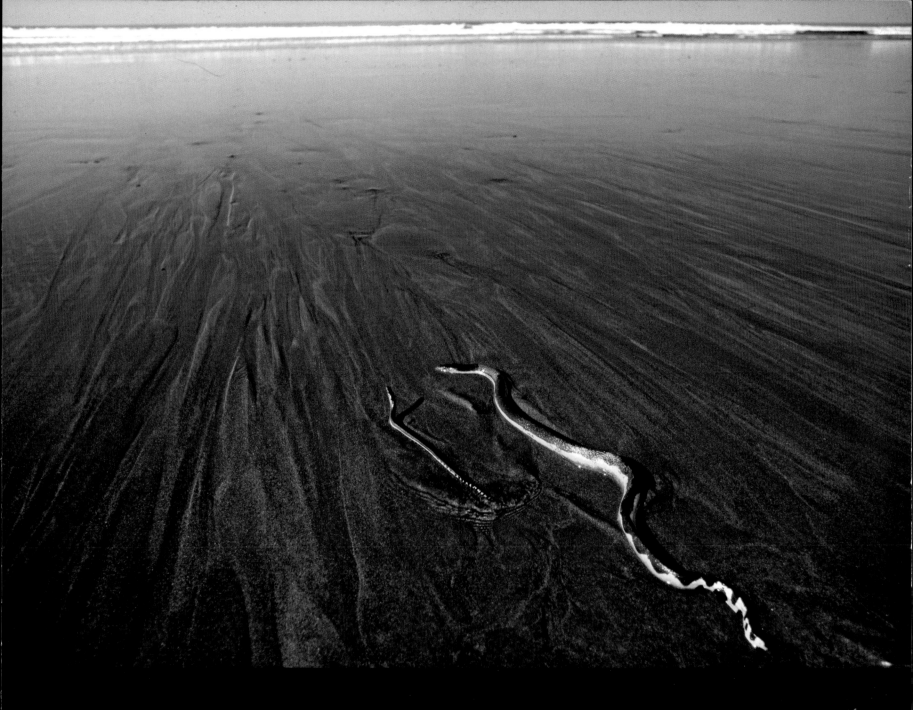

There is only one species of Costa Rican snake that lives exclusively in the ocean: the yellow-bellied sea snake. It feeds on fish, killing them with a poisonous bite. Yellow-bellied sea snakes have evolved a paddle-like tail with which to propel themselves through the water; but, despite this adaptation, they are poor swimmers. Strong tidal currents often wash them up onto beaches, especially if they are old or weak. Exposure to direct sunlight will soon dehydrate and kill a beached snake. This female (above), which appeared on Ostional Beach early one morning, seemed close to death. However, quite suddenly, she gave birth to a baby, and both snakes then began to wriggle on the warming sand in an attempt to reach the sea. Eventually, the incoming tide took them back into the ocean. Yellow-bellied sea snakes are not aggressive and, if not provoked, pose little danger to humans.

Above: On Ostional Beach, a female yellow-bellied sea snake and her newly born baby struggle to return to the ocean.

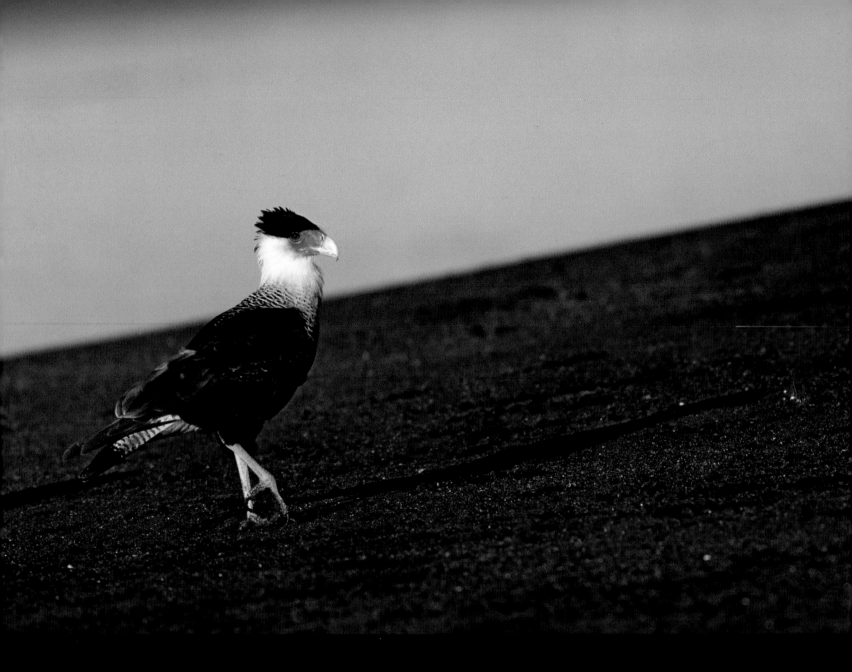

Unlike most birds of prey, the crested caracara (above) will search for food on foot as well as from the air. In addition to live animals such as rodents, snakes, and frogs, this predator also feeds on carrion, and will compete with vultures at a carcass. Crested caracaras prefer open country rather than forest, and they are frequent visitors to beaches where

vultures for turtle eggs that the tide uncovers and for hatchlings that emerge during the day.

Above: Crested caracara surveying Ostional Beach for turtle eggs and hatchlings.
Right: Wood storks patrolling the shoreline of Ostional

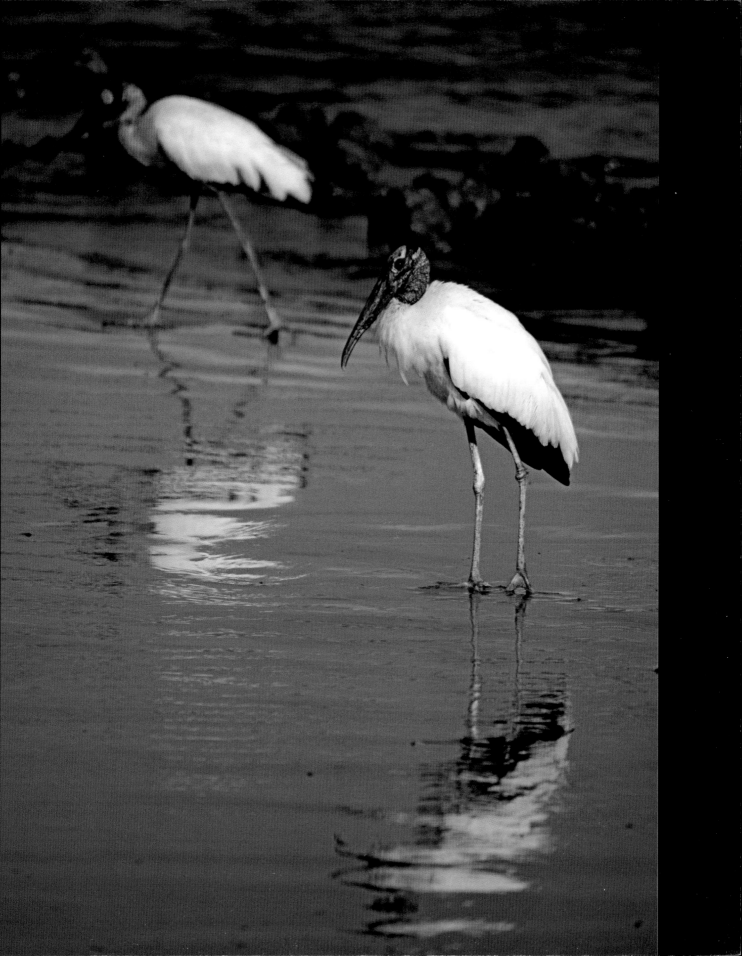

Every year, Nancite Beach in Santa Rosa National Park and Ostional Beach (left) are invaded by olive ridley turtles coming ashore to dig nests and lay their eggs. In Spanish, this gathering of turtles is known as an *arribada*. By dusk, the beach is already crowded with these slow-moving silhouettes, and as the sun goes down the number of turtles emerging from the sea increases dramatically. Counts have revealed that tens of thousands of individuals arrive on this small beach during the course of a single night.

Left: An *arribada* of olive ridley turtles invading the beach at Ostional as darkness falls.

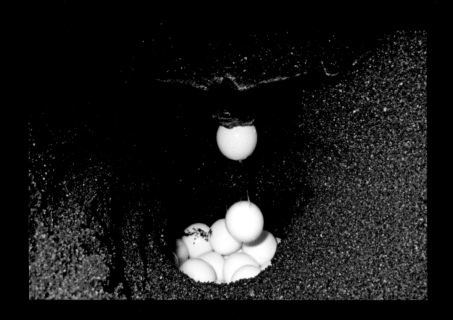

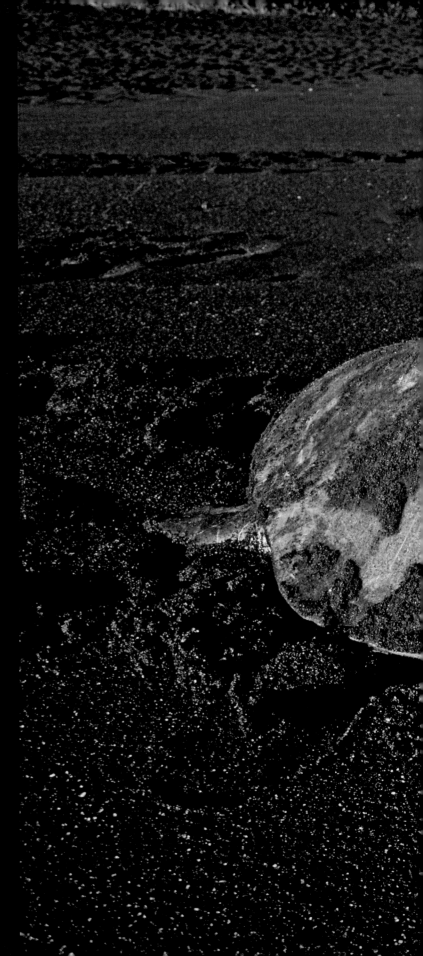

A female olive ridley turtle usually mates every one to three years; during a breeding season, she will come ashore to lay eggs on several different occasions. Once she is on the beach, she digs a hole in the sand with her back flippers. This hole is approximately 30 inches (80 cm) deep and takes around twenty minutes to complete. She then lays an average of one hundred billiard-ball-sized eggs in the hole (above) before filling in the nest with sand to protect the eggs from the sun and scavengers. From this moment on, her parental responsibility is over. In a scene reenacted for millions of years, the female returns to the ocean (right) and leaves her offspring to fend for themselves.

Above: Olive ridley turtle laying eggs in her nest hole on the beach.
Right: Olive ridley turtle returning to the sea after laying her eggs on Ostional Beach.

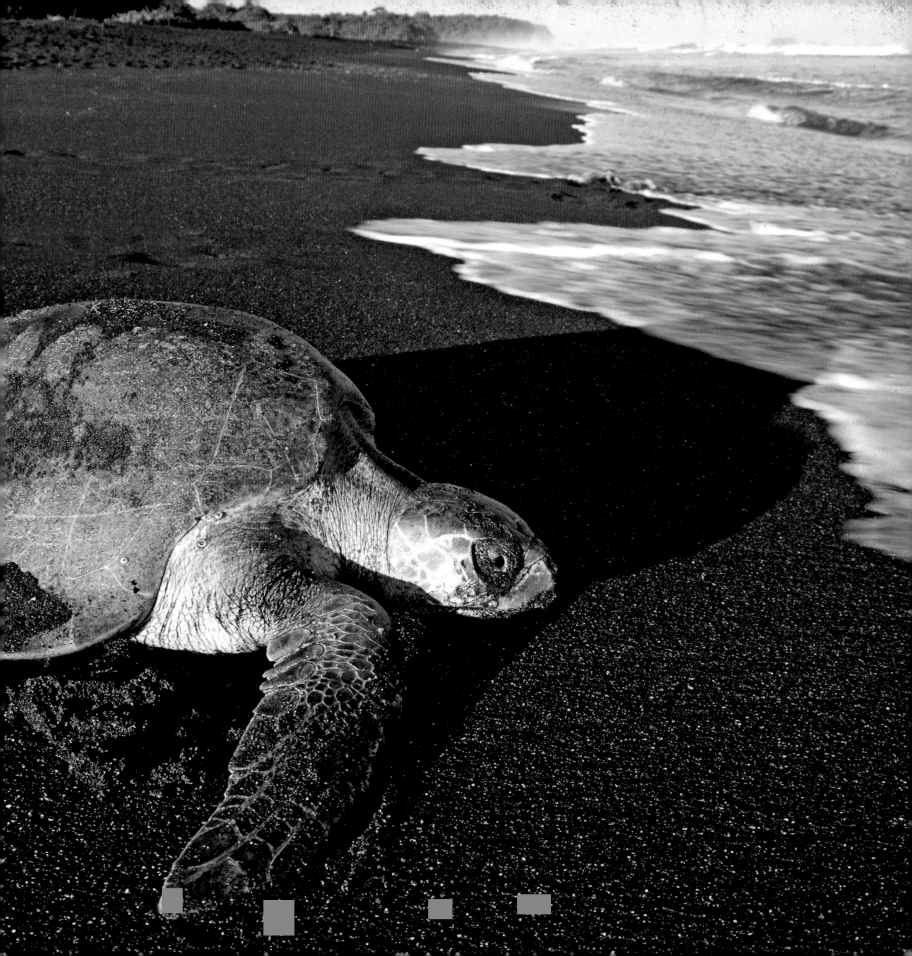

Olive ridley eggs hatch between fifty and fifty-six days after being laid. The hatchlings break through the eggshell with the aid of a temporary egg tooth called a *caruncle*, then dig their way to the surface. Most turtle hatching happens at night. The natural instinct of the newly hatched turtles is to scramble down the beach toward the brightest source of light, which, on an undeveloped beach, is the sea. Once they reach the tide line, a wave sweeps over them and drags them into the ocean as it recedes. Some turtles hatch during daylight hours (right) and must escape the attention of hungry birds and crabs if they are to reach the surf alive. If a nest is spotted and swooped on by one bird, others will arrive promptly and a large number of the hatchlings will be eaten. Under natural conditions as few as 1 percent of turtle hatchlings from a nesting beach may survive to become adults. At Ostional Beach, the local residents escort the hatchlings from their nests to the sea, thus greatly increasing the turtles' chance of surviving.

Right: Olive ridley hatchlings scuttling down to the sea at Ostional Beach.

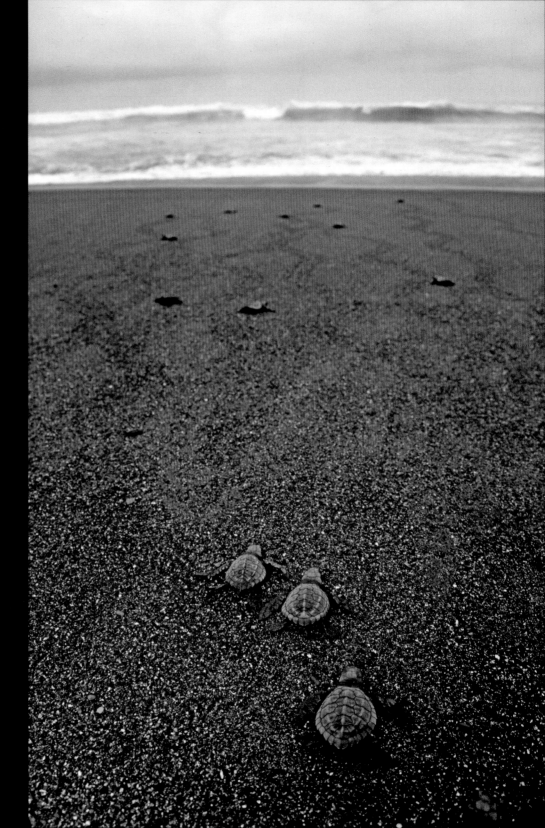

Perched on top of a log, this black vulture (right) has found an excellent vantage point from which to scan the beach for signs of movement as the day's light fades and turtle hatchlings begin to emerge. Any hatchling making a dash for the surf now risks being spotted by the vulture and eaten, but the onset of darkness will soon serve to make the journey a much safer one.

Right: The black vulture is the most common predator of turtle hatchlings at Ostional Beach.

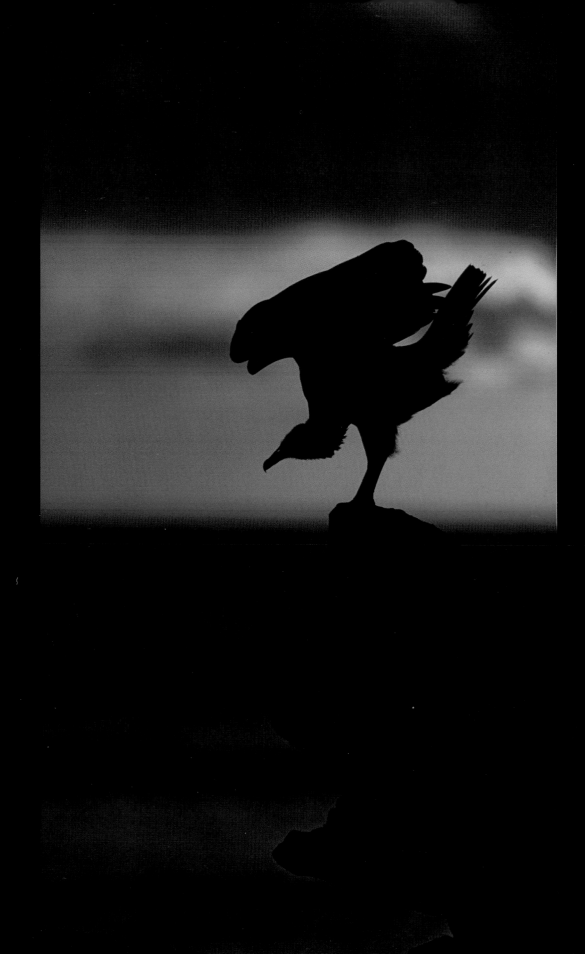

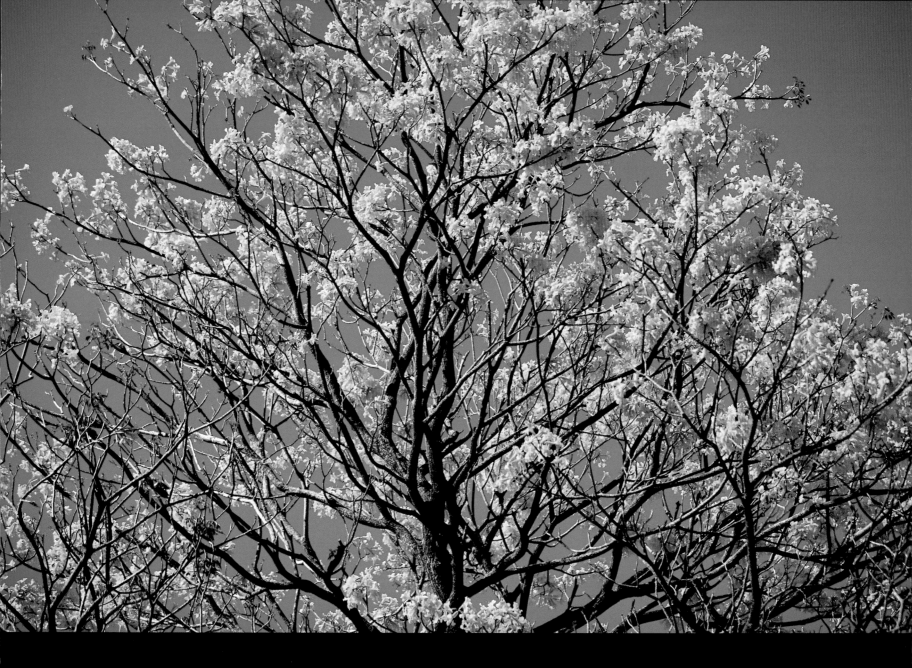

During the wet season, the yellow cortez is a rather unexceptional tree of Guanacaste's tropical dry forests. In the dry season between January and April, however, several days after a spell of cool weather or rainfall, this tree bursts into bloom (above). The inflorescence of each tree lasts for four or five days, but individual flowers remain fully open for just one. Howler monkeys and iguanas feast on these flowers while they can. Bees, hummingbirds, and butterflies all feed on the nectar, but it is only the bees that actually pollinate the flowers.

Above: Yellow cortez tree in full bloom during the dry season, Guanacaste National Park.

During the long, hot dry season in Guanacaste, most trees shed their leaves in order to slow down the loss of their precious internal water supplies. Without chlorophyll-rich leaves, a tree normally can no longer photosynthesize, and growth temporarily stops. A small number of species, however, such as the naked Indian, or gumbo limbo tree (above), have green chloro-phyll in the outer layer of their trunk and branches, which enables them to continue to photosynthesize and produce energy for growth even when all of their leaves have fallen off.

Above: A praying mantis sits on the chlorophyll-rich trunk of a naked Indian tree in Palo Verde National Park.

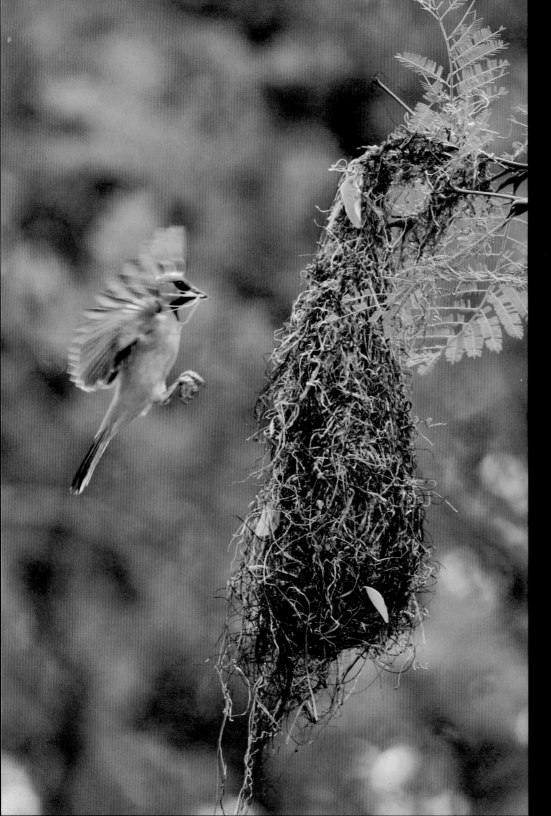

When building a nest, birds choose their location very carefully. The nest must be hidden—or difficult to reach—in order to keep the eggs and chicks safe from predators. The streak-backed oriole (left) commonly builds its nest in the branches of ant acacia trees. These trees have large bulbous thorns and a resident colony of viciously biting acacia ants that attack any animal unfortunate enough to come into contact with the tree. Interestingly, the birds themselves are able to construct their nests without being driven away by these ants. This is because, after a short time, the ants begin to tolerate the presence of the new nest material. As a result, the oriole benefits from the protection that the ants, along with the tree's thorns, provide against the birds' predators.

Left: Streak-backed oriole landing at its nest with building material.
Right: Turquoise-browed motmots live almost exclusively in tropical dry forests, where they often travel in pairs.

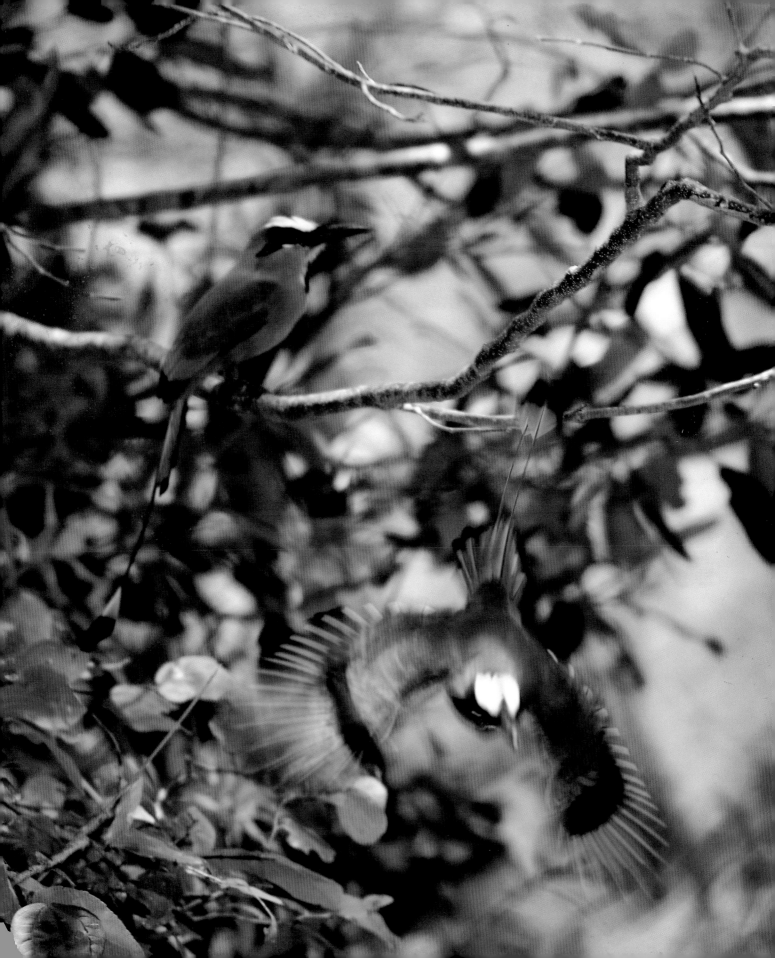

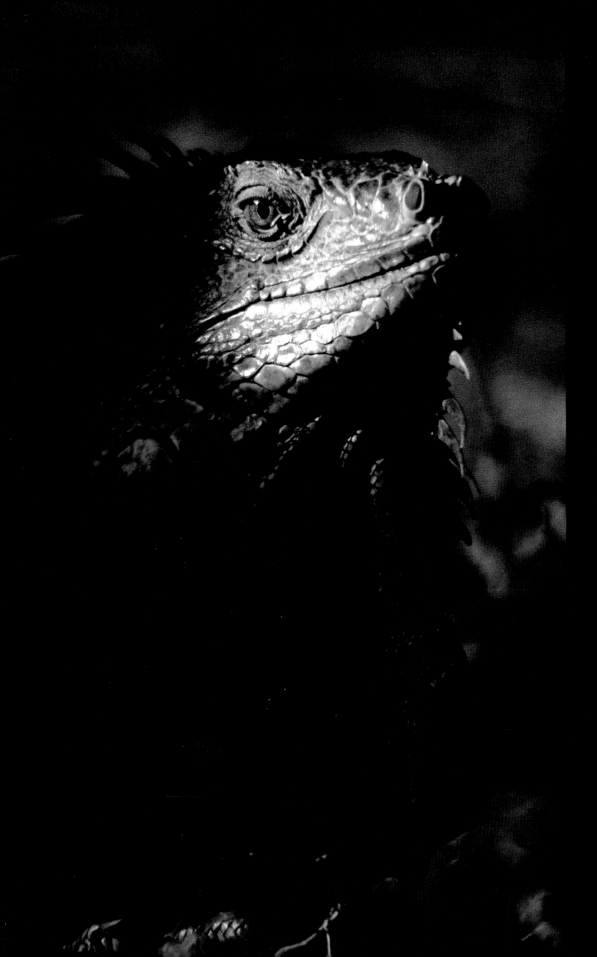

The hot, arid conditions of tropical dry forests prove no problem for the dinosaur-like green iguana. The body tissues of an adult (left) require very little liquid in order to function properly and so, unlike humans, they don't drink water, but instead are able to survive on the small amounts of liquid they obtain from eating flowers and leaves.

As with all reptiles, iguanas cannot regulate their own body temperature metabolically. Instead, they depend on the surrounding environment to heat and cool their blood and organs. Once their body temperature drops below its norm of around 97 degrees Fahrenheit (36 degrees Celsius), they move out of the shade and bask in the sunshine.

Green iguanas are the largest lizards in Costa Rica. Males can reach a total length of 5 feet (1.5 m) or even longer. In Guanacaste, these sizeable lizards are normally spotted either lying along the higher branches of trees, especially those overhanging rivers, or slowly crawling across a sunny clearing when there is no canopy through which to travel.

Left: Adult green iguana in Palo Verde National Park.

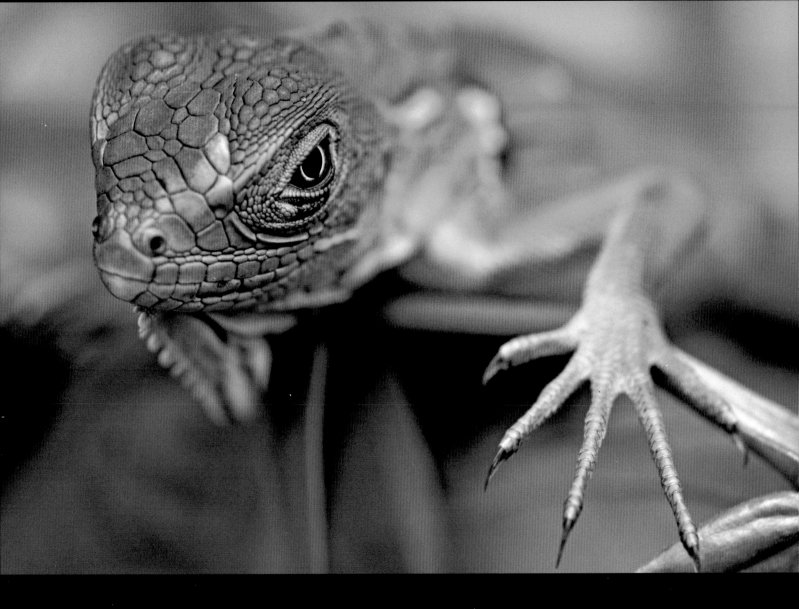

A young iguana is a sought-after meal for many predators in the forest. Its main form of defense is stealth. By remaining perfectly still when it senses danger, the emerald-green body of the iguana can blend perfectly with the surrounding vegetation.

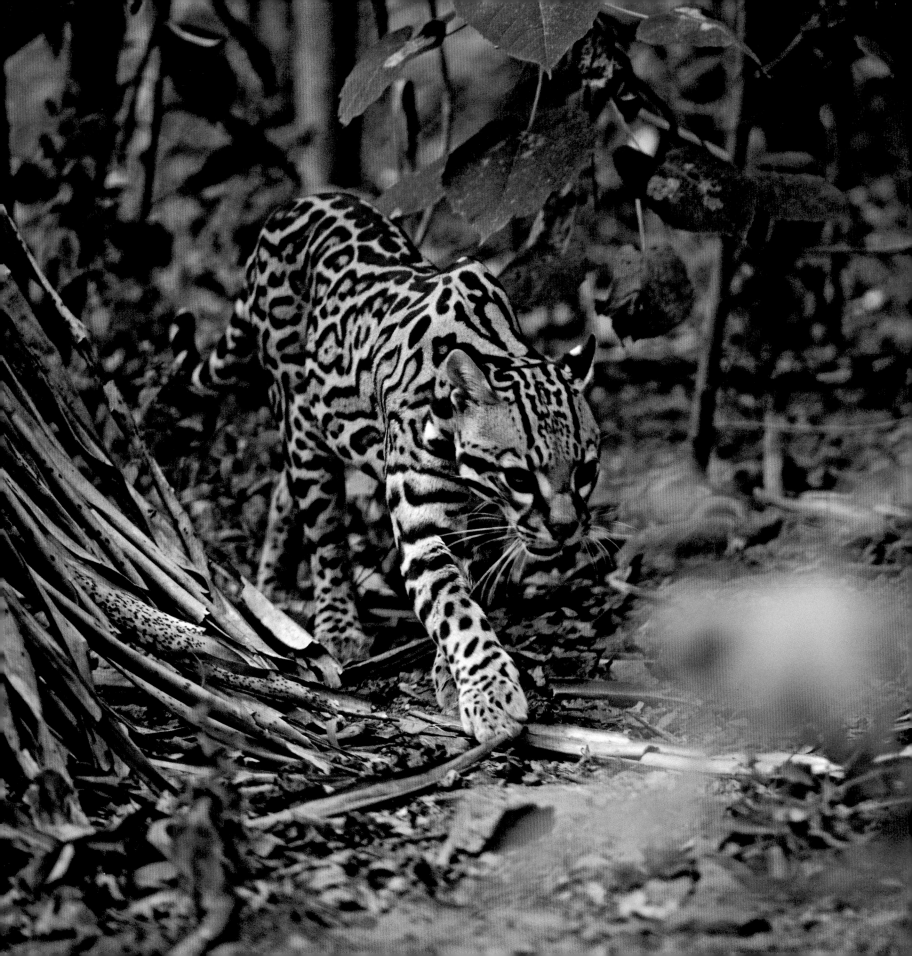

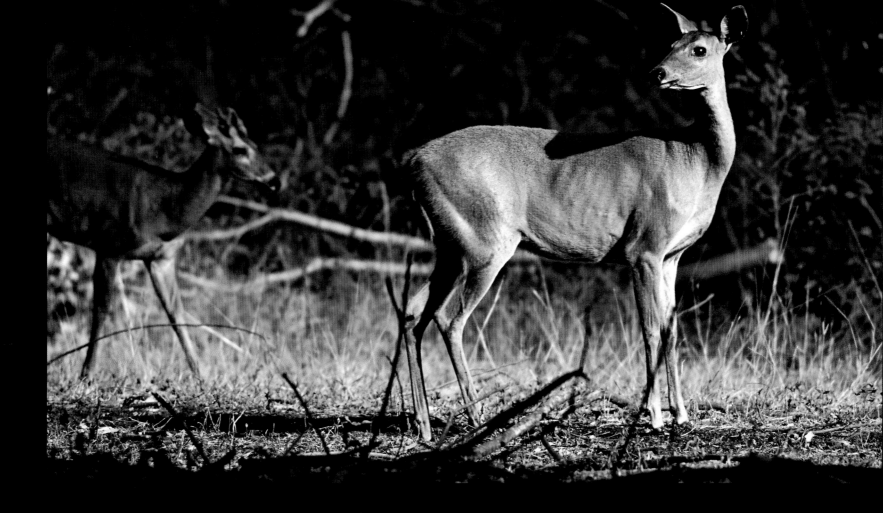

The ocelot (left) is a medium-sized cat; it stands 20 to 25 inches (50 to 64 cm) at the shoulder and weighs about 25 pounds (11 kg). It is typically active at night, though it is not unusual for individuals to begin hunting in the late afternoon. Its camouflaged coat and soft, padded paws allow it to move stealthily through the forest as it searches for prey. Once a suitable animal is encountered, these same paws take on the less delicate role of pinning the prey to the ground as the cat kills it with a powerful bite.

Ocelots eat mainly small terrestrial mammals such as rats, opossums, and agoutis, but if the opportunity arises they will also pounce on bats, coatis, monkeys, anteaters, snakes, birds, and sloths.

Because of its large size, the adult white-tailed deer (above) is very unlikely prey for an ocelot. But the deer must remain alert for the presence of the bigger cats—the puma and the jaguar—both of which inhabit the largest tract of dry forest in Costa Rica, within Santa Rosa National Park. The deer's best defense is to do nothing. The color of its fur matches the surrounding vegetation so perfectly that deer are very difficult to spot when they are standing still.

Left: The soft, padded paws of an ocelot allow it to walk silently through the forest.
Above: White-tailed deer are common in the dry forests of Guanacaste.

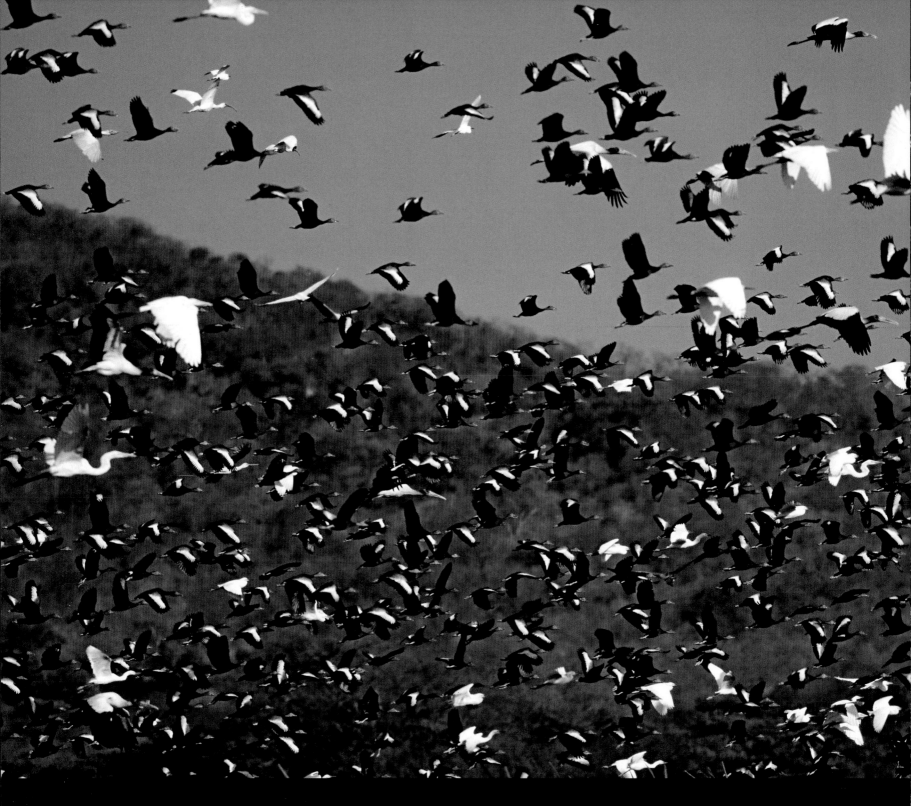

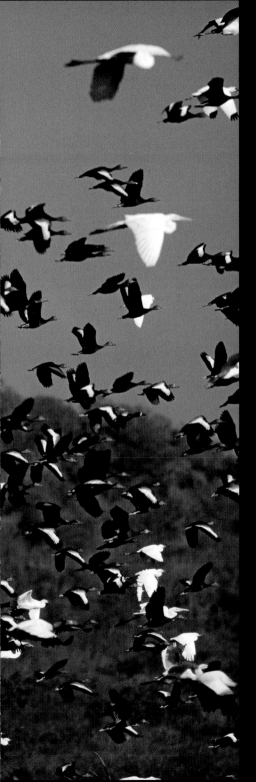

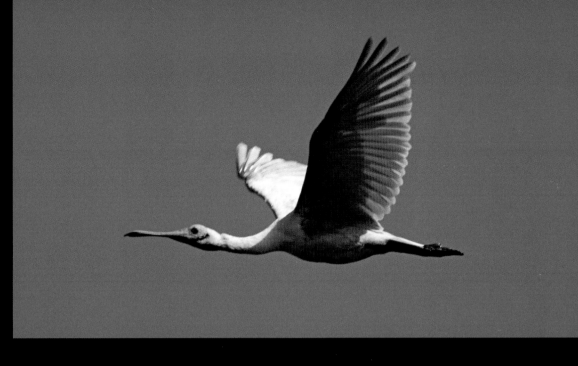

During the dry season of January to April, thousands of migrant and resident birds congregate to feed in the seasonal marsh of Palo Verde National Park (left). Jabirus, roseate spoonbills, wood storks, ibises, herons, and ducks come in search of the fish, mud eels, crustaceans, mollusks, and insects that inhabit these waters.

The flattened, spatula-shaped bill of the roseate spoonbill (above) is ideal for sifting for food in the shallow water of lagoons. It has sensitive touch receptors that can detect the movement of small fish and crustaceans in the water. When something makes contact, the bill snaps shut on reflex. This greatly aids the bird when it feeds in murky waters or at night.

The roseate spoonbill is a close relative of another bright pink bird, the flamingo. The feather color of both birds is derived from the food that they eat. The spoonbill eats small shrimp, and those crustaceans have, in turn, fed upon algae that produce their own red and yellow pigments. The pigments are preserved as they pass down the food chain to the bird.

Left: Mixed flock of ducks, storks, egrets, and ibises lifting off from a lagoon in Palo Verde National Park.
Above: The roseate spoonbill derives its pink color from the pigment in the shrimp it eats.

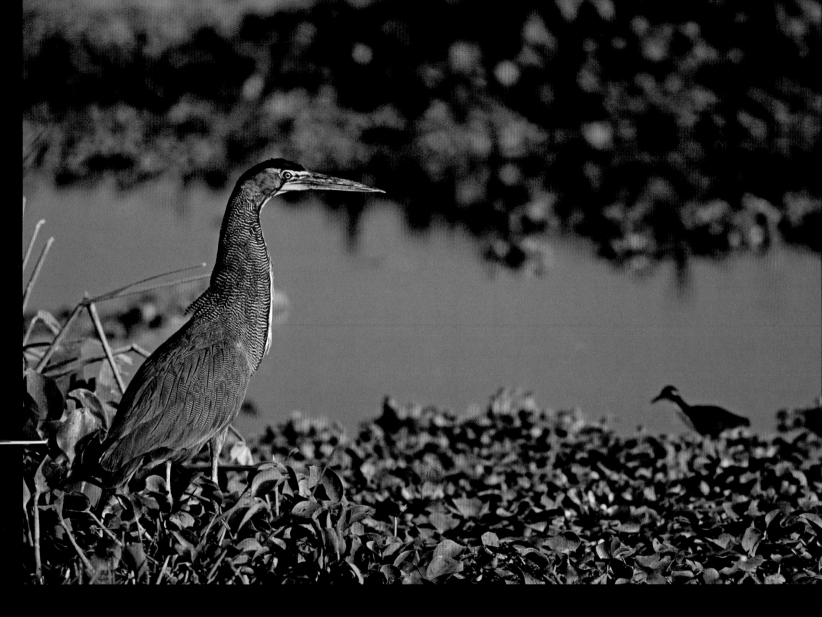

The bare-throated tiger heron lives in freshwater habitats such as streams, lagoons, and mangroves, where it typically leans over the water waiting to snatch passing fish, frogs, and crabs with its long, sharp beak.

Above: Bare-throated tiger heron scanning for food in the freshwater shallows of Palo Verde National Park.

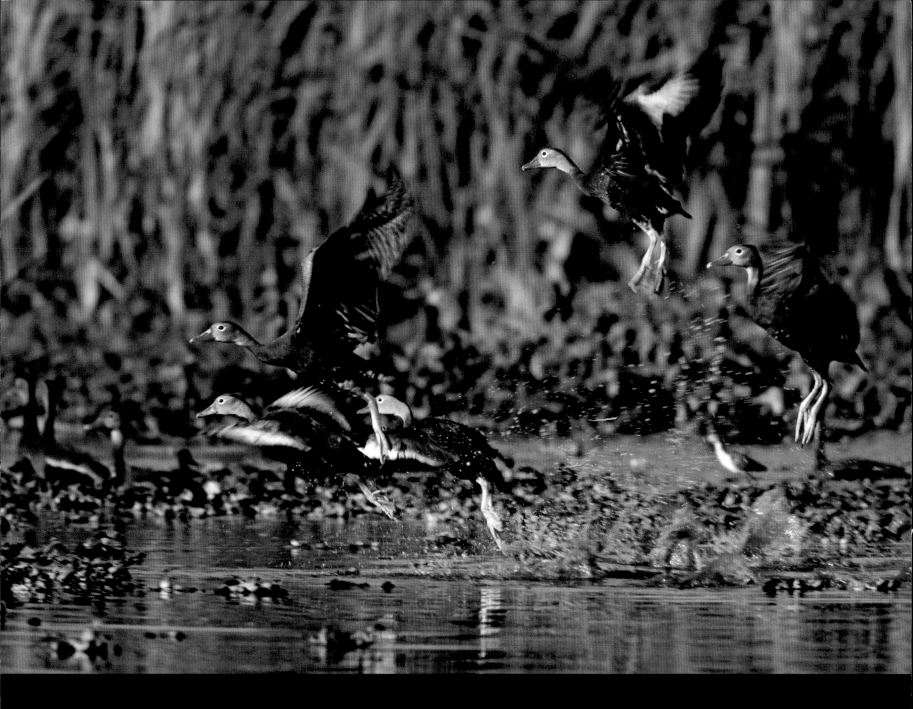

Black-bellied whistling ducks are common visitors to the lagoon in Palo Verde National Park. They spend the day resting on the water in large flocks or flying short sorties to neighboring areas. These ducks normally feed at night on shoots, leaves, and, occasionally, small invertebrates.

Above: Black-bellied whistling ducks taking off from the lagoon in Palo Verde National Park.

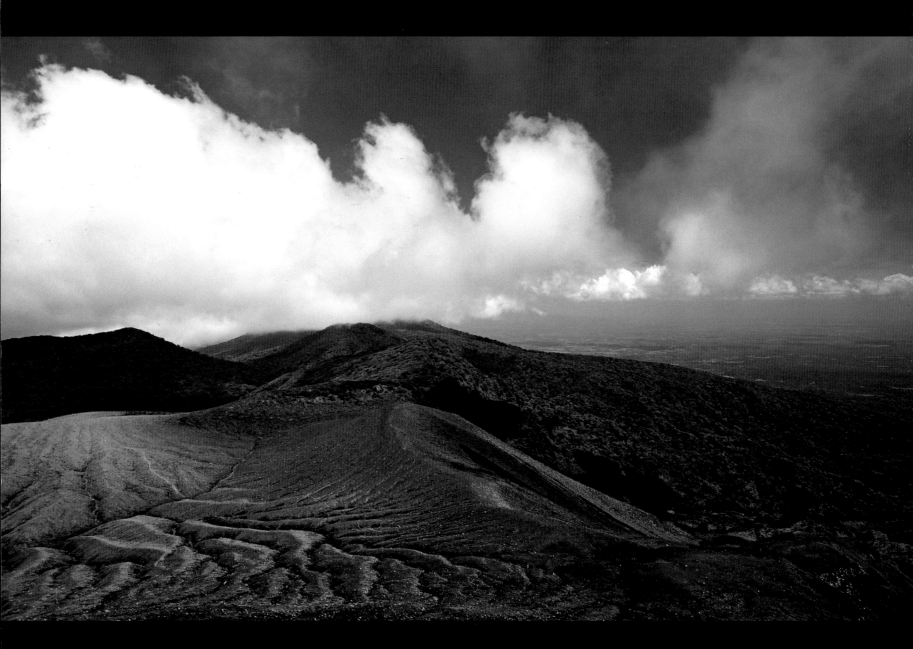

As one travels east from the arid plains of Guanacaste, the terrain begins to climb upward with a dramatic change in topography. Grasslands and tropical dry forest are replaced by rainforest and cloud forest on the slopes of the Rincón de la Vieja Volcano. Above the tree line, a petrified landscape of old lava flows created by past eruptions (above) surrounds two prominent peaks. The lower peak is Von Seebach, named after the young German geologist who visited Costa Rica in the 1860s. At its summit, which reaches 6,217 feet (1,895 m), lies an eroded, dormant crater. The second, slightly taller, peak is the active volcano Rincón de la Vieja (right), which reaches a height of 6,286 feet (1,916 m). Wherever one walks in this area, there is plentiful evidence of current volcanic activity.

Above: The view from Von Seebach of old lava flows and, in the distance, the Guanacaste lowlands.

The active crater of Rincón de la Vieja Volcano is approximately 984 feet (300 m) wide. Its walls encircle a vast lagoon, which sometimes glows bright blue. The color results from the ash and acidic chemicals suspended in the water. This crater has produced more than a dozen large eruptions since the mid-nineteenth century. The last eruption took place in 1998. It shot rocks several hundred yards out of the crater and produced a plume of steam and gases 6,500 feet (2,000 m) high. Ash was recorded falling 2 miles (3.2 km) away.

Above: The active crater of Rincón de la Vieja Volcano.

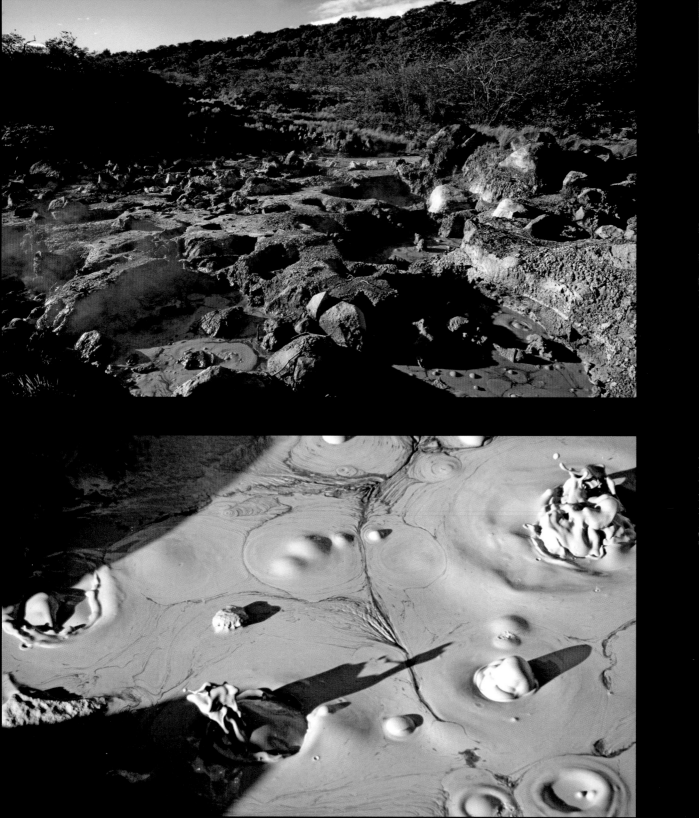

Several million years ago, the main active volcanic crater in the area now known as Rincón de la Vieja was an enormous caldera several miles southwest of the present day crater. Today, this area still clearly shows residual activity in the form of numerous boiling mud pools (left) and hot springs. Here steam, hydrogen sulfide, and other gases escape from underground cavities. Scientists believe that this constant release of pressure has helped to reduce the size and frequency of the volcanic eruptions in the main crater of Rincón de la Vieja Volcano.

Left: Two views of boiling mud pools in Rincón de la Vieja National Park.
Above: The enormous black boulders that dot the grass-land around Rincón de la Vieja Volcano are remnants of an ancient volcanic crater.

Between the months of February and April, the cloud forest on the upper slopes of Rincón de la Vieja Volcano is one of the best places in the country to find wild specimens of the *guaria morada* orchid—Costa Rica's national flower. The name comes from the indigenous word *gua*, which means "tree," and the Spanish word *morada*, which means "purple."

The bright blue color of the lagoon below La Cangreja Waterfall is caused by the relatively high levels of copper found naturally in the water.

Left: Rincón de la Vieja National Park is one of the easiest places to see the national flower of Costa Rica, the *guaria morada*, in its natural habitat.
Right: La Cangreja Waterfall in Rincón de la Vieja National Park.

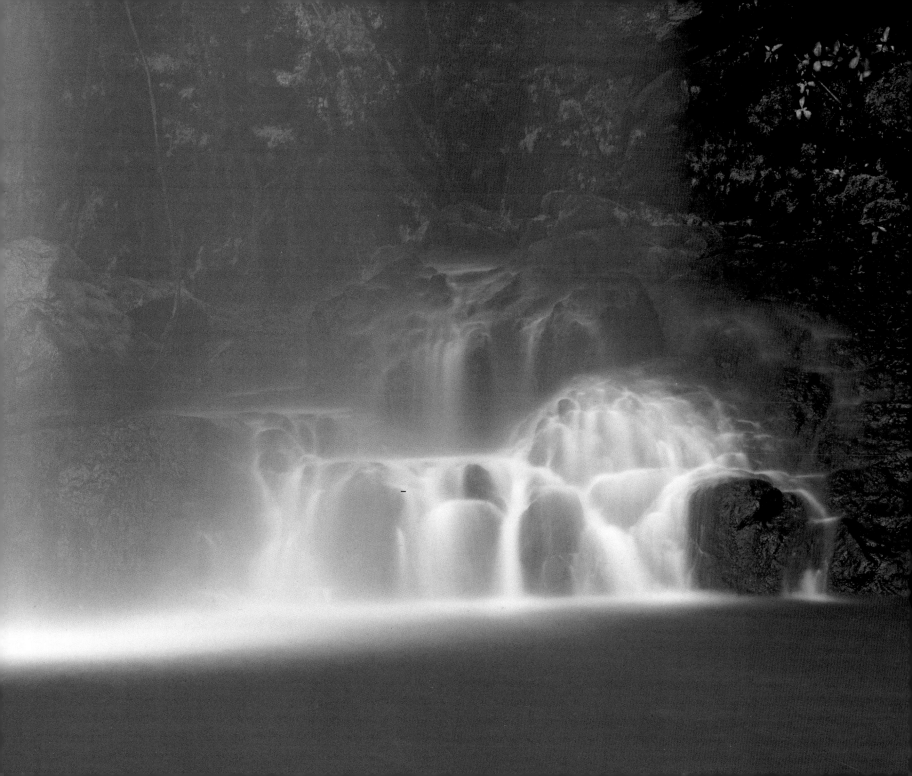

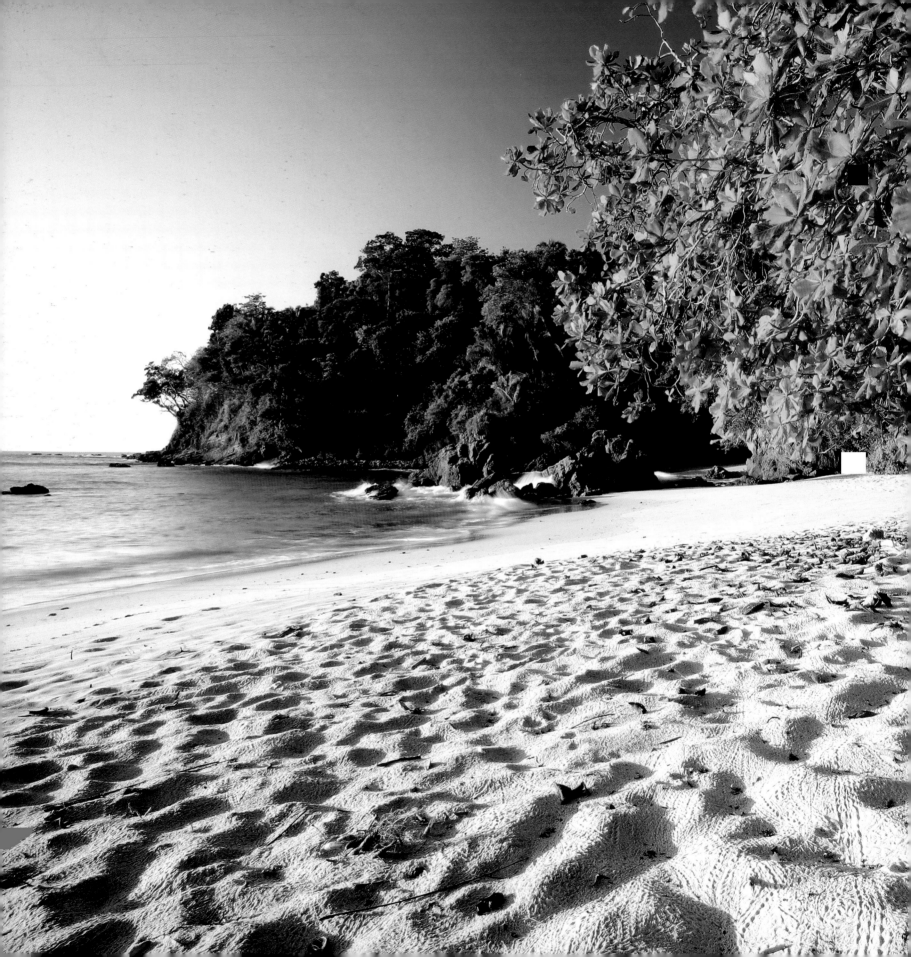

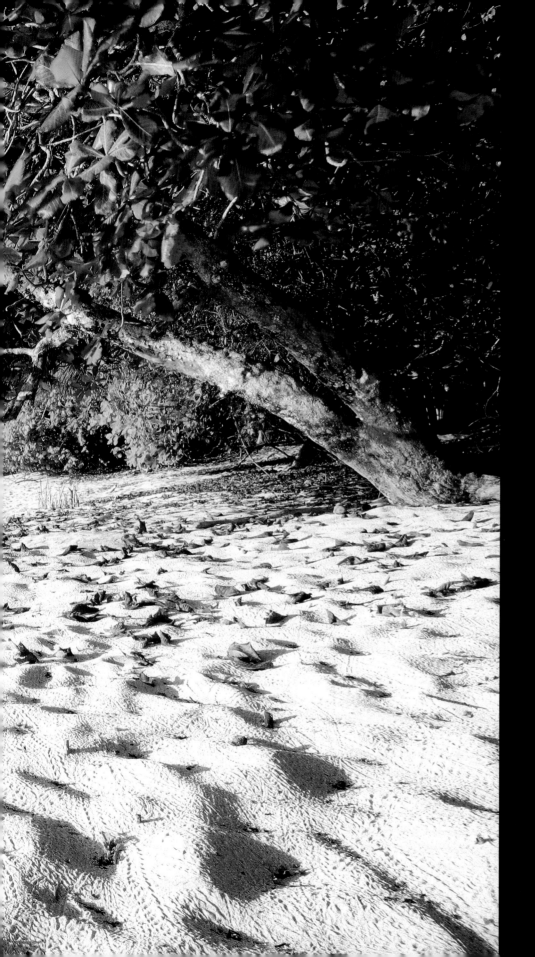

The Central Pacific
Nature's Oasis

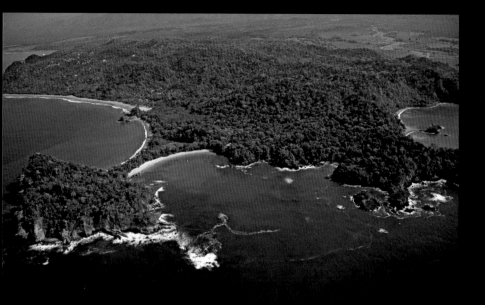

On Costa Rica's central Pacific coast, the national parks of Carara and Manuel Antonio offer refuge to an abundance of exotic wildlife within breathtaking settings.

Carara National Park is a 21-square-mile (55 km²) evergreen transitional forest. Because of its location between the dry tropical forests to the north and rainforests to the south, Carara is unique in supporting a mix of tree species normally found in one or the other of these habitats. The Tárcoles River, home to the largest population of American crocodiles in Costa Rica, meanders through the park. A highway bridge crossing the river serves as an observation point to see these giant reptiles basking in the sunshine on the banks below. At dusk, the bridge is the ideal place to watch scarlet macaws flying from the forest to their overnight roosts in the mangroves.

The relatively small Manuel Antonio National Park (above) is virtually cut off from other forested areas. It contains a mix of both primary and secondary forest and is home to a wide variety of rainforest and shoreline wildlife. An isolated population of the endangered squirrel monkey inhabits the park, as do troops of white-faced capuchin and howler monkeys. Sloths are common in trees along the forest and beach trails; and lizards and crabs have colonized the ground space. A wide array of bird species, including ospreys, woodpeckers, and herons, also find refuge here.

Previous pages: Numerous lizard tracks traverse the white sands of Manuel Antonio National Park.
Above: The famous Cathedral Point in Manuel Antonio National Park is joined to the mainland by a 165-foot-wide (50 m) natural causeway of sand and rainforest.
Right: In Manuel Antonio National Park, shadows lengthen as the sun sets, bathing Playa Espadilla in the golden glow of late-afternoon light.

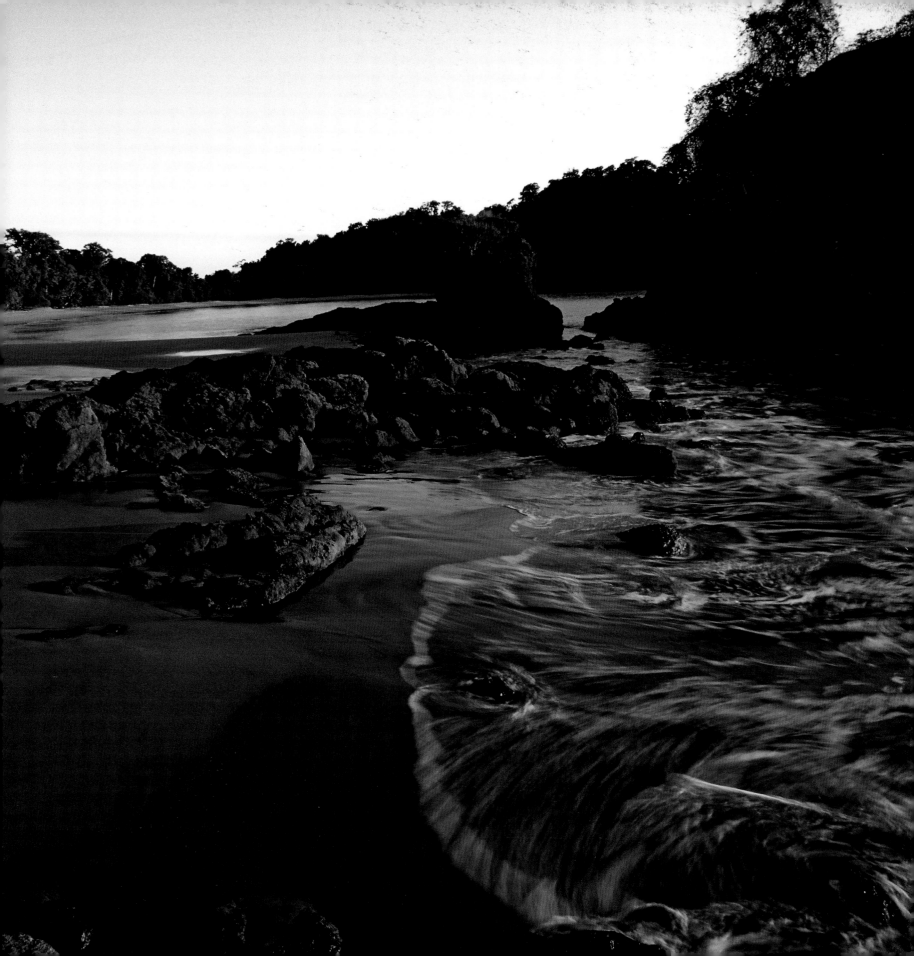

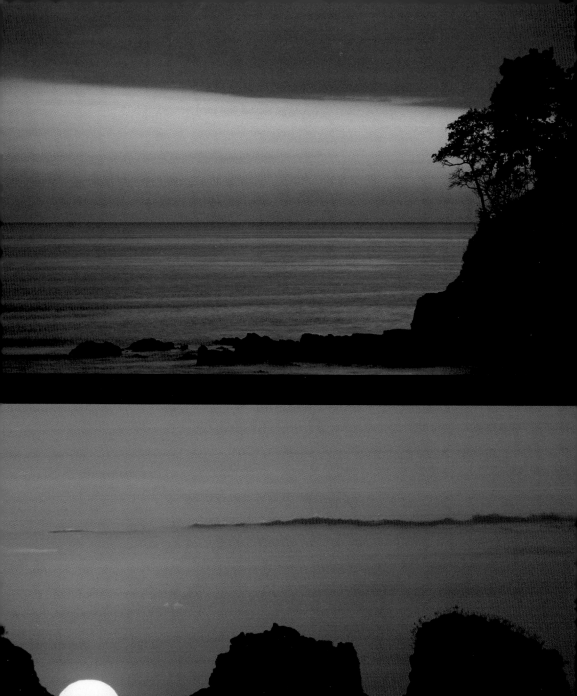

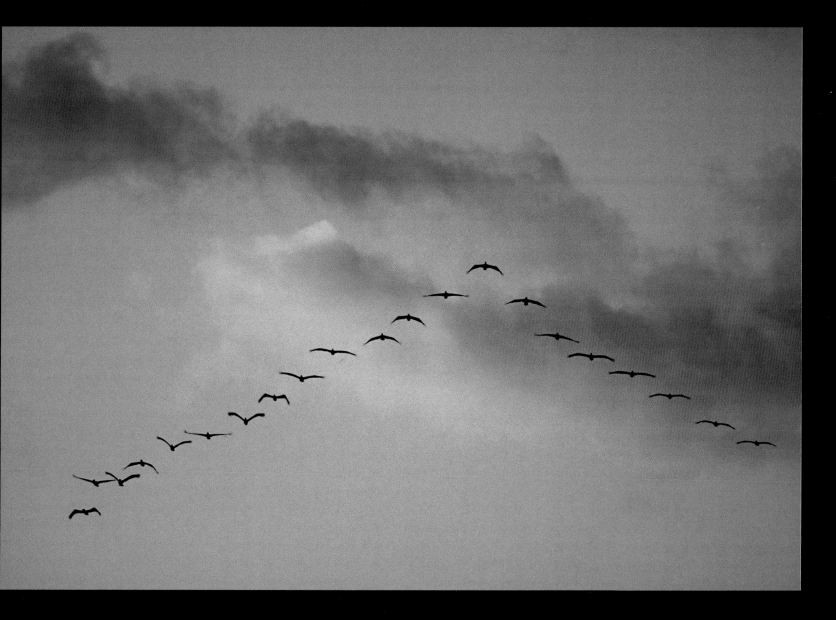

The rocky headlands (top left) and offshore islands (bottom left) of Manuel Antonio National Park provide an interesting foreground for photographs of sunsets. These magnificently colored skies are the result of the sun's rays being atmospherically filtered. When the sun is low in the sky, light enters the atmosphere at a lower angle, so it must pass through more air before being seen by an observer. The shorter wavelengths of blue and violet light penetrate poorly, but the longer wavelengths of yellow, orange, and red reach the observer's eye.

The abundance of fish species that thrive on the rocky coastlines and offshore reefs of Manuel Antonio National Park attracts a large number of brown pelicans. These birds may spend hours each day plunge-diving for fish close to beaches in the park. At dusk, they typically group in their famous V-formations and fly south to roost. This flying formation is a way of saving energy. Each bird leaves a slight upward current of turbulence in the wake of its wing tips as it flies. By flying immediately behind and to one side of each other, pelicans have

learned to use this technique to ease the effort of flight. Obviously, the lead bird, being at the front, receives no benefit, so after a period of time it will drop back and another will take its place.

Left: Sunsets off the coast of Manuel Antonio National Park.
Above: Brown pelicans flying in a V-formation to conserve energy.

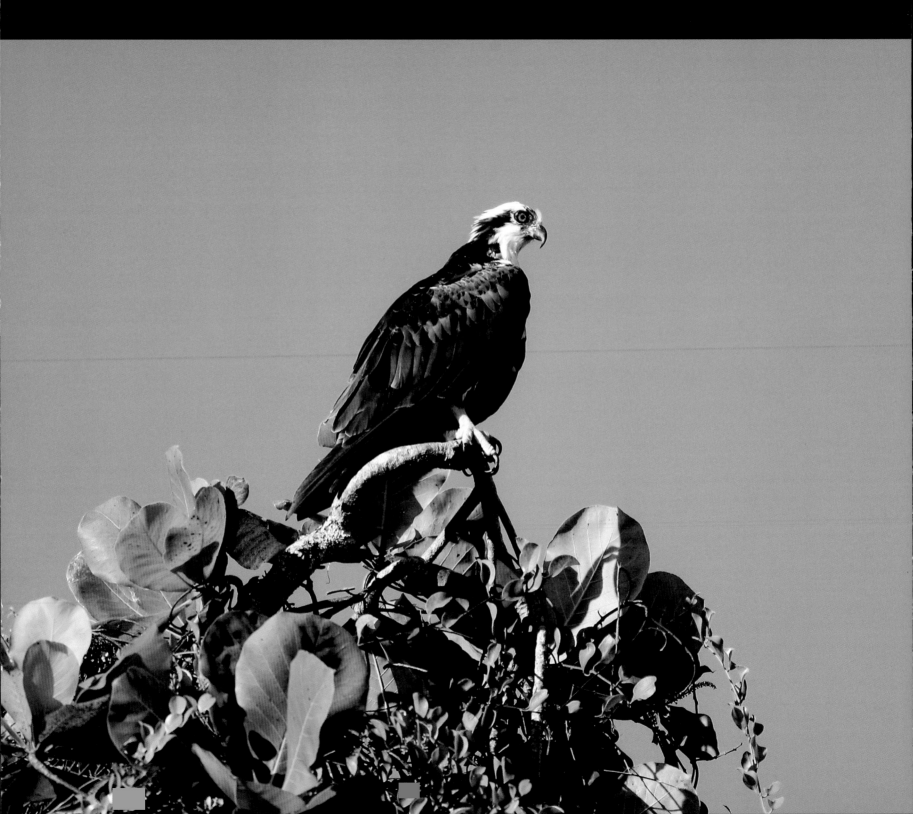

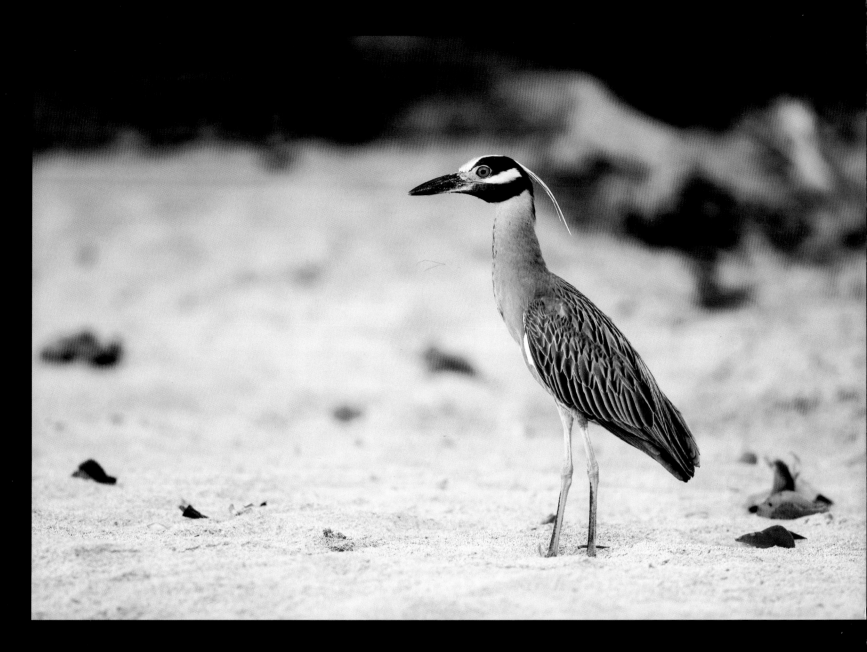

The sandy beaches of Manuel Antonio National Park, and the vegetation that surrounds them, are popular feeding spots for a number of local bird species, including ospreys, white ibises, brown pelicans, boat-billed herons, and yellow-crowned night herons. The osprey (left) is one of the larger birds of prey found in Costa Rica; a fully mature adult will usually grow to over 20 inches (0.5 m) in height. Unlike most other raptors, it predominantly feeds on fish and normally establishes its territory over sheltered bays, lagoons, or canals. The osprey hunts using surprise tactics: it swoops down and, with its huge, curved talons, skillfully snatches its prey from the surface of the water. It then carries the fish to a nearby perch to eat.

Stealth is the key to successful hunting for a yellow-crowned night heron (above). Contrary to what its name suggests, this bird is active mainly during the day. It forages along the beach for crabs, standing motionless for long periods as it waits to strike.

Left: Osprey studying the ocean from the top of a tree in Manuel Antonio National Park.

Above: Yellow-crowned night heron on Manuel Antonio Beach.

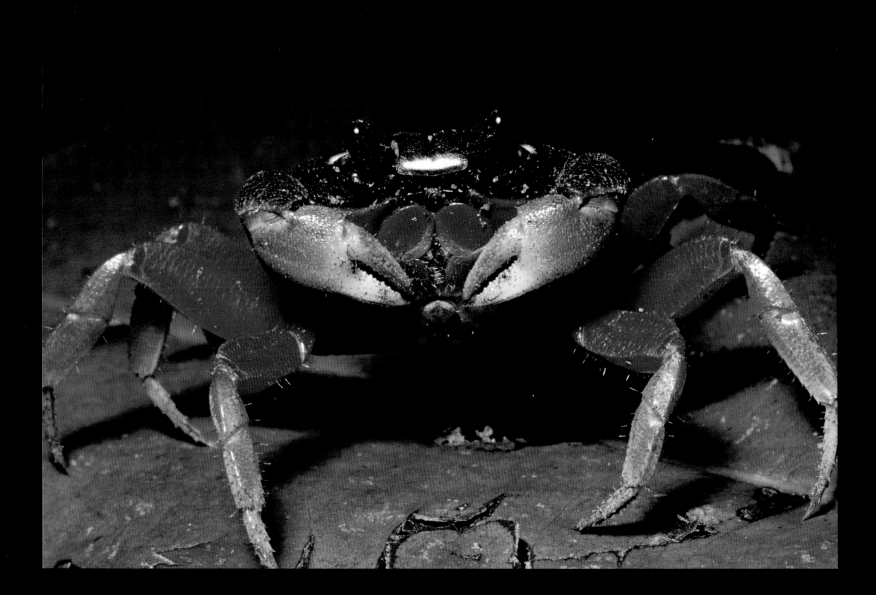

Scores of purple-and-orange land crabs inhabit the forest floor along the Central Pacific coast. They venture warily from their underground burrows to carefully sift through the leaf litter in search of fruits, seeds, and seedlings. The crab's stalked eyes are very sensitive to movement, and the approach of a larger animal will cause it to scuttle quickly back into its hole.

Above: Land crab creeping cautiously across the forest floor in search of food.

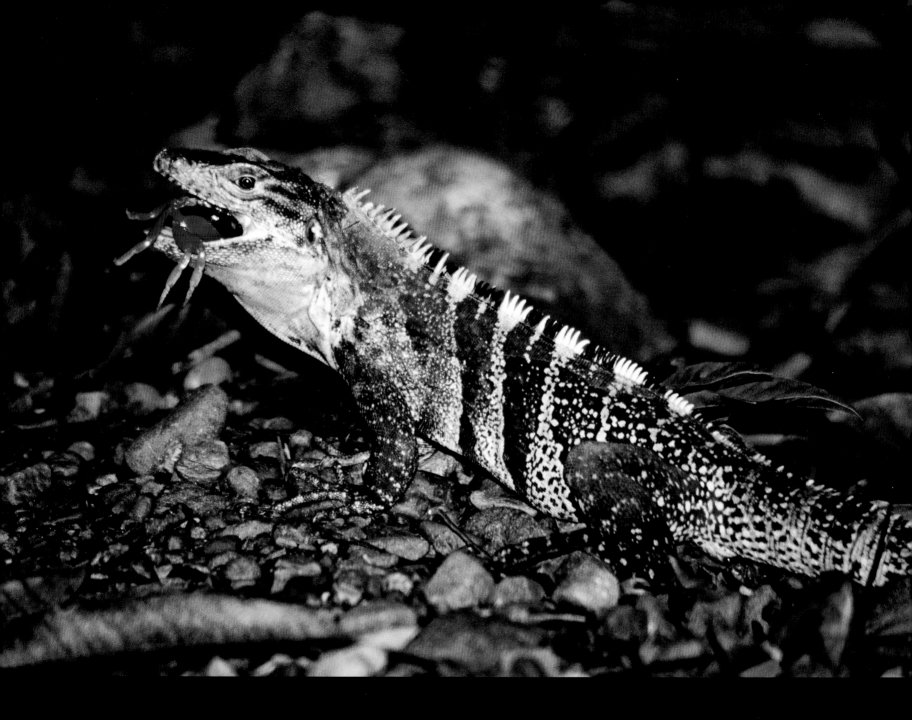

The adult black spiny-tailed iguana usually eats plant material and fruit. It will, on occasion, supplement its diet with animal prey, including mice, lizards, and crabs. At such times it can be a patient and aggressive predator. The individual above vigilantly waited as a foraging land crab gradually moved further and further from the safety of its burrow. Suddenly, the iguana sprinted forward and lunged at the crab. A brief scuffle ensued,

with the lizard trying to crush its prey in its jaws while avoiding a nip from the crab's powerful pincers. This time the iguana prevailed, and the unfortunate crab was swallowed whole.

Above: The black spiny-tailed iguana is common on the forest floors of Carara and Manuel Antonio National Parks. This individual is eating a land crab.

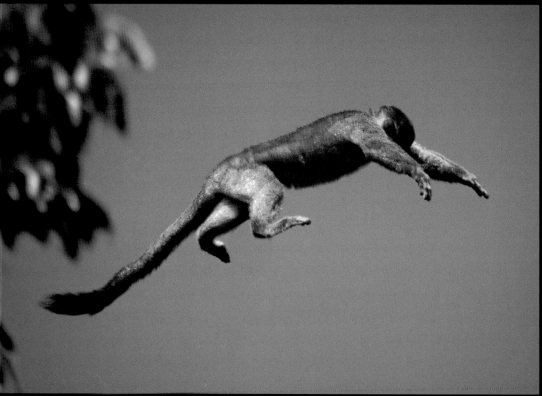

Monkeys normally avoid traveling along the forest floor, because they are more vulnerable there to predators such as cats and snakes. In order to remain above the ground when crossing a wide gap between trees, white-faced capuchin monkeys and squirrel monkeys leap from branch to branch. A troop's alpha male will select a route and lead the way. After he jumps, the others follow, usually leaping from the very same branch. Sometimes an individual will pause before jumping and rock forward and backward as if calculating the distance and assessing the risk. If not convinced, the monkey will turn back and look for a better branch from which to jump.

Left: White-faced capuchin monkey (top) and squirrel monkey (bottom) leaping between trees in Manuel Antonio National Park.

Several troops of white-faced capuchin monkeys live in the rainforest of Manuel Antonio National Park. They are the most commonly seen mammal on the trails. White-faced capuchin monkeys are extremely active and spend a lot of time on the move, searching for food. They take regular rest periods, however, especially during the middle of the day, when they doze briefly or groom each other. On the few occasions that the monkeys descend to the ground to forage, they can inadvertently pick up parasites such as ticks. Grooming is an essential means of removing these parasites; youngsters and dominant members of the group are typically groomed the most.

Above: White-faced capuchin monkeys grooming.

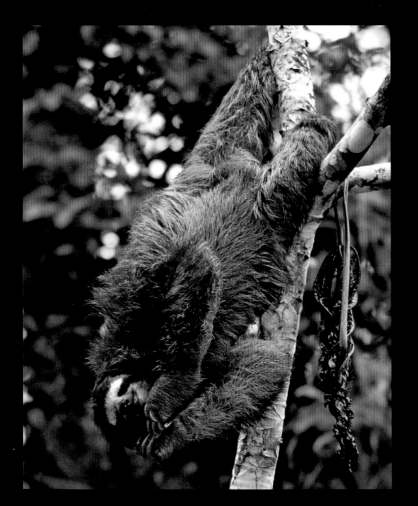

The three-toed sloth (above and right) spends the greater part of its life immobile, high up in trees. It feeds exclusively on leaves, which are very difficult to digest and yield little energy. To compensate for this, the sloth has evolved a very slow metabolism, and to conserve energy it leads an extremely lethargic lifestyle, moving only when necessary and even then very slowly.

One of the sloth's principal natural predators in Costa Rica, the harpy eagle, has become all but extinct as a result of hunting and deforestation. With the disappearance of its top predator, the sloth has become more numerous. Because of its inactive lifestyle, however, it is still difficult to spot.

Above: Three-toed sloths rest for most of the day, sometimes in the most bizarre positions.
Right: Female three-toed sloth with baby.

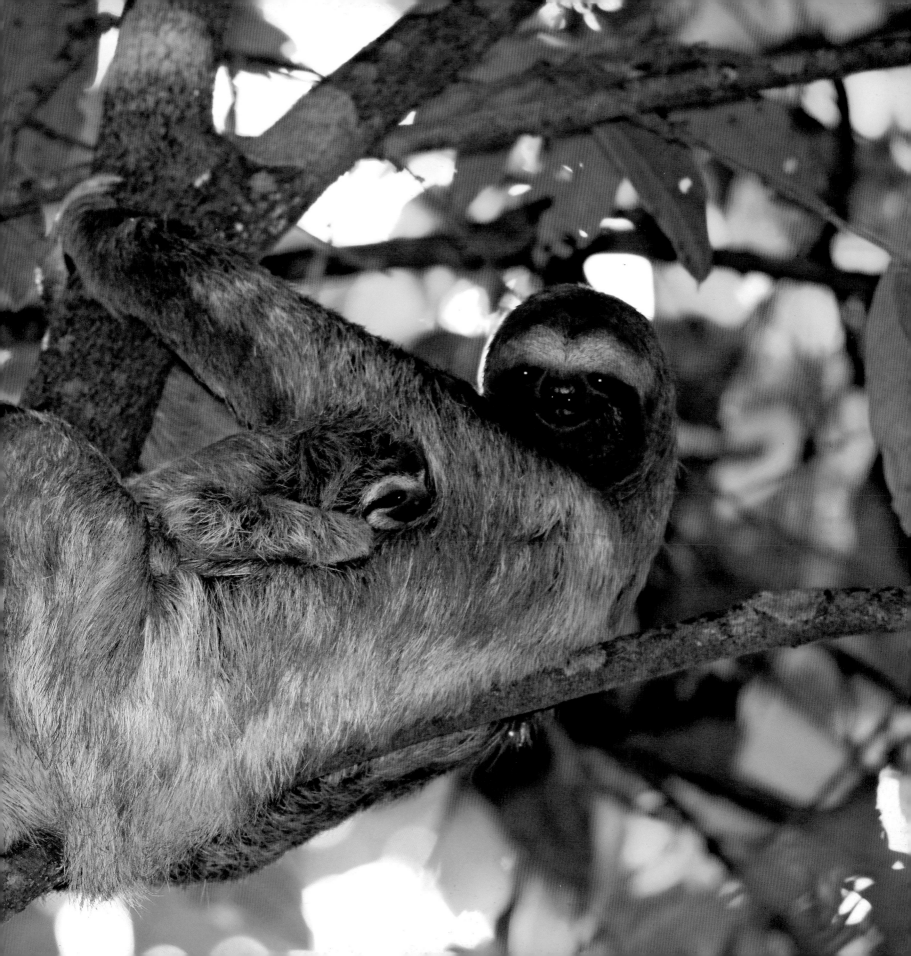

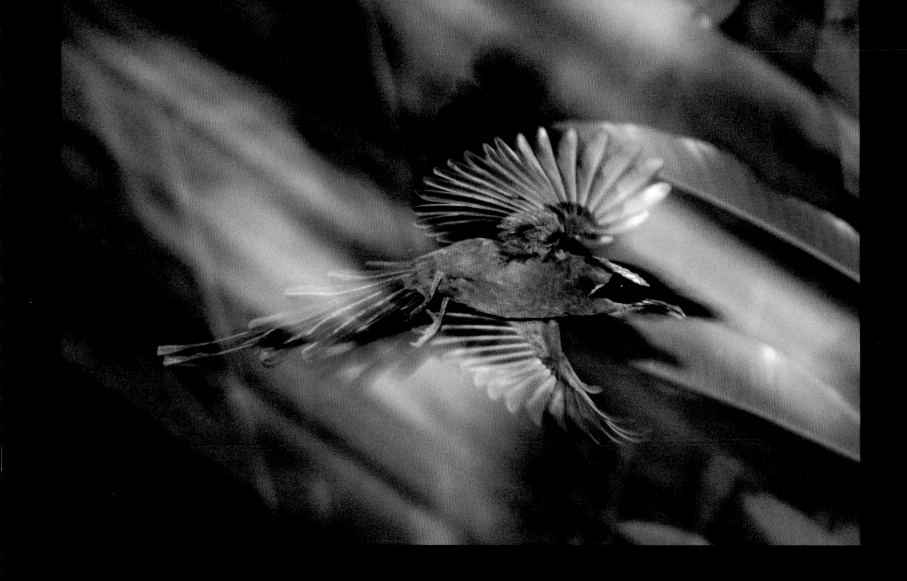

The blue-crowned motmot spends long periods of time perched on branches in the shadows, patiently surveying the forest for insects, spiders, worms, small lizards, and even snakes. When a suitable food item is spotted, the bird darts out from its hiding place and snatches its prey.

Two challenges face any bird that wishes to feed on wood-boring beetles and their larvae. First, it has to bore into a tree trunk; and second, it must extract the insect from its burrow, which is quite often deeper than the length of the bird's beak. The pale-billed woodpecker is well-equipped to accomplish both of these tasks. The woodpecker's head hammers repeatedly into the wood at approximately 25 miles (40 km) per hour. Its brain is positioned above the base of the beak and is partially surrounded by a layer of muscles, two adaptations that protect it from the shock of impact. Once the wood has been splintered away, the woodpecker seeks out hidden insects with a long and sticky tongue.

Right: Pale-billed woodpecker searching for grubs in a dead tree.

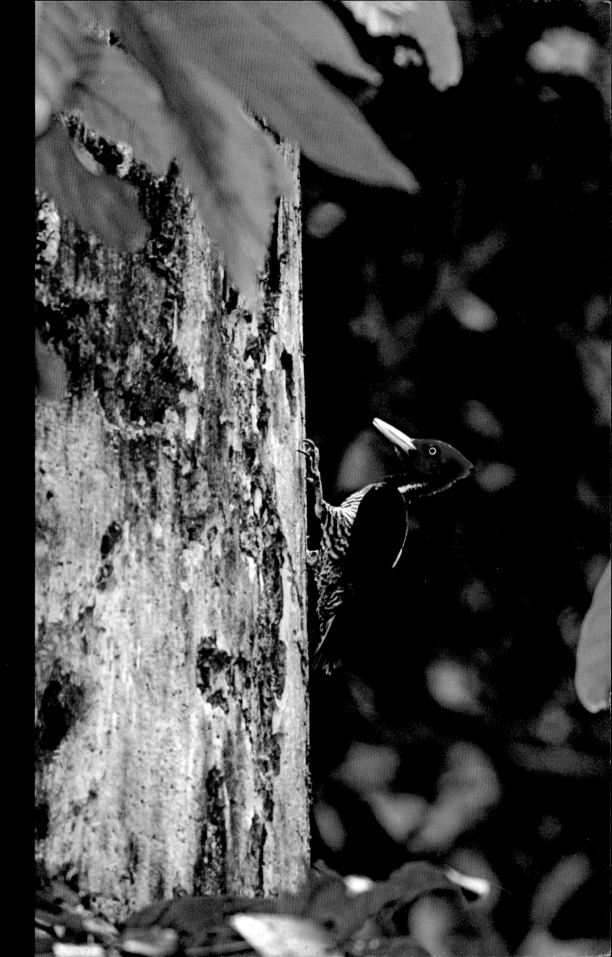

When a morpho butterfly emerges from its pupa, its wings are crumpled and damp (top left). In order to fly, it must straighten them into smooth, flat surfaces that can then dry in the open air. The butterfly achieves this by pumping blood from its body through the wing veins. In an hour or two, the newly emerged morpho is ready to lift off.

The upper surfaces of a morpho butterfly's wings appear to be a beautiful iridescent blue, but, surprisingly, the natural pigment of the wings is dull brown. The wings are covered in tiny scales with multiple layers that reflect only wavelengths in the blue end of the visible spectrum, thus giving the morpho its shimmering blue appearance.

Top left: Newly-emerged morpho butterfly.
Bottom left: Close up of a morpho butterfly's underwing.
Right: A morpho butterfly, six species of which live in the forests of Costa Rica.

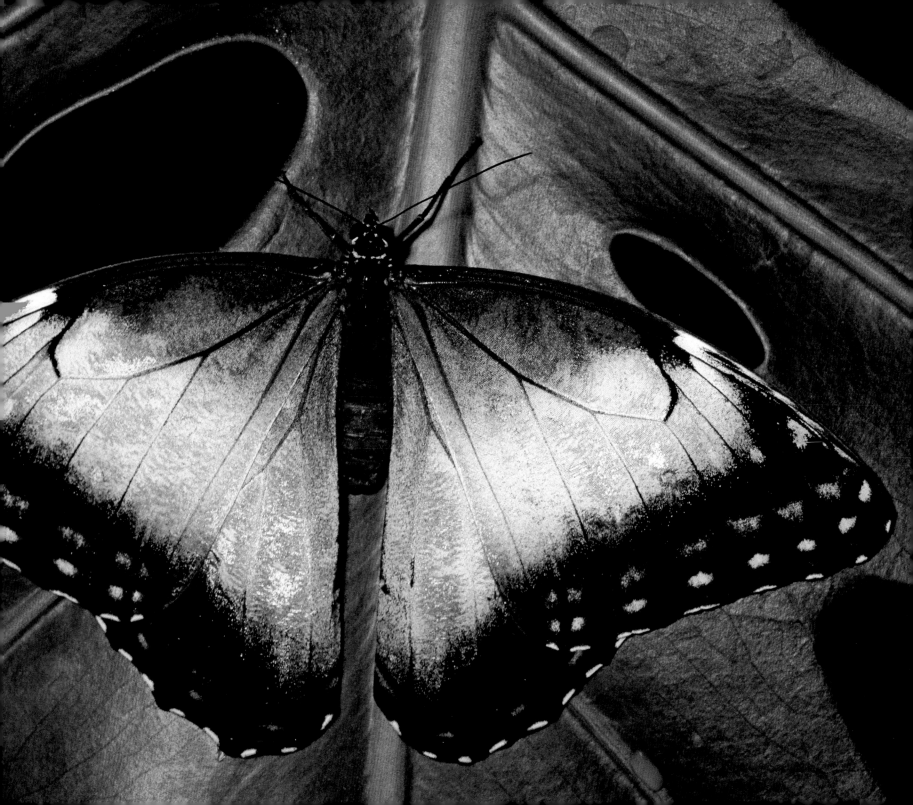

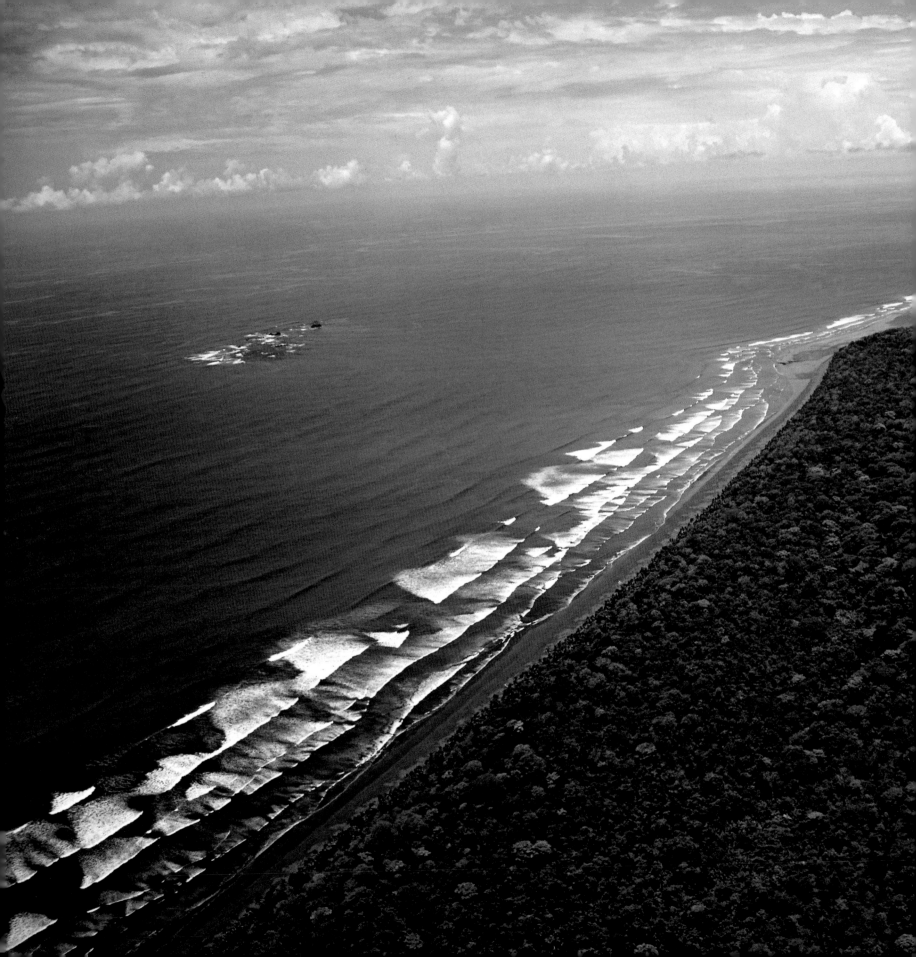

The Osa Peninsula
Jungle

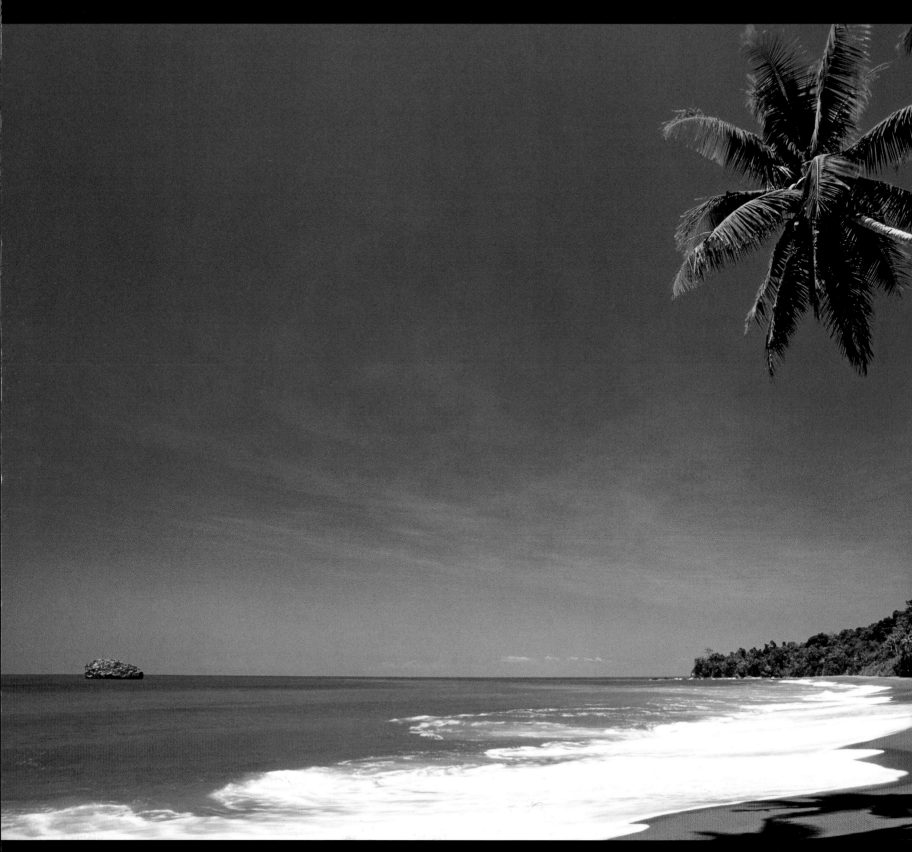

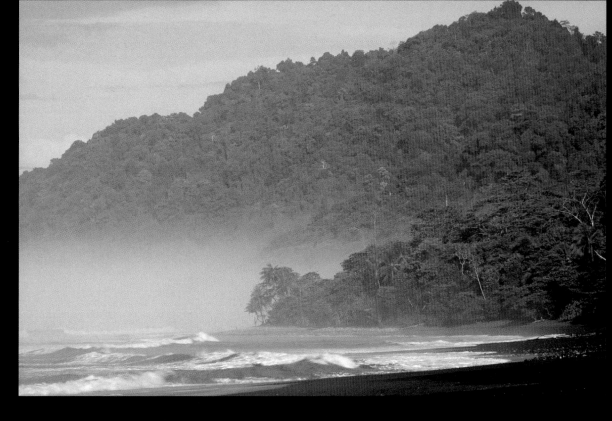

Costa Rica's southern Pacific coast is, without a doubt, one of the most rewarding areas in the country for wildlife enthusiasts. This region has lush forests, numerous rivers, and miles of coastline, all of which support an extremely rich biodiversity. The main geographical feature of the region is the Osa Peninsula, which extends out from the mainland into the Pacific Ocean. The world-famous Corcovado National Park covers a substantial area of the peninsula. The Osa Peninsula holds the largest and most remote area of lowland rainforest on the Pacific coast of Costa Rica. To the northwest, around the deltas of the Térraba and Sierpe Rivers, are dense mangrove swamps that provide important breeding and roosting sites for many bird species, including the mangrove hummingbird and the yellow-billed cotinga. To the south, between the peninsula and the mainland, lies the Golfo Dulce, an important calving ground for humpback whales.

The wildlife in Corcovado National Park is prolific and includes many rare and endangered species.

Spectacular birds such as the scarlet macaw, the king vulture, and possibly the harpy eagle are among more than 350 species that nest in the park. Green turtles come ashore every year to lay their eggs on the park's beaches. Many waterways throughout the park are home to spectacled caimans, American crocodiles, and bull sharks. Troops of spider monkeys and howler monkeys are common in the forest canopy, while white-faced capuchin monkeys, squirrel monkeys, and anteaters are active lower down in the trees. On the ground roam ocelots, pumas, and herds of white-lipped peccaries, as well as the largest land mammals in Costa Rica, the tapir and the jaguar.

Previous spread: The coastline of Corcovado National Park.
Left and above: Rainforest grows to within yards of the surf in Corcovado National Park.

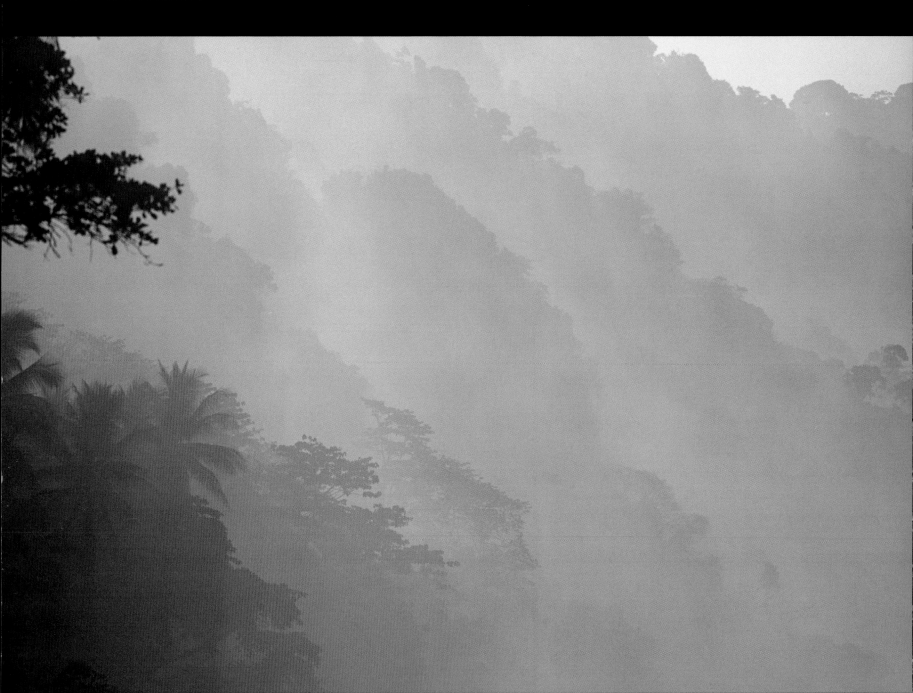

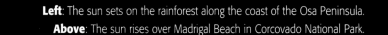

Macaws are the largest members of the parrot family, with the adults of some species growing to an impressive 40 inches (1 m) in length. Costa Rica is home to two species, the scarlet macaw (left) and the green macaw. Scarlet macaws are common on the Osa Peninsula and further north on the central Pacific coast in Carara National Park. Green macaws are scarce but widespread inhabitants of the Caribbean lowlands. Macaws live a monogamous life but nevertheless are extremely sociable birds. They feed and travel in small family groups or sometimes in flocks of up to twenty-five individuals.

Corcovado National Park protects the largest population of scarlet macaws in the country. They are commonly seen flying along the coast, where they feed in tropical almond trees (right). Their diet consists of fruit and nuts. They have a thick, muscular tongue and a hinged upper mandible that work together to help them crush and manipulate even the toughest food. In addition, macaws can use their feet to pass food to their mouths, a rare ability among birds.

Though once abundant on both the Pacific and Caribbean slopes, hunting and poaching for the pet trade have caused a dramatic reduction in the populations of both macaw species.

Left: Scarlet macaw lifting off from its perch.
Right: The distinctive foliage of a tropical almond tree.

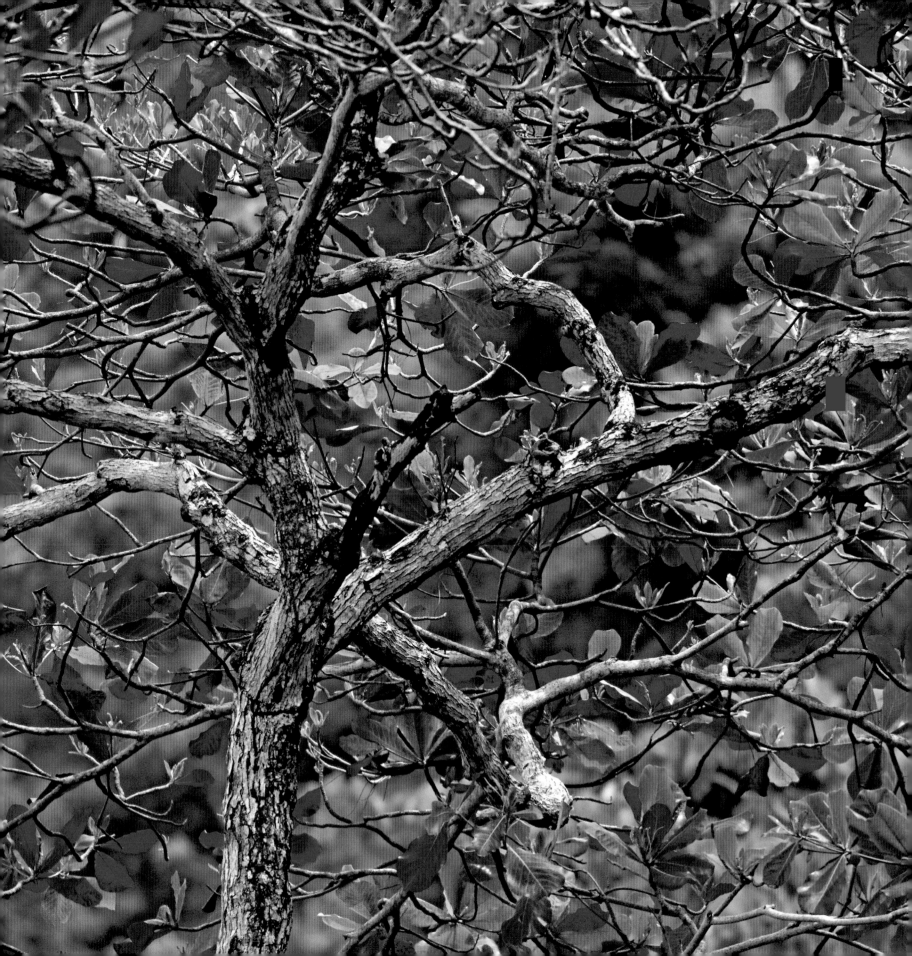

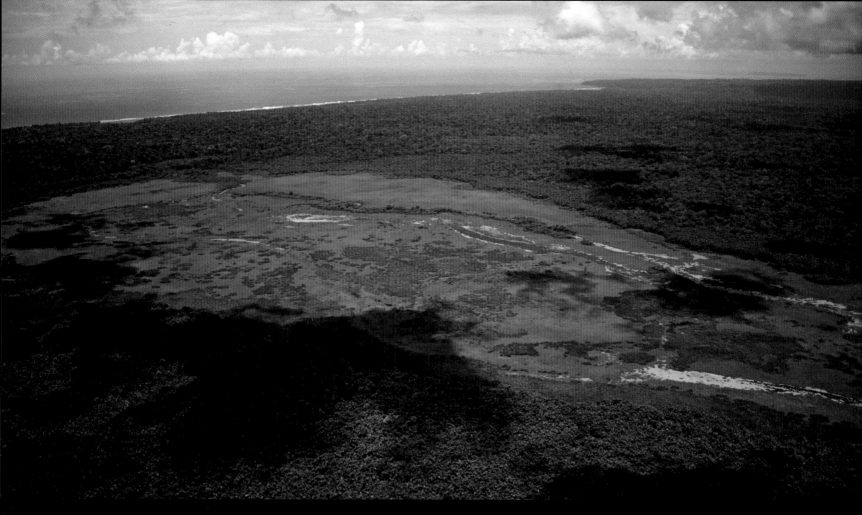

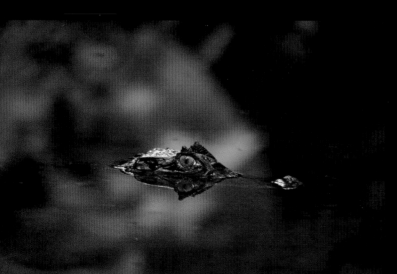

The largest body of freshwater in Corcovado National Park is the Corcovado Lagoon (above). These nearly 4 square miles (10 km²) of swampland are made almost inaccessible to humans by the prolific growth of spiny palms and dense floating vegetation. Crocodiles several yards long have been sighted by park guards and scientists working within the area.

During the dry season, spectacled caimans (left) lie motionless in the shallow, still water of jungle streambeds, often undetected by both predator and prey. This le-thargic behavior is misleading, though. When the caiman wants to catch a passing fish or waterfowl, it is capable of making an explosive, lightning-fast lunge that leaves its prey little chance of escape. Similarly, if it feels threatened, it will disappear with a sudden, violent splash intended to startle a potential predator.

Above: The Corcovado Lagoon is an important breeding ground for American crocodiles.
Left: A spectacled caiman waits to ambush a passing fish or waterbird.

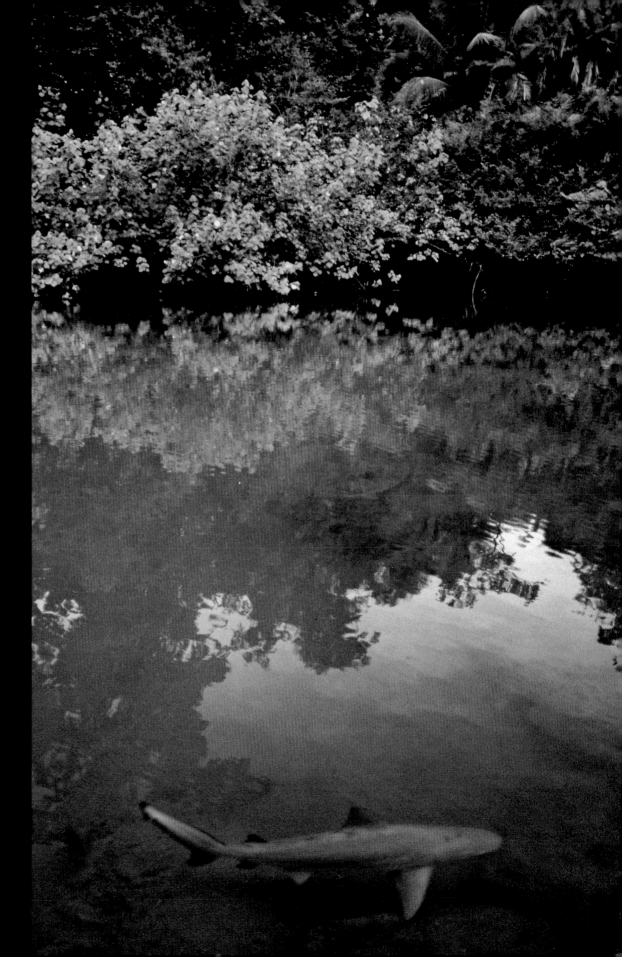

The Corcovado Lagoon is linked to the ocean by one of the principal waterways of the Osa Peninsula, the Sirena River. Close to its mouth, the current changes direction twice a day. During an ebbing tide, freshwater drains from the river into the ocean; but several hours later, at high tide, the flow is reversed and the sea floods dramatically back into the estuary. The incoming tide brings hungry visitors to the river, such as this 5-foot-long (1.5 m) bull shark. It was one of several that the author photographed during a single high tide.

Interestingly, the bull shark, which normally lives in saltwater, can temporarily alter its internal body chemistry and spend prolonged periods of time in freshwater with no apparent ill effects. Individuals have been recorded both in Lake Nicaragua and more than 1,200 miles (2,000 km) up the Amazon River.

Right: Bull shark entering the Sirena River from the ocean at high tide.

Strangler figs, found throughout the New and Old World tropics, are common in both the lowland and highland rainforests of Costa Rica. They are parasitic plants that usually begin life as epiphytes growing high up on a host tree. As the fig gradually extends its roots down to the ground, enveloping its host, it grows tighter and tighter around the trunk of the host, preventing it from growing any wider. At the same time, the fig develops a leafy crown above that of the original tree, thereby reducing the amount of light that reaches the host tree's leaves. It is believed that the combination of these two factors is what leads to the eventual death of the host. Many years later, once the host has totally decomposed, all that remains is the shell-like form of the mature fig tree.

Left: The upward view inside a strangler fig, where the host tree once stood.

More than five hundred species of trees have been recorded in Corcovado National Park, many of which grow to more than 130 feet (40 m) in height; some, such as the ceiba, or kapok tree, can easily exceed 200 feet (60 m).

A breeze blowing through the canopy sways the branches of a tree, causing a great amount of physical strain to the base of the trunk. To remain firm, rainforest trees require extremely strong roots to hold them in place; but because most nutrients in rainforest soil are found close to the surface, a tree's root system must also be relatively shallow. Such a system is inherently unstable, and to compensate, the tree gains stability by forming mammoth buttress roots above the ground (right). The same technique is applied in architecture, where buttresses are used to strengthen walls.

Right: Enormous buttress roots, Corcovado National Park.

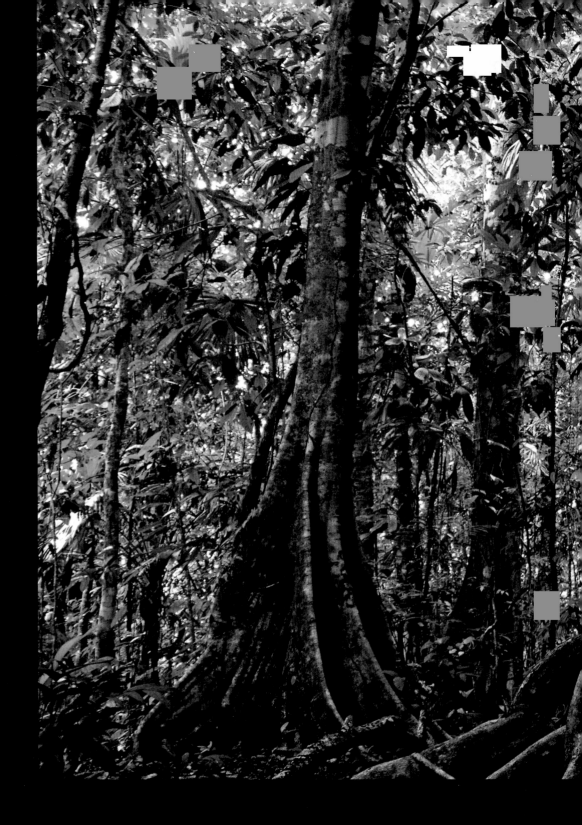

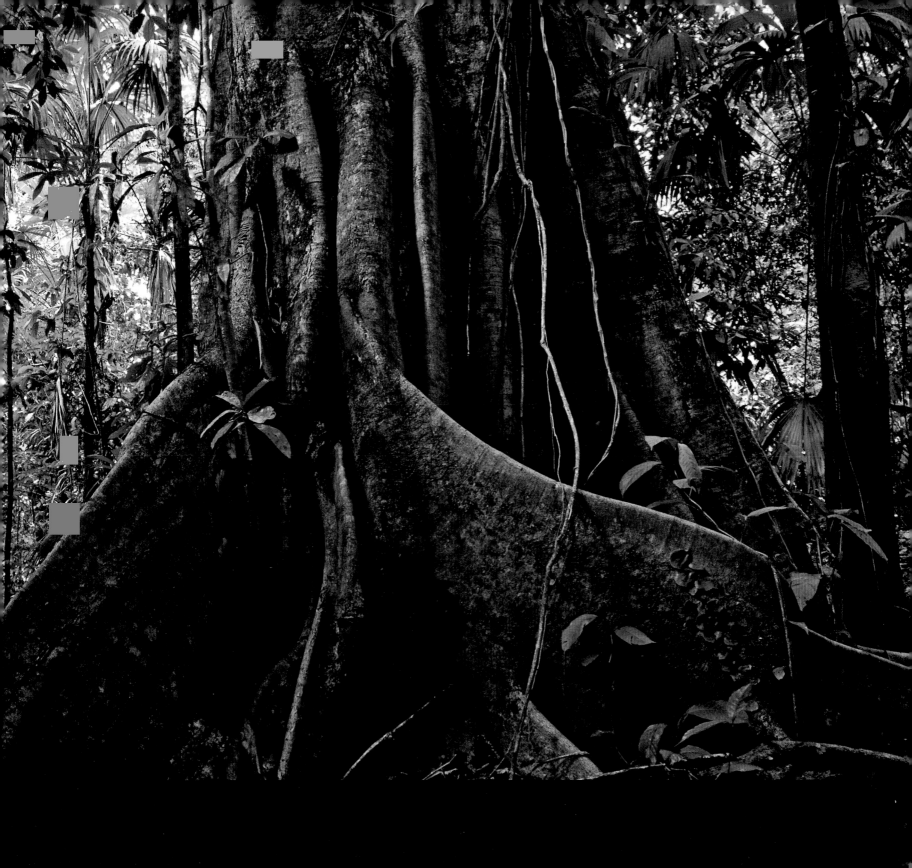

Compared to most other animals, mammals have few off-spring and devote a lot of time to caring for their young. This adult spider monkey (top) is helping a juvenile from its own troop cross a gap between trees using a technique known as bridging.

Spider monkeys use their very long arms and a strong prehensile tail to swing almost effortlessly through the canopy (bottom). When these animals travel with their tail and four limbs in constant motion, it is easy to understand how their common name originated.

The spider monkey's diet consists mainly of fruit. Since fruit is found seasonally and sporadically throughout the forest, and usually only at the ends of branches, fruit-eating animals must be able to travel long distances without expending too much energy, and—once the food source is located—they must be able to reach it. This explains why spider monkeys have developed such amazing mobility and dexterity.

Only large regions of primary forest can provide troops of spider monkeys with enough fruit to satisfy their specialized diet. This requirement thus limits spider monkeys' distribution to the largest protected areas of Costa Rica, such as Corcovado National Park.

Top: Spider monkeys bridging from one tree to another in Corcovado National Park.
Bottom: Spider monkey using its four limbs and prehensile tail to swing through the rainforest.

Of the four species of monkey found in Costa Rica, the squirrel monkey (right) is the smallest. It has an average body length of just 11 inches (28 cm), excluding its tail. It is also the most active of the monkeys. A large troop will continuously leap and bound through the forest in search of insects and fruit. Photographing these animals can be challenging, and because the monkeys are so active, it is difficult to concentrate on a single individual. This movement can also be distracting to predators such as hawks, eagles, and cats when they are trying to single out a victim. Consequently, squirrel monkeys find safety in numbers.

The mother carries the young either on her back or slung under her belly. In both cases, the baby must grip tightly as the mother quickly runs up trunks and along branches and leaps from tree to tree.

There are two subspecies of squirrel monkey in Costa Rica. One exists as a small, highly endangered, isolated population in Manuel Antonio National Park. The second subspecies occurs more numerously throughout the forested areas of the southwestern region, including in Corcovado National Park. The protection of these forested areas and the development of biological corridors to link them with other parks or reserves are essential for the continued survival of these monkeys.

Right: Female squirrel monkey, with baby, eating a katydid.

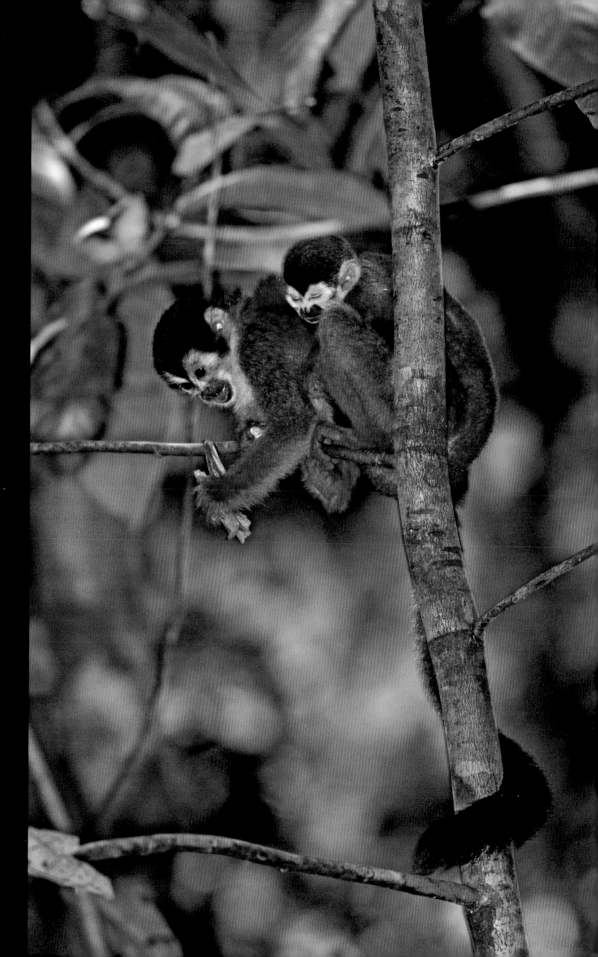

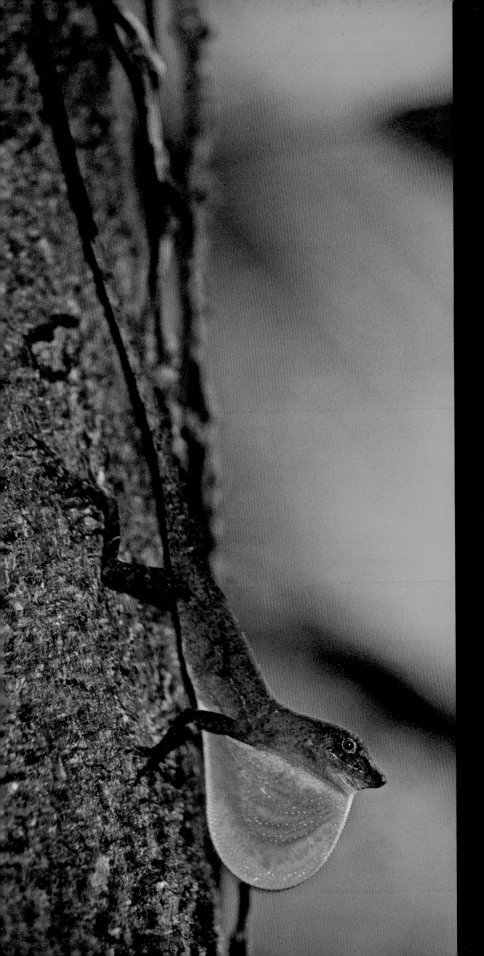

The small, well-camouflaged anole lizards inhabit a range of niches in the tropical forest; some species live in the canopy, while others appear in understory vegetation and on the forest floor. Males are extremely territorial, each one defending an area of between 320 and 650 square feet (30 to 60 m²). When there are territorial conflicts, an individual such as this Golfo Dulce anole (left) confronts an intruder by hopping onto an exposed branch or root, bobbing its head, and extending a brightly colored dewlap from under its chin. The other male may stand his ground and return the display or retreat; a short chase often ensues until the trespasser has left.

This threat display is not only reserved for other lizards—the tiny anole in the photograph below (on right-hand side of photo) approached a scarlet macaw that had perched in its territory. The anole tried to impose its authority with a vigorous show of head bobbing; but on this occasion, the bird responded with nothing more than mild curiosity.

Left: Male Golfo Dulce anole extending its yellow dewlap during a territorial display.
Below: This tiny anole lizard angrily confronted a scarlet macaw that landed in its territory.

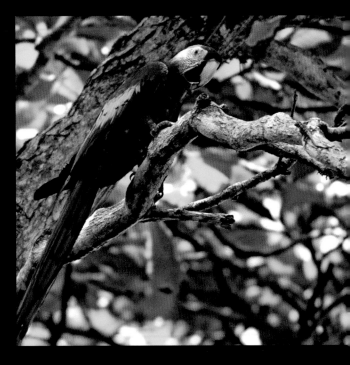

While searching for small lizards and frogs among trees and bushes at night, the brown blunt-headed vine snake can extend up to a third of its body length as it passes from one small branch to another. This feat is possible due to the combination of strong vertebrate muscles, a triangular body section, and a low body weight. Such suppleness enables the snake to approach its prey without having to touch the twig or leaf the animal is resting on.

Above: Brown blunt-headed vine snake suspended in the air between branches.

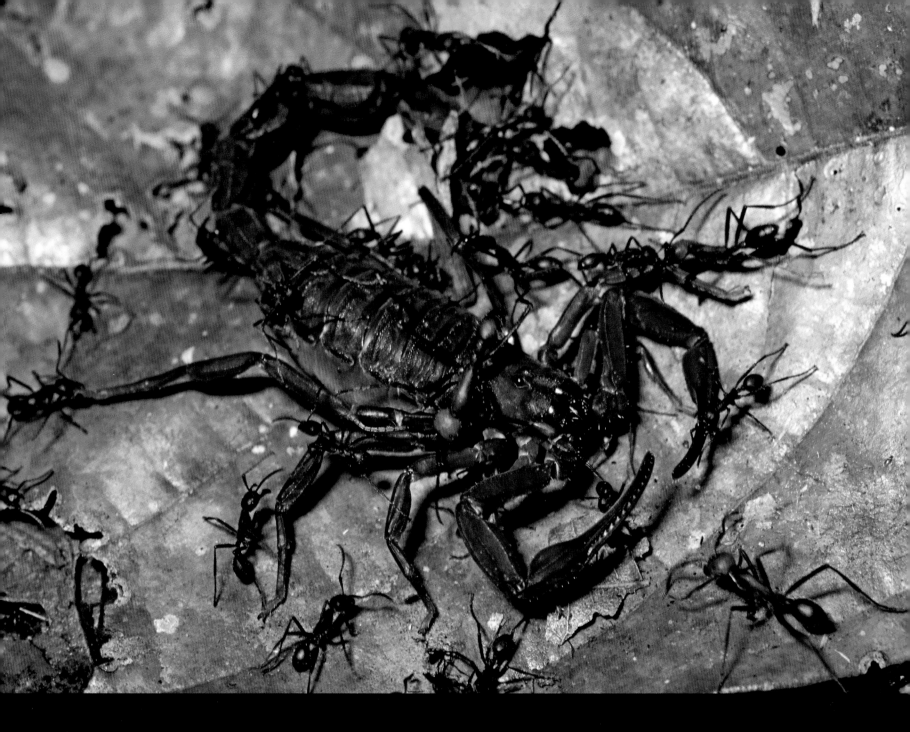

Army ants are among the most successful, ruthless, and feared hunters in the rainforest. When on the move, they travel en masse and are simply unstoppable. Army ants have no permanent nest; instead, each night the worker ants crowd together around their queen to form a temporary nest called a bivouac. At dawn, several hundred thousand workers and soldiers fan out across the jungle floor, where they swarm upon and kill every creature in their path. They tear apart their victims and carry the remains back to the bivouac to be eaten. Insects, tarantulas, scorpions, frogs, lizards, and snakes can be seen frantically running, jumping, or slithering away from an army-ant swarm.

The scorpion in the photograph above scuttled out from beneath a log as soon as the ants discovered it, but it was overrun and killed before it could run more than a few feet, its sting proving useless against such a small enemy.

Above: Army ants attacking a scorpion on the forest floor.

Ants and termites are prolific in the rainforest, and the collared anteater has evolved to effectively exploit this plentiful food source. Its prehensile tail and clawed hands and feet enable it to travel up and down lianas and trunks with ease as it searches for nests, guided by a keen sense of smell. Once it discovers a nest, it uses its strong, sharp claws to rip the structure open. The anteater then licks up the insects with a long sticky tongue that can protrude up to 16 inches (40 cm) from its tiny mouth. In this way, the anteater can consume almost ten thousand insects per day.

Anteaters tend to avoid ant species that have numerous aggressive soldier ants (leaf-cutter ants, for example), or those with strong chemical defenses, such as army ants.

Right: Collared anteater using its strong grip to descend a tree trunk.
Below: Collared anteater feeding on an arboreal termite nest.

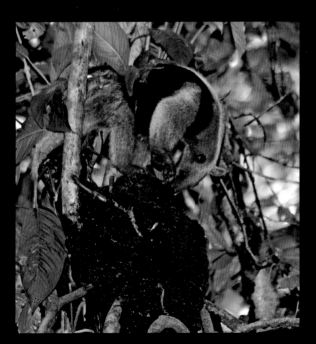

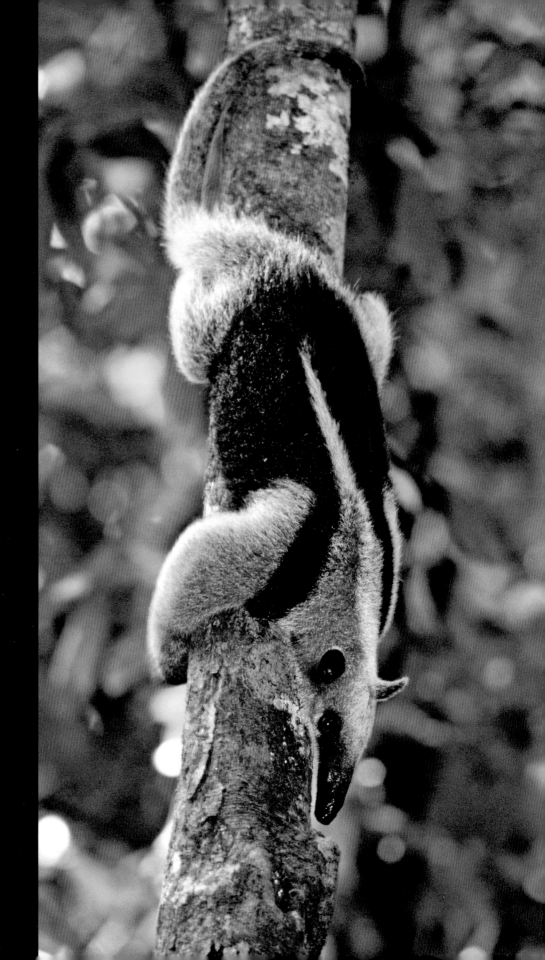

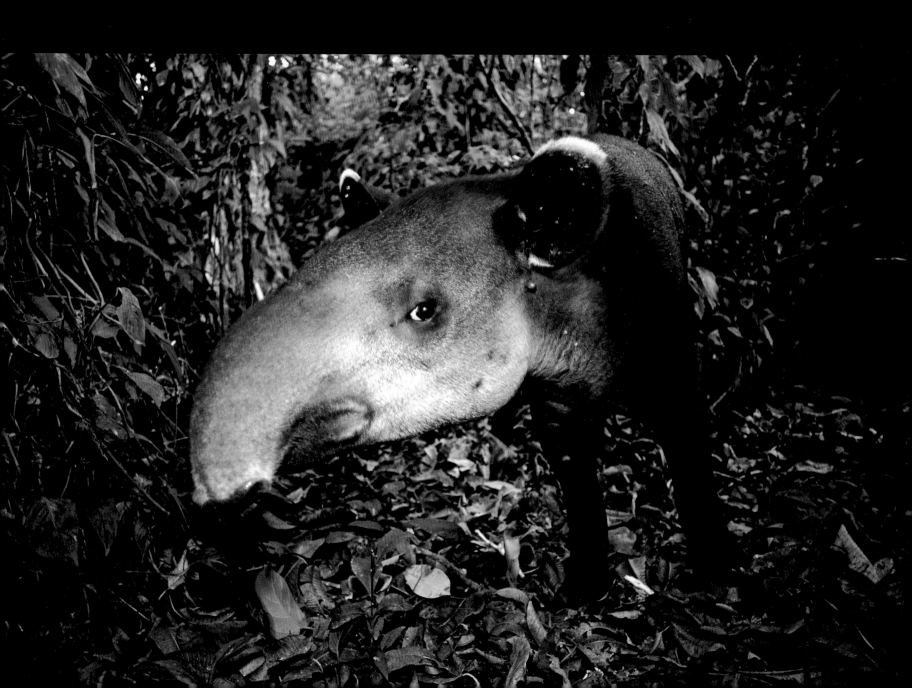

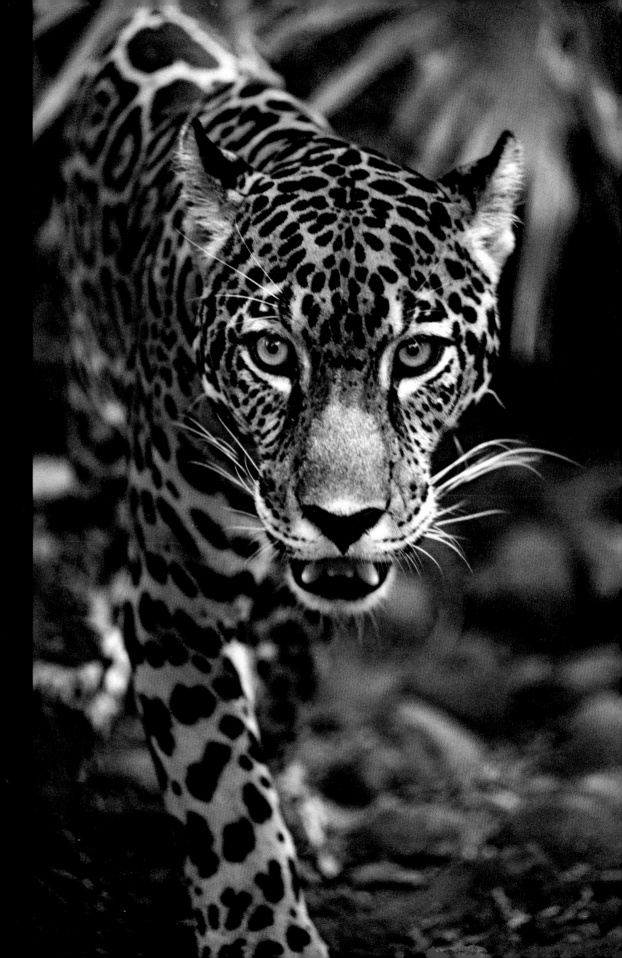

An adult Baird's tapir (left) stands as tall as a small donkey and can weigh up to 550 pounds (250 kg). The Baird's tapir—a distant relative of the rhinoceros—and two other South American tapir species are the largest land mammals in the neotropics.

By eating a lot both day and night, this large animal is able to survive on a low-energy diet of mainly leaves and stems. The tapir's elongated, prehensile nose is perfectly formed for pulling at vegetation and shoveling small, fallen fruit from the forest floor into its mouth. Compensating for poor eyesight, this enlarged nose gives the animal a very acute sense of smell for sniffing out its favorite leaves and warning it of the presence of predators such as pumas and jaguars.

The jaguar (right) is the largest land carnivore in Costa Rica. At the top of the rainforest food chain, it hunts almost anything smaller than itself, including peccaries, turtles, iguanas, and monkeys, and it sometimes hunts two animals larger than itself: the deer and the tapir. Its spotted yellow-brown fur provides a superb camouflage that enables it to stalk and ambush its prey.

Corcovado is one of the few remaining national parks in Costa Rica where jaguars still roam. Deforestation and the hunting of both the jaguar and its prey have severely depleted populations around the country. Unfortunately, recent estimates suggest that as few as forty individuals now remain in Corcovado National Park.

Left: The Baird's tapir is the largest land mammal in Costa Rica.
Right: The camouflage effect of a jaguar's spotted fur helps it to stalk and ambush its prey.

Of the 850-plus species of birds that inhabit Costa Rica, close to half have been recorded on the Osa Peninsula. More than a dozen of these are subspecies endemic to the area.

Male birds are usually showier than females, and their bright colors commonly function as a means of communication during territorial and mating rituals. When rival males compete for the attention of a female, the showiest male usually wins out.

Many of the red, orange, and yellow colors in birds' feathers and beaks are derived from chemical pigments called carotenoids, which are found in the fruits and seeds that the birds eat. Carotenoids do more than give the birds an attractive appearance, however; they also help them maintain a healthy immune system. If a bird is not suffering from parasites or infection, its body can afford to incorporate some of the ingested carotenoids into the coloration of its beak and feathers. Healthier male birds will thus generally be more colorful, and more likely to catch the eye of a mate.

Left: The beautiful male green honeycreeper occurs on both the Caribbean and the southern Pacific coasts.
Below: A male slaty-tailed trogon displaying its brightly colored plumage.
Right: The eye-catching fiery-billed araçari.

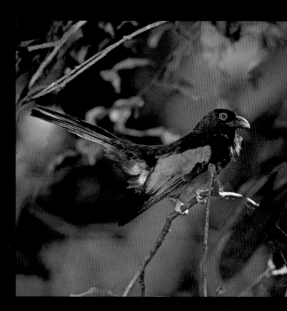

Probably the most colorful bird of prey in Costa Rica is the king vulture. A fully-grown adult stands 30 inches (80 cm) tall and commands respect from all other scavengers when it arrives at carrion. It is a very shy and wary bird, usually perching high up in treetops. The individual in this photograph spent several minutes soaring in circles above the forest in Corcovado where a small group of turkey vultures had gathered. It suddenly folded its wings and dropped like a stone through the canopy. Perhaps this was to reduce the chance of being spotted by competing carrion feeders on the ground that would welcome the opportunity to share in an easy meal. The prize was a dead spider monkey. As soon as the king vulture had eaten its fill and left the carcass, a crowd of eagerly awaiting turkey and black vultures, patiently perching in surrounding trees, moved in to finish off the remains.

Left: King vulture peering down from a tropical almond tree in Corcovado National Park.

The bicolored hawk swoops down on its prey and grabs it with razor-sharp talons. It uses its extremely strong feet to grip and control its struggling prey. The hawk then kills the animal with its beak.

Right: Bicolored hawk holding a freshly killed mangrove cuckoo in its talons.

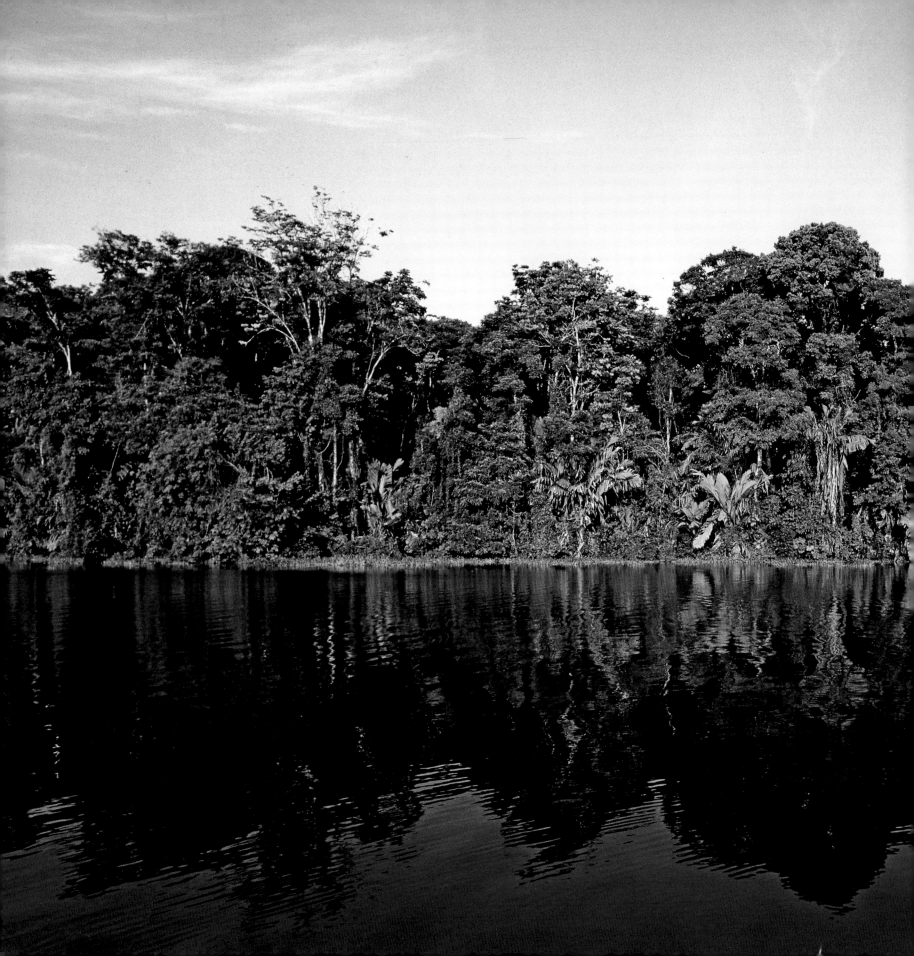

The North Caribbean
Living Waters

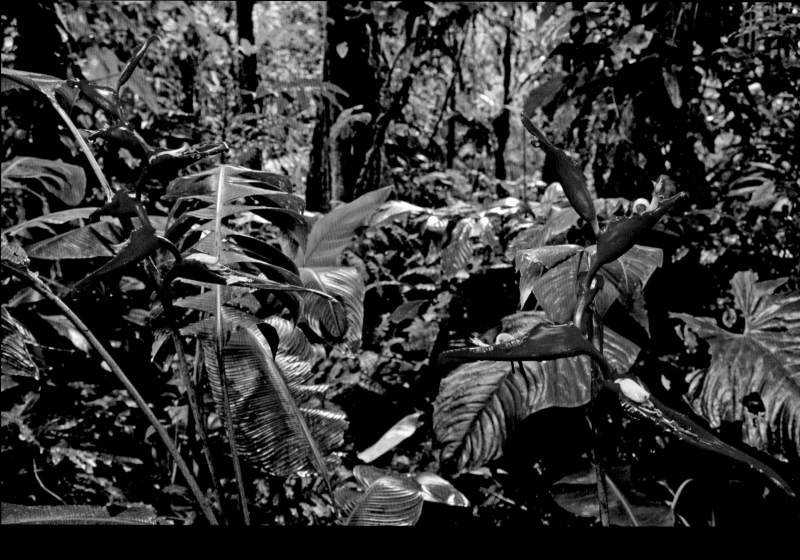

The North Caribbean lowlands of Costa Rica boast a sizeable area of dense rainforest crisscrossed with a maze of freshwater canals and bordered by miles of undeveloped beaches. Along the coast, most of this land is enclosed within the boundaries of Tortuguero National Park and, to its north, the Barra del Colorado Wildlife Refuge. Further inland, in the region of Sarapiquí, privately-owned reserves such as La Selva, La Tirimbina, and Rara Avis, on the edge of Braulio Carrillo National Park, offer their own natural sanctuaries to flora and fauna. The amount of wildlife here is astonishing. The forests are home to brightly colored poison arrow frogs and tree frogs. Mammals include tapirs, three species of monkey, and a variety of cats. The waterways harbor crocodiles, caimans, green basilisks, manatees, and river otters. Tortuguero's beaches are an important nesting ground for green, leatherback, hawksbill, and loggerhead turtles. The presence of these turtles makes the beaches here ideal hunting territory for the largest wild cat in Costa Rica, the jaguar.

Among the rich green vegetation live hundreds of bird species, including tanagers, green macaws, large nesting populations of the Montezuma oropendula, and the chestnut-mandibled toucan (right). The enormous bill typical of toucans is an essential tool that the bird uses with great dexterity when feeding. The bill is filled with a foamlike material, making it light in weight, but it is also very strong. Toucans feed predominantly on fruit, which generally occurs at the end of thin branches. Its long bill allows the toucan to stand on a stronger part of the branch, then reach out and either remove small berries from the end of a branch or scoop out the pulp of larger fruits. Toucans supplement their fruit diet by eating small lizards, snakes, and—if they come across an unattended nest—young birds.

Previous pages: Freshwater canal in Tortuguero National Park.
Above: Heliconias in Braulio Carrillo National Park.
Right: The chestnut-mandibled toucan's bill is light but strong.

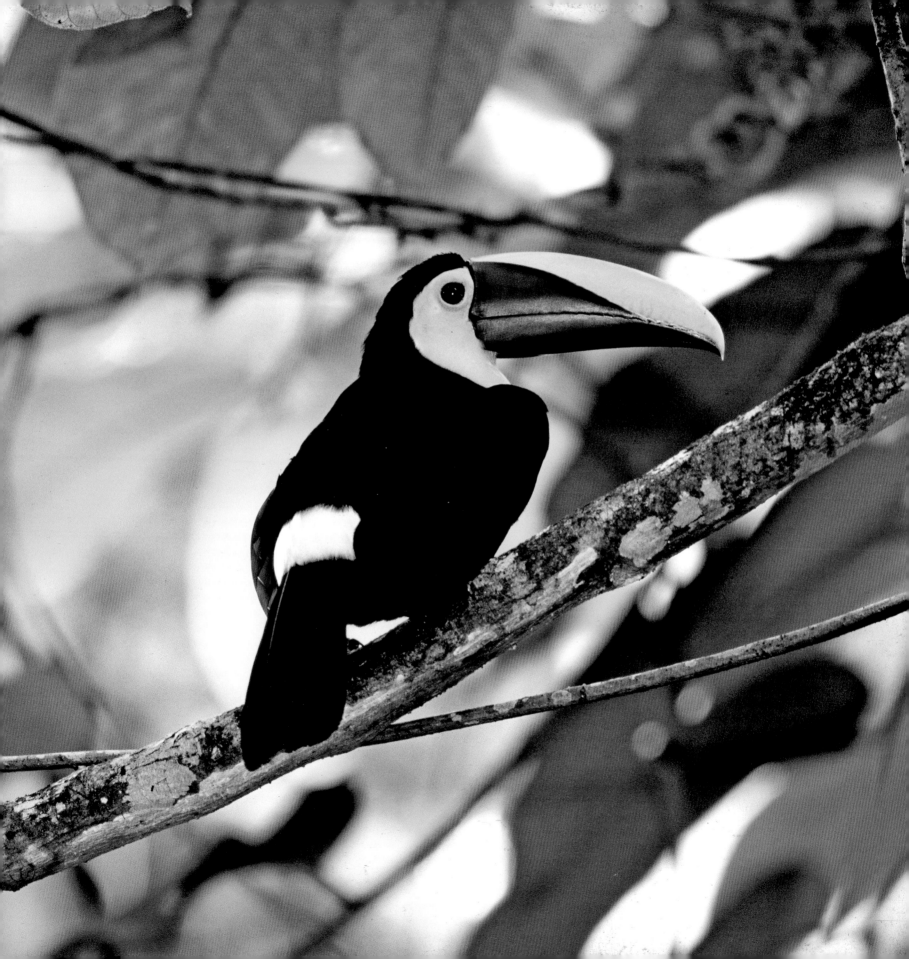

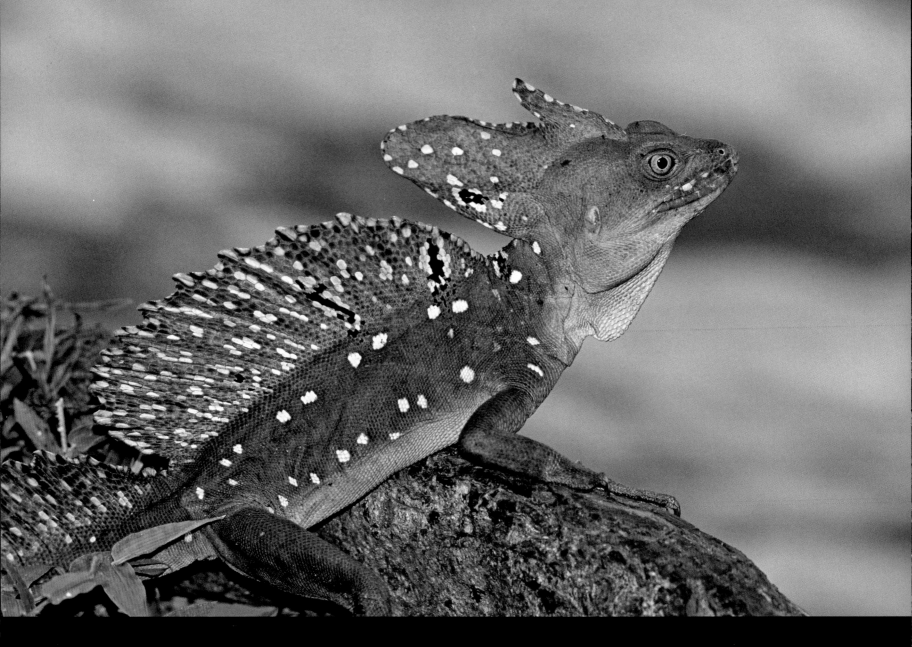

Green basilisks are large, majestic lizards that inhabit the Caribbean lowlands and waterways of Costa Rica, Nicaragua, and Honduras. Their striking yellow eyes and emerald-green skin distinguish them from all other land lizards along this coastline. During the mating season, to help attract females, the color of the adult male's throat becomes a deep blue (above). Green basilisks favor resting places on logs, roots, and the branches of trees that overhang freshwater canals. These perches also

provide them with a fast escape route from potential predators such as snakes, birds of prey, and cats. When threatened, the lizard dives headlong into the canal below and swims confidently back to a different stretch of the riverbank. Alternatively, aided by large, partly webbed feet and extremely powerful leg muscles, basilisks are able to sprint short distances across the water surface to evade predators. The ability to run on the surface in this manner has earned them the nickname "Jesus Christ lizards." The

name *basilisk* is derived from the Greek work *basilisko*, which means "little king." In ancient Greek literature, the *basilisko* was described as a fearsome, fire-breathing serpent with a crownlike crest on its head.

Above: Adult male green basilisk perched on a canal bank in Tortuguero National Park.
Right: The juvenile male green basilisk has a much smaller crest than adult males.

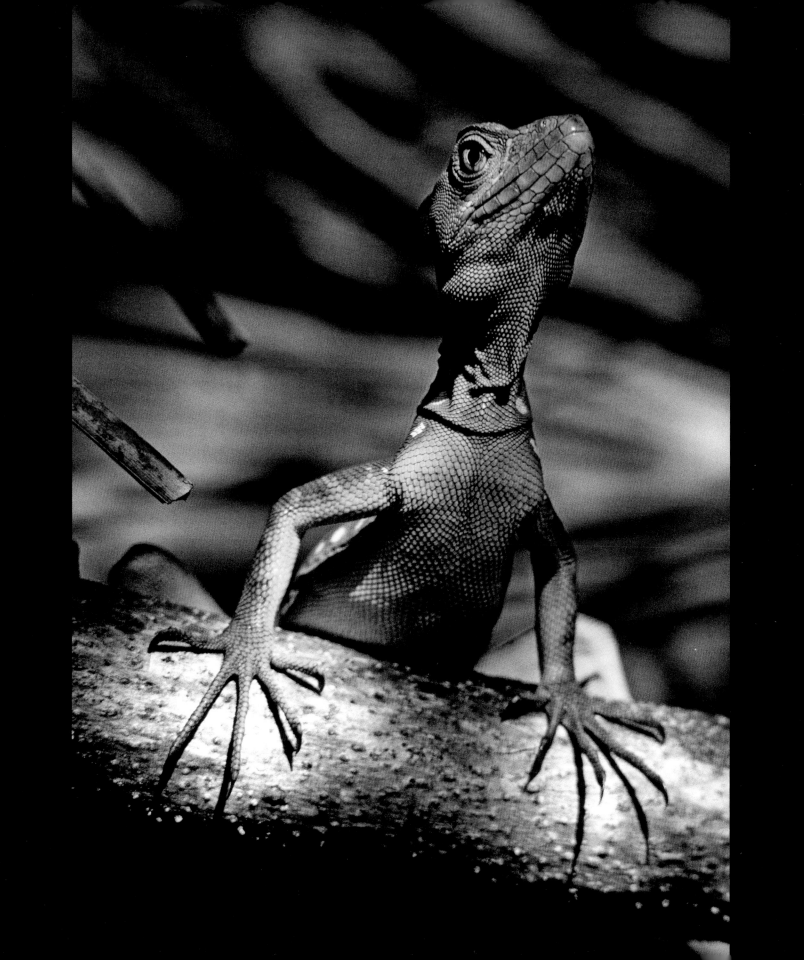

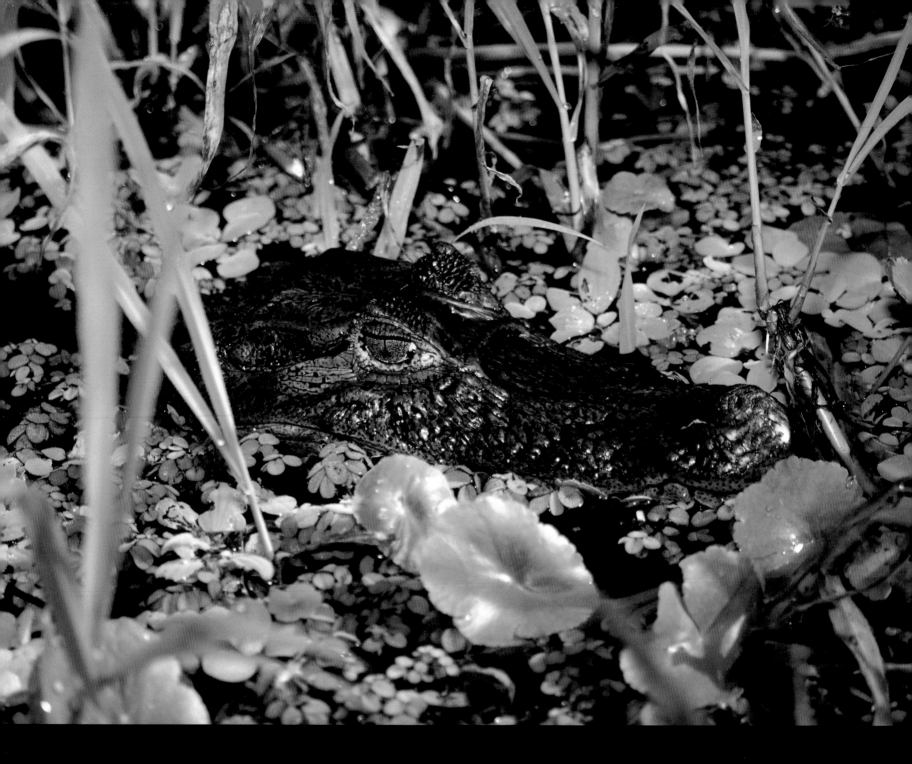

Two species of very large reptiles inhabit the lowland rivers, swamps, canals, and lagoons of Costa Rica: the spectacled caiman and the American crocodile.

Spectacled caimans (above) prefer to hunt at night, patrolling the dark waters of their feeding grounds in search of fish, frogs, and sleeping birds. In the early morning, these reptiles often stretch out on trunks or hide among floating vegetation, warming their bodies in the sun. Like all reptiles, they are unable to produce their own body heat, so this behavior is vital after a night spent in cool water.

Spectacled caimans are members of the alligator family. They get their name from the bony ridge in front of their eyes that looks like the centerpiece of a pair of glasses. This helps to differentiate caimans from crocodiles, which do not have this structure.

Above: Adult spectacled caiman warming itself in the early morning sun, Tortuguero National Park.

The mottled brown color of juvenile spectacled caimans (right) provides perfect camouflage among floating dead leaves or against a muddy streambed. Though adults have no predators other than large cats, boa constrictors, and humans, their young are particularly vulnerable to wading storks, herons, and sharp-eyed birds of prey.

Right: Juvenile spectacled caiman camouflaged among dead leaves in a stream.
Below: A canal that runs through primary rainforest in Tortuguero National Park.

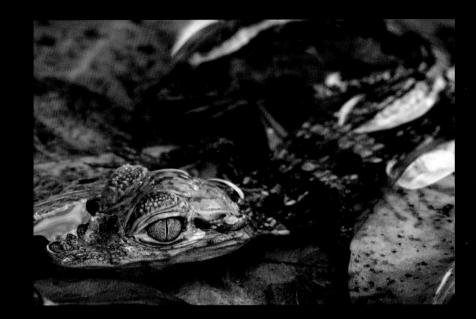

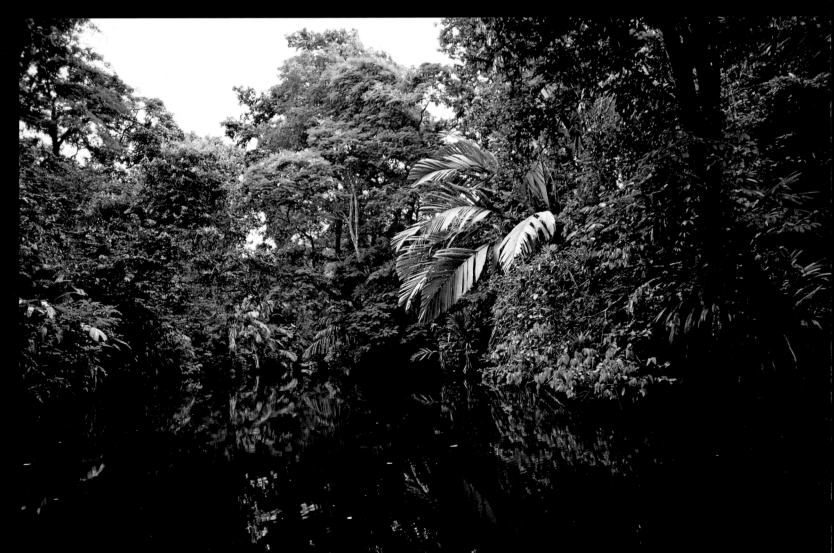

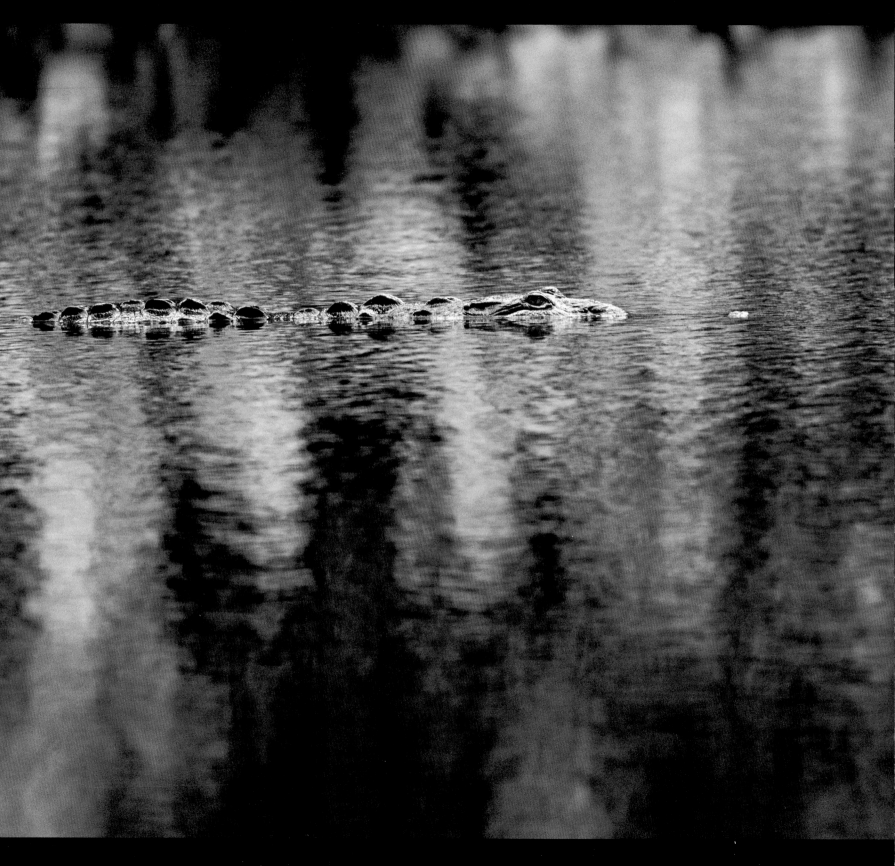

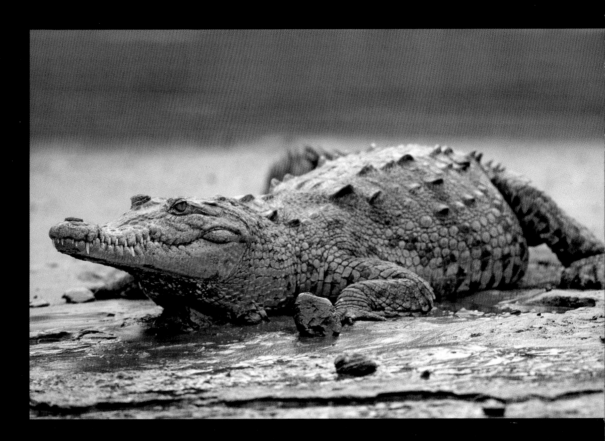

The huge body, elongated head, and daggerlike fourth tooth protruding from its lower jaw distinguish the American crocodile (above and left) from the spectacled caiman. In Costa Rica, crocodiles grow to an average length of 10 feet (3 m), although in protected areas such as Tortuguero and Corcovado National Parks individuals up to twice that size have been reported.

Crocodiles are easiest to see when they are basking along the muddy banks of rivers and estuaries. Once the sun has heated their bodies to an optimum temperature, these huge reptiles will either slip back into the water or open their jaws, a behavior known as gaping that allows the breeze to cool the blood passing through the mouth and tongue.

Crocodiles feed on almost any animal that they can find in the water, from crustaceans to mammals.

Although rare, attacks on humans have been recorded in Costa Rica. When hunting on the surface of the water, a crocodile will swim or drift slowly toward the intended prey with only its eyes and nostrils clearly visible. Once close enough to the unsuspecting prey, it lunges forward, propelled by its powerful tail, and seizes the animal in its jaws. On one occasion, the author was sitting on a partially submerged log photographing a 6-foot-long (2 m) crocodile (shown on opposite page). Without warning, it launched itself across the log to snap at a family of otters that was playing on the other side.

Left: American crocodile patrolling its territory.
Above: A 10-foot-long (3 m) American crocodile sunbathing on a mud bank in Tortuguero National Park.

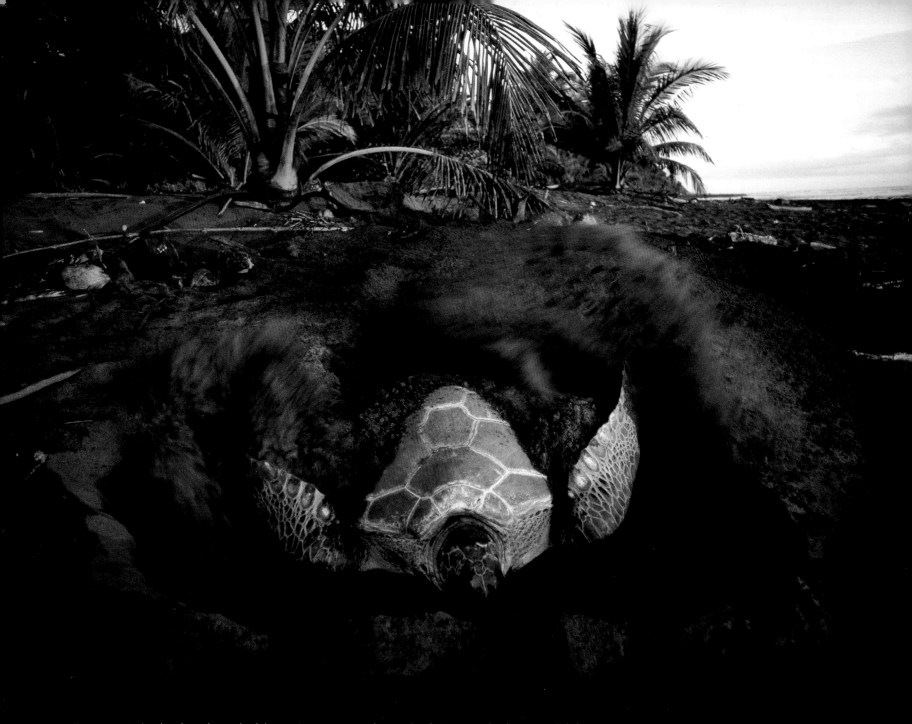

In Tortuguero National Park, at the peak of the nesting season in August, dozens of green turtles come ashore at night to lay their eggs. Once a female turtle finds a satisfactory spot on the beach, she digs a hole in the sand with her back flippers, deposits her eggs, and then buries them. Roughly an hour after emerging from the ocean, she drags herself back into the surf. Sea turtles typically come ashore to lay their eggs under the cover of darkness, when the risk of predation is lowest. Occasionally, however, an individual can be spotted still covering her nest at first light of day.

Above: At daybreak, a female green turtle buries her newly laid eggs in Tortuguero National Park.

Tortuguero National Park is the largest nesting site for green turtles in Costa Rica. It is relatively safe from poachers and other human interference. In many areas the beach appears as untouched now as it has been for thousands of years. Poaching of adult turtles and their eggs does occur, however, and the unfortunate shortage of park rangers patrolling the area makes protecting the turtles difficult. Tourism in the park is encouraged, but carefully controlled; only a limited number of visitors are allowed on the beach at night, and they must be accompanied by a guide. Such regulations are essential, since flashlights and human voices can easily dissuade turtles from coming ashore to lay their eggs.

Above: Female green turtle returning to the ocean in Tortuguero National Park after laying her eggs safely above the high-tide mark.

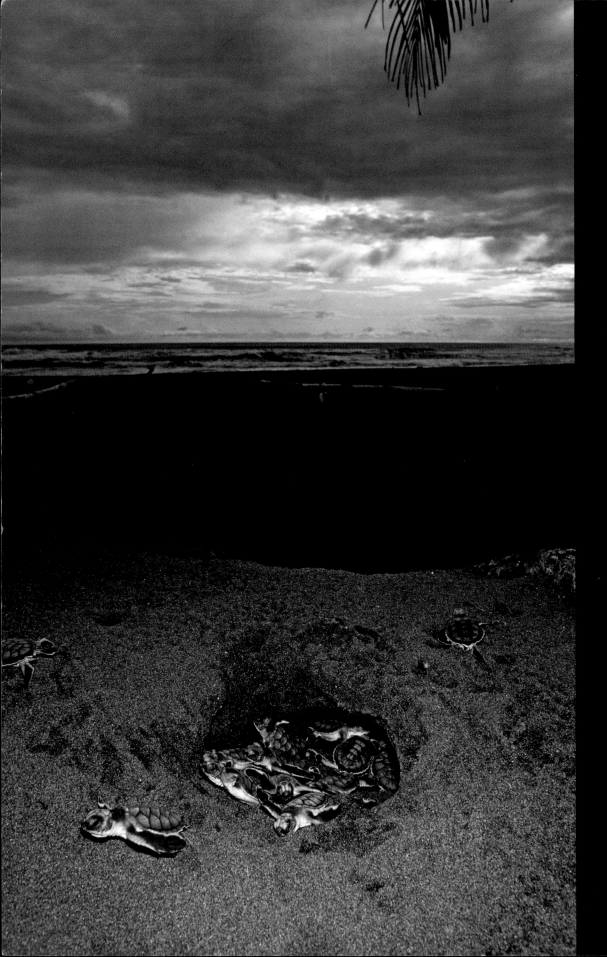

Baby turtles usually hatch during the night, which protects them from the heat of the sun and the watchful eyes of predators. Some individuals, however, emerge from the nest in the half-light of dusk or dawn, making their scramble down to the sea much more perilous. During the two-minute journey from nest hole to ocean, the hatchlings are easy prey for any crab, vulture, or hawk that spots them. A substantial number of the hatchlings never reach the sea. The females that do survive usually return between ten and thirty years later to lay their own eggs. They will then, as adults, face a new danger: the jaguar.

Left: At dusk, green turtle hatchlings beginning their journey from their nest to the sea in Tortuguero National Park.

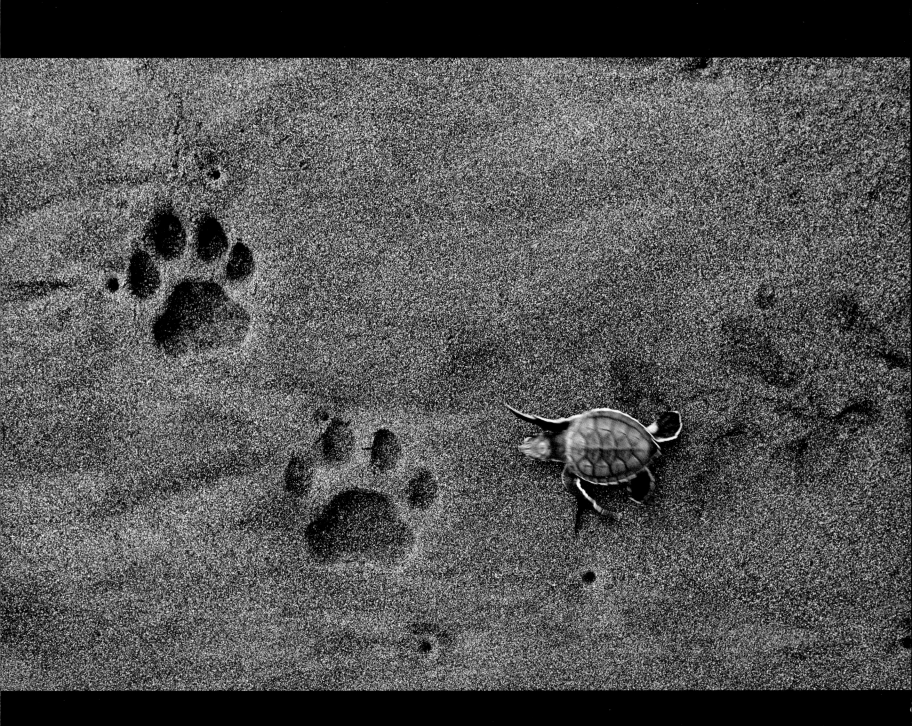

Above: Green turtle hatchling scurrying past fresh jaguar tracks at dawn in Tortuguero National Park.

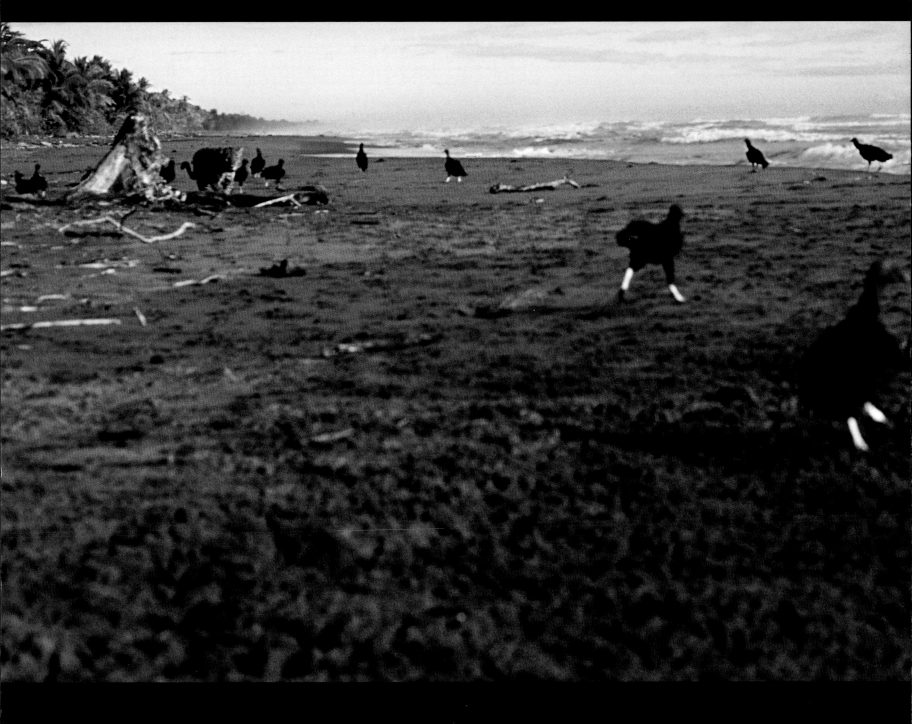

Above: Adult jaguar in Tortuguero National Park approaching a green turtle killed the previous night by two smaller jaguars. This photograph captures an incredibly rare, face-to-face encounter with a jaguar in its natural environment. The light levels at dawn were very low, which meant that the author was forced to take the photograph with a short lens at a very wide aperture. The jaguar is therefore quite small in the frame and the foreground is out of focus. The photograph does, however, realistically capture the drama of the moment.

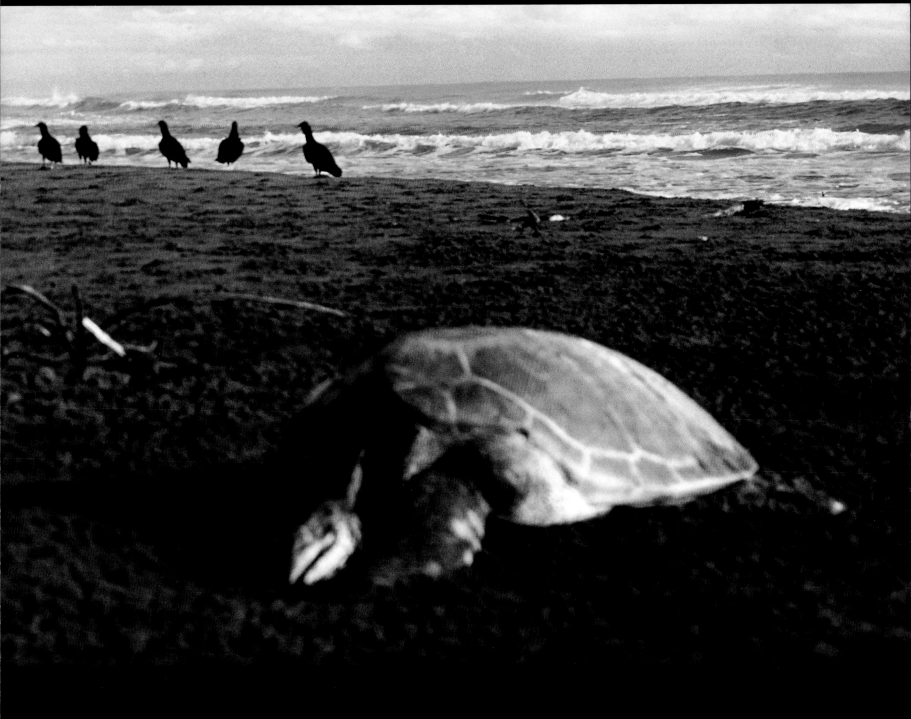

The beach is a hostile environment for a sea turtle; without the buoyancy of water, it must make a tremendous effort to drag its huge bulk across the sand. This inability to move quickly on land makes it very vulnerable to predation by jaguars, its one natural land predator.

During the nesting season, jaguars patrol the beach at night searching for adult turtles. After making a kill, they normally drag the carcass into the jungle to hide it from other predators, and then return to feed on it over the next few days. Just before sunrise one morning the author found the fresh footprints of two young jaguars

that had killed the turtle in this photograph and abandoned it in the middle of the beach. Shortly after the sun had risen, this adult jaguar appeared from the forest and approached the scene. It came within twenty-five paces of the author's position before it noticed him and swiftly bounded back into the undergrowth.

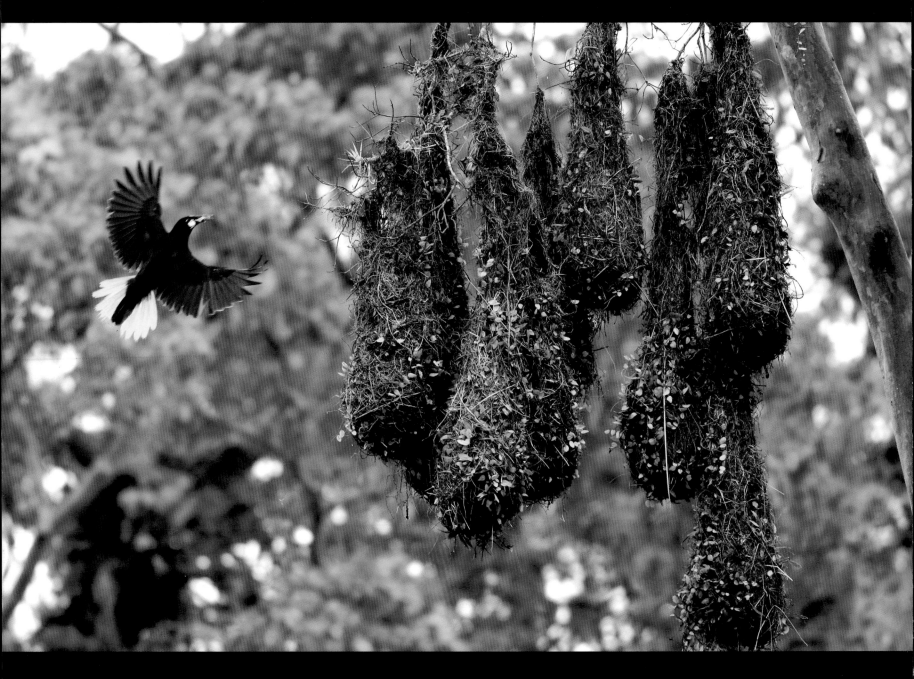

In an evolutionary process spanning millions of years, many birds evolved into expert nest-builders in order to keep their offspring safe from terrestrial predators. Today, some of their descendants produce remarkably comfortable and sturdy refuges in the most precarious of places.

One of the most impressive examples of nest building in Costa Rica is the work of the Montezuma oropendola. When nesting, a colony of these birds will typically fill an isolated tree in a forest clearing with dozens of hanging nests. It is wonderfully entertaining to sit and watch these yellow-tailed, orange-beaked birds swooping back and forth overhead as they forage for food or nest-building materials. The females demonstrate great dexterity and patience as they construct their pendulous, tightly woven nests, which can measure up to 6 feet (2 m) in length. They begin by tying strands of leaves into loops at the end of a branch, forming what will become the nest opening. The bird continues tying and weaving new material in a downward direction to create a tube, eventually closing it off once it is long enough. When the eggs are laid, they rest on a bed of dead leaves at the very bottom of the nest.

Above: Montezuma oropendula returning to its nest with food.

At first light on the freshwater canals of Tortuguero National Park, a little blue heron (bottom right) stares hungrily through its reflection into the water below. Little blue herons may remain motionless for some time, waiting patiently for an unsuspecting fish to swim within reach of their long, spearlike beak. Their modified neck vertebrae allow them to stab their head forward at great speed. Little blue herons only develop their distinctive color when they become adults; as juveniles they are not blue at all, but all-white with a gray bill.

Top right: Early morning mist drifts over the canopy in Tortuguero National Park.
Bottom right: Little blue heron waiting patiently to spear a passing fish or crustacean in Tortuguero National Park.

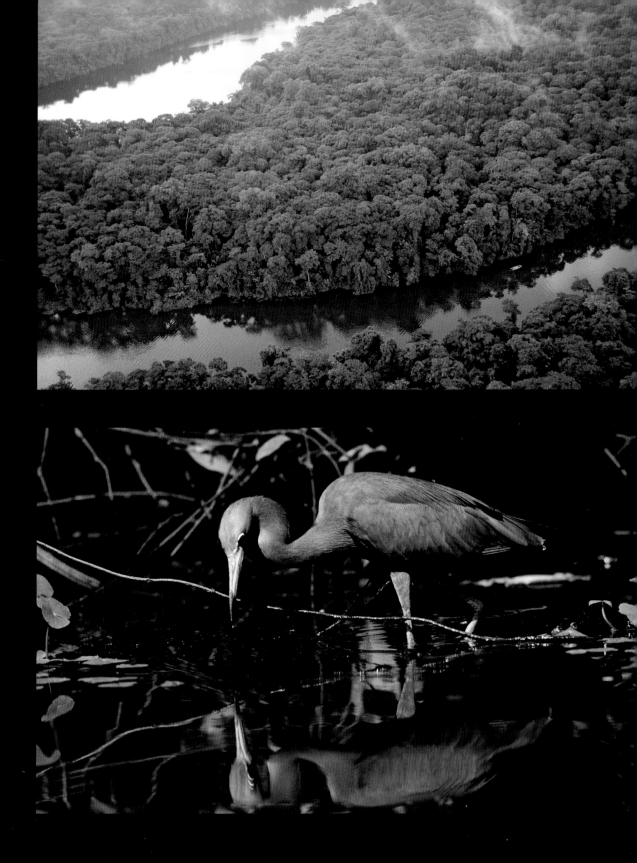

The spider monkey has a stronger prehensile tail than any other mammal in the world. The tail can support the monkey's entire body weight, leaving its hands free to pluck fruit from branches or, in the case of this juvenile (left), to have a good, healthy scratch.

Baby howler monkeys—like all newborn land mammals—are weak and vulnerable, though they are strong enough to hold on to their mother's fur. Indeed, young monkeys spend the first two months of life cling-ing to their mothers as the troop moves through the canopy. But from the third month on, mothers begin to encourage their babies to move around on their own, at least when the troop is resting or feeding. Even when not close to their mothers, young monkeys stay close to other members of the group, relying on the troop to protect them from predators. But baby howler monkeys sometimes face an ominous threat from within their own group; when a new male howler monkey takes over the alpha position of its troop, he is likely to kill any of his predecessor's offspring that are less than one year old. He then mates with the females to produce his own offspring.

Left: Juvenile spider monkey making full use of its pre-hensile tail.
Below: Juvenile howler monkey accompanied by an adult female.

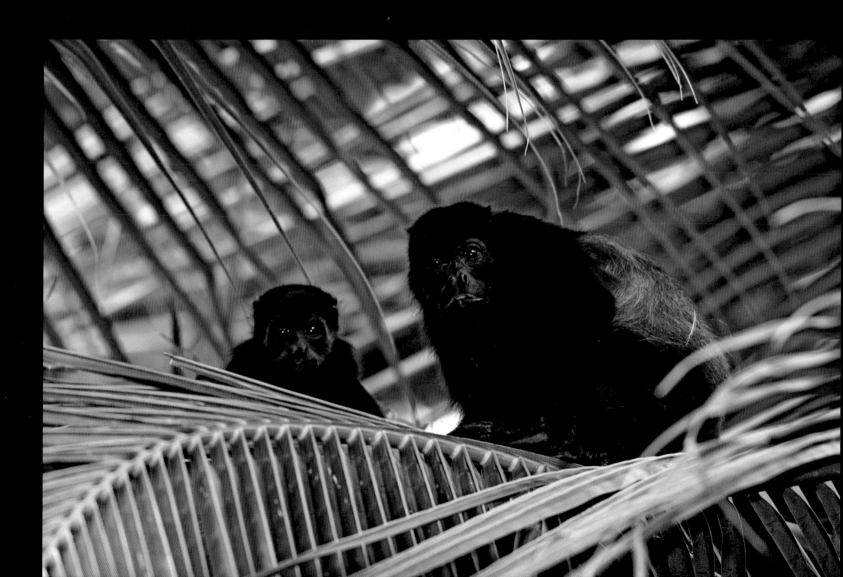

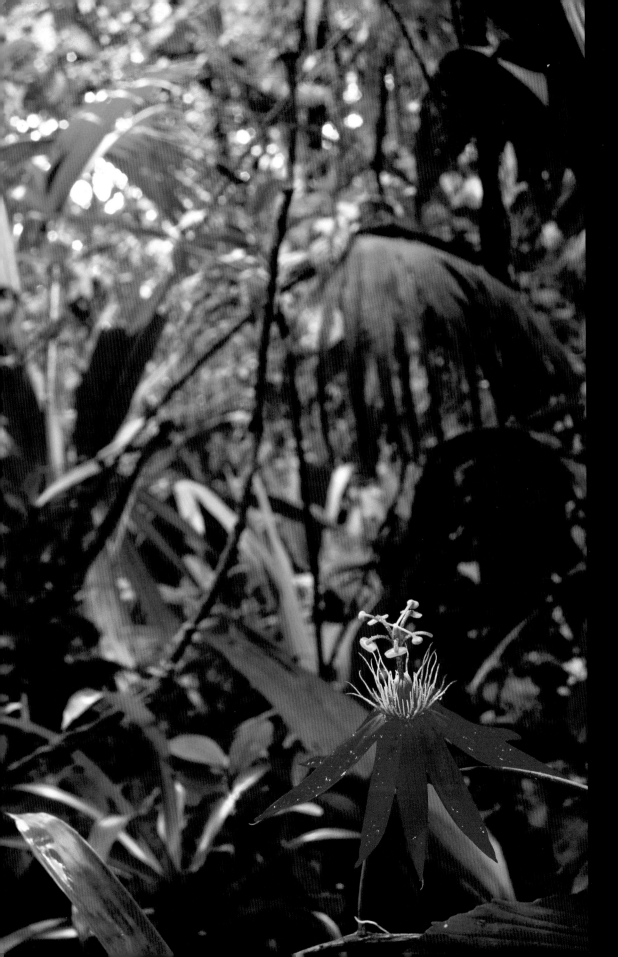

Left: A splash of red catches the eye in an otherwise mostly green rainforest. The vivid color of this passion flower serves as a visual beacon for hummingbirds, the plant's principal pollinator.

Right: This rainforest tree snail uses its bright colors to ward off other animals rather than attract them; the mucous secretions from its skin are believed to be toxic.

Thorn bugs are tiny, half-inch-long (1 cm) insects that live in trees and bushes; they feed on the plant sap that they extract using their sharp mouthparts. Their bodies cleverly mimic plant thorns to help them remain unnoticed by predators. Even if a bird or lizard is not fooled by this camouflage, it will think twice before attempting to eat such a sharp object.

Left: Thorn bugs find safety in numbers on a tree branch.

Worker leaf-cutter ants carry to their nest a section of a leaf or petal that is usually several times their own size. In human terms, they carry a five-hundred-pound load for up to thirty miles, all at a four-minute-mile pace. In a tropical rainforest, these insects can account for the removal of about 15 percent of the leaf-mass produced.

Right: Column of worker leaf-cutter ants carrying petals from a tonka bean tree back to their nest.

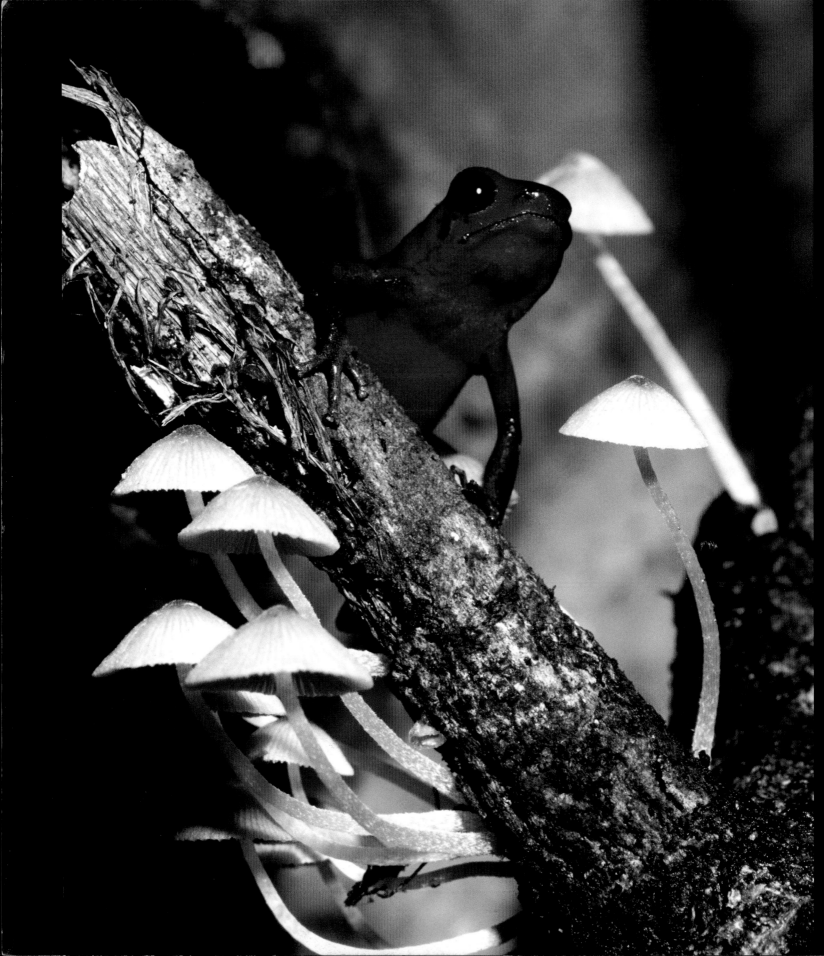

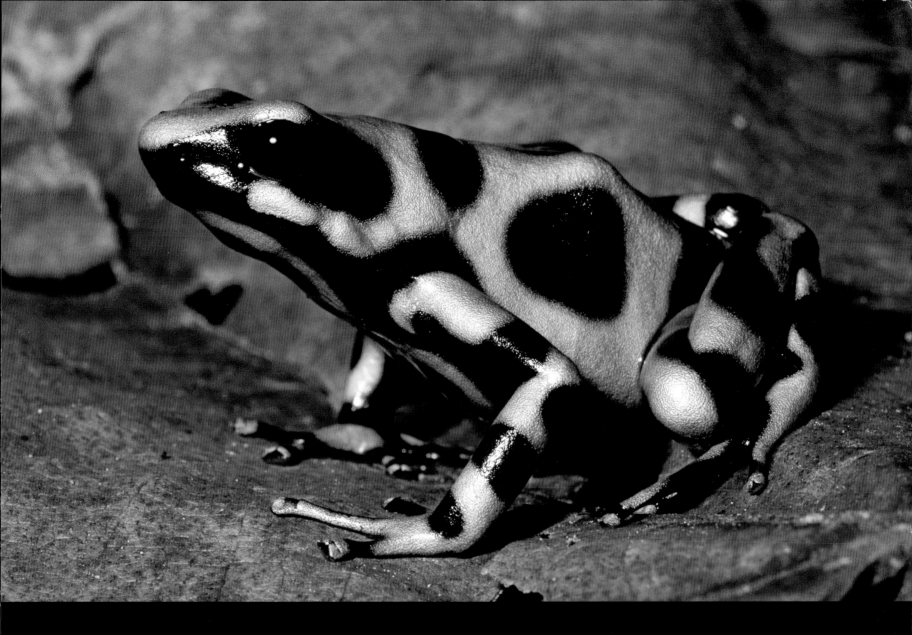

Poison arrow frogs feed mainly on ants and termites, whose toxic alkaloids accumulate in the frogs' bodies. When stressed, poison arrow frogs secrete these poisonous substances through their skin; any animal that ignores their vivid warning colors—and ingests one of them—may suffer effects ranging from nausea to paralysis and cardiac arrest.

Phyllobates terribilis, a species of poison arrow frog that lives in South America, produces one of the most powerful animal toxins yet discovered. Indigenous tribes of the Amazon use the poison from this species for their hunting arrows and darts, hence the name ***poison arrow frog***. Hunters carefully wipe the tips over the amphibian's skin to create a lethal missile that, if shot accurately, can bring an adult monkey tumbling out of the canopy.

Left: Poison arrow frog *Dendrobates pumilio*.
Above: Poison arrow frog *Dendrobates auratus*.

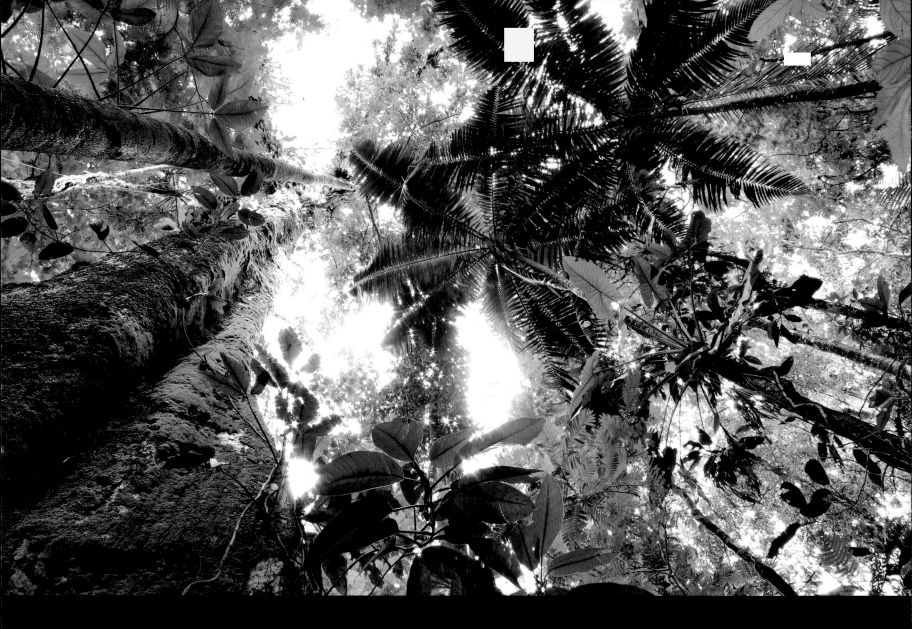

The structure of the rainforest is determined by competition for light. Most plants attempt to position their leaves above those of their neighbors in order to receive sunlight. Trees in a primary forest with a dense canopy typically have a tall trunk that opens into spreading branches at the very top. When a falling tree or branch creates a gap in the canopy, light illuminates a section of the forest floor, allowing seeds to sprout and a new generation of

Above: Light gaps in primary rainforest canopy at La Selva Biological Station.

The abundance of decaying trees, branches, and leaves that lie in the damp and gloom of a rainforest understory provide ideal growth conditions for fungi. The majority feed on nutrients they obtain from dead organic matter. Once a fungus grows to maturity, it reproduces by releasing spores into the air from its fruiting body, which is more commonly known as a mushroom or toadstool. One group of fungi, the cup fungi (top and bottom), has fruiting bodies that closely resemble small cups. The inner surface of the cup produces the spores, and the curvature of the structure helps to protect the spore-producing cells. It is believed that the spores are dispersed by water droplets that fall into the bowl and then splash out of it.

Top and bottom: Two species of *Cookeina* cup fungi attached to rotting logs on the forest floor.

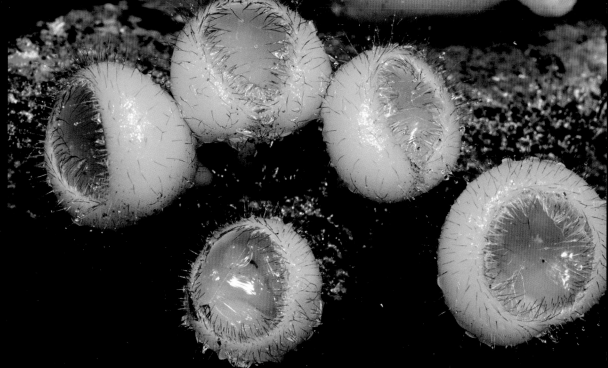

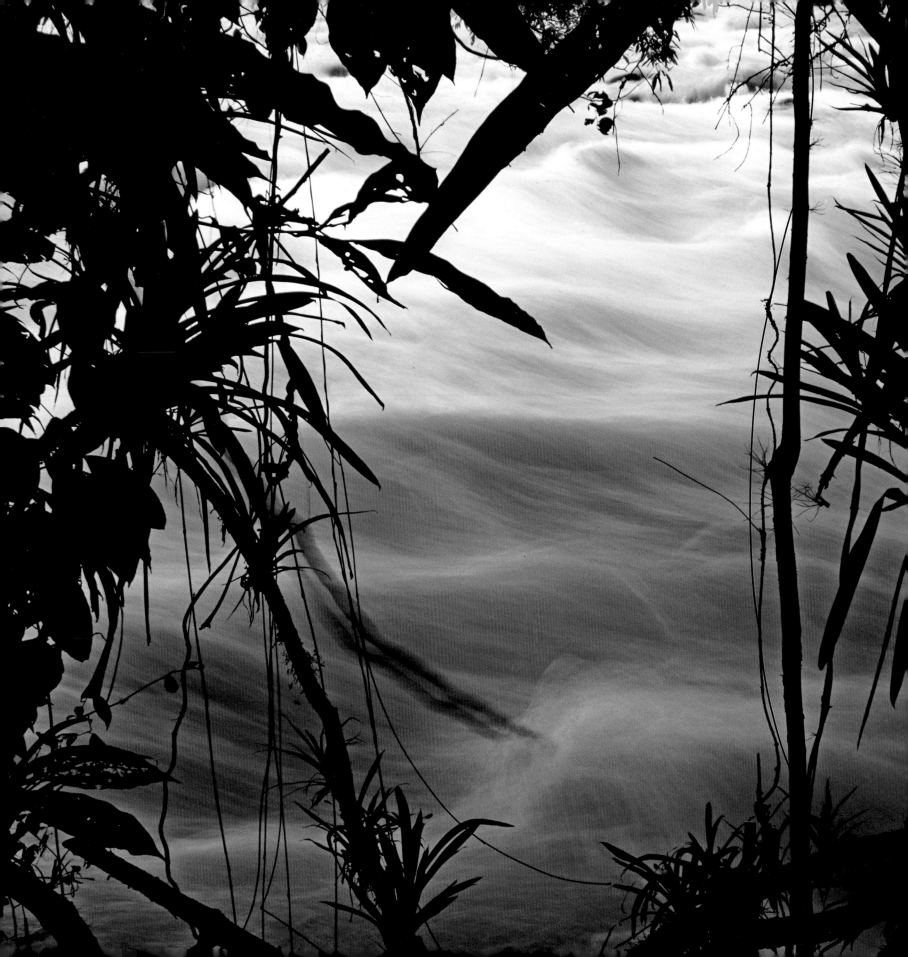

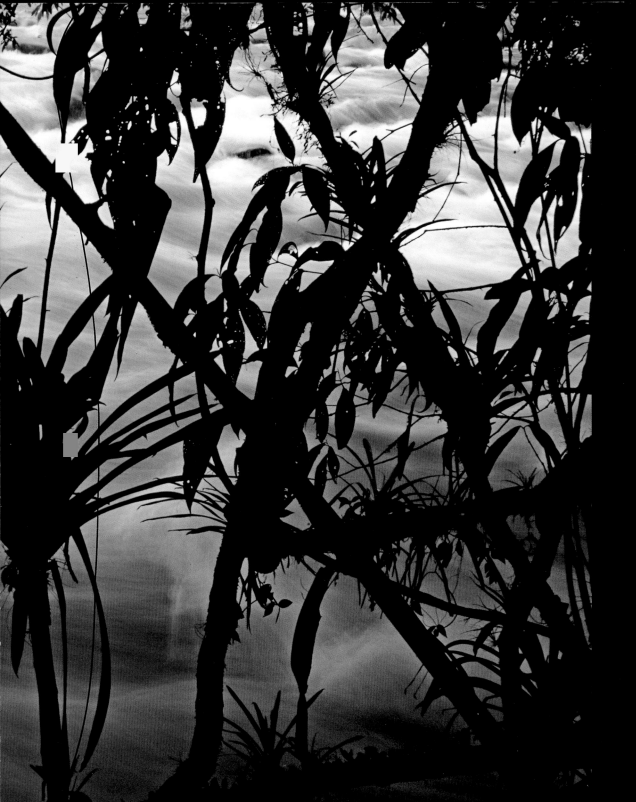

The Sarapiquí River flows from the mountains of Braulio Carrillo National Park, through Caribbean lowland rainforest, and into the San Juan River on the Nicaraguan border.

The rainforests of Costa Rica receive between 80 and 236 inches (2,000 and 6,000 mm) of rainfall per year, depending on their location. Although a constant supply of water is vital to these ecosystems, excessive rainfall saturates the soil and slows down the activity of microorganisms that provide nutrients to the plants. Rivers play a crucial role by rapidly carrying off the excess rainfall.

Left: The fast-flowing waters of the Sarapiquí River.

In contrast to the eye-catching colors of many Costa Rican birds, some species prefer to keep a low profile. The common potoo (left) spends the daylight hours perched perfectly still on a tree stump or branch. Its upright posture and brown-gray plumage will convince all but the most keen-eyed observer that it is part of the tree. At night, it becomes active and flies sorties from its perch to snatch large, winged insects from the air.

All nocturnal animals share the potoo's need to be inconspicuous while sleeping during the day. Not all such species, however, rely on camouflage or cryptic forms and colors to become invisible while remaining in view; some opt to simply stay out of sight.

White tent bats (right) make daytime shelters for themselves underneath the leaves of banana or heliconia plants. With their sharp teeth, they gnaw along the length of the leaf on either side of the midrib so that the two sides hang down to create a tentlike structure. Small groups of individuals snuggle together to help conserve body heat. Each group has more than one leaf tent prepared in its territory. If disturbed at one, the members of the group all fly away to another.

Left: The common potoo is very difficult to spot when perched on top of a tree stump.
Right: White tent bats sleeping under a heliconia leaf.

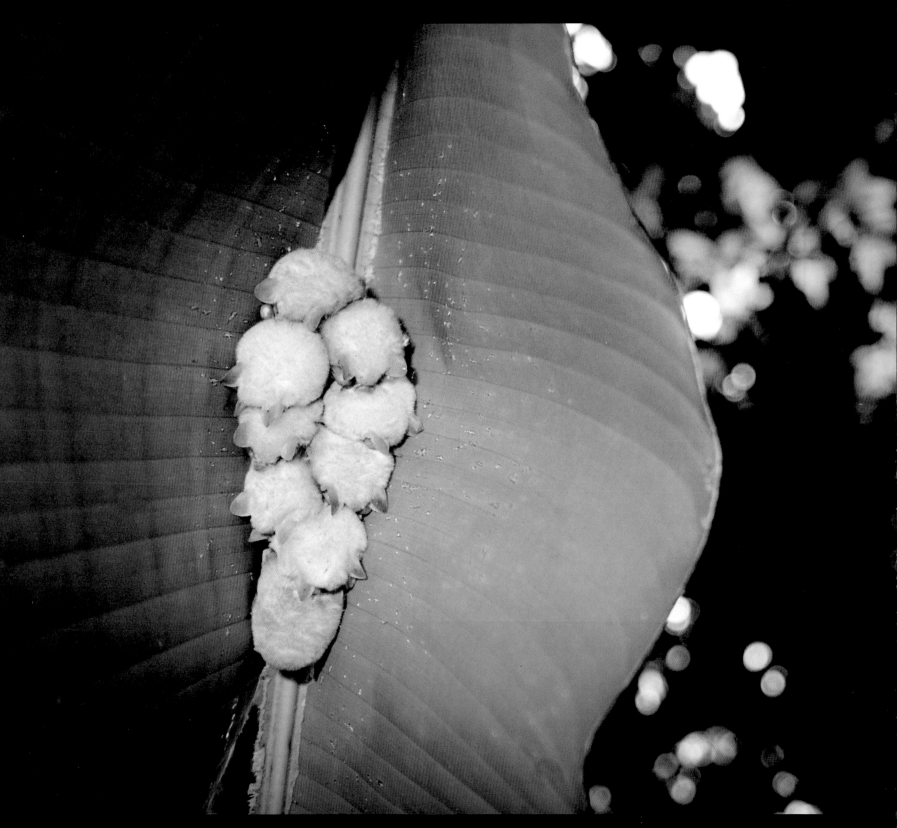

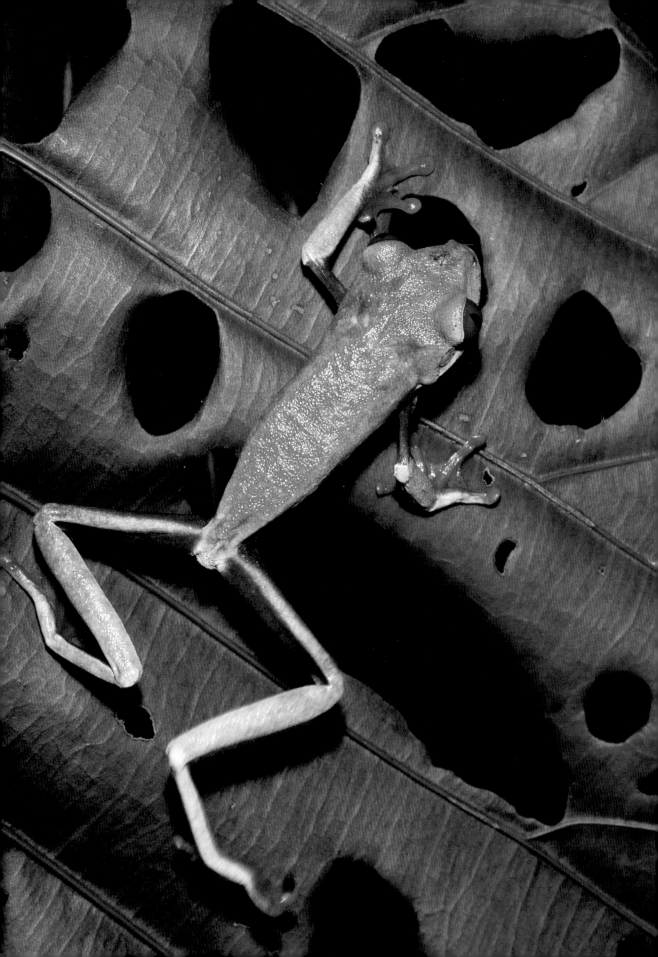

The red-eyed tree frog is one of the most eye-catching animals of the neotropical rainforest. Its vibrant colors startle potential predators and act as a warning of the frog's mild toxicity. These amphibians normally spend the daylight hours, and indeed most of the dry season, high up in the canopy. While sleeping during the day, they make themselves less noticeable by folding their long legs under their body; their skin tone also subtly changes to a less gaudy green (right). Strongly adhesive pads on the animals' toes allow them to cling onto a vertical surface or even upside down. They become active at night, feeding on insects and spiders.

Left: Red-eyed tree frog walking across a leaf at night.
Right: Red-eyed tree frog asleep on a tree trunk during the day.

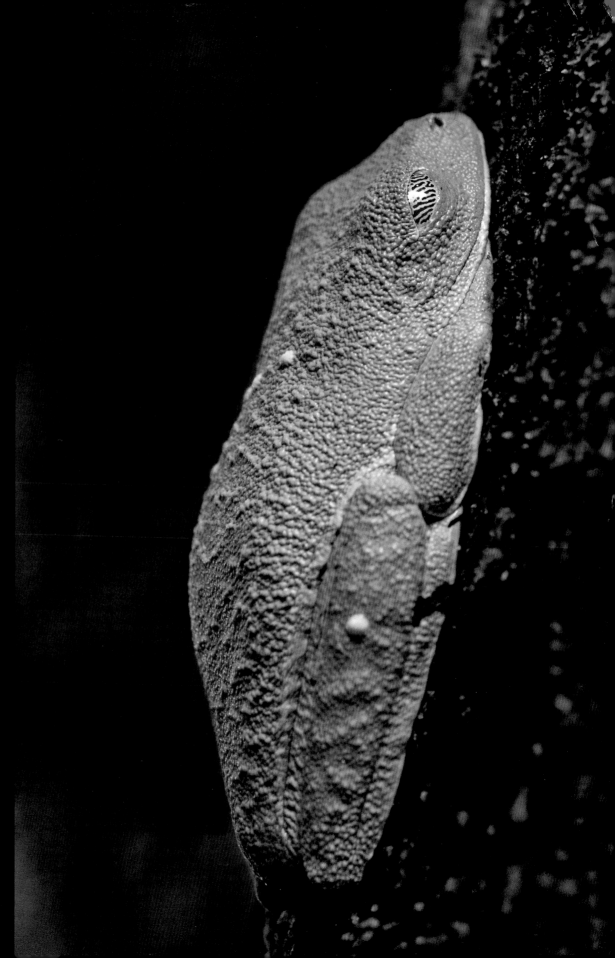

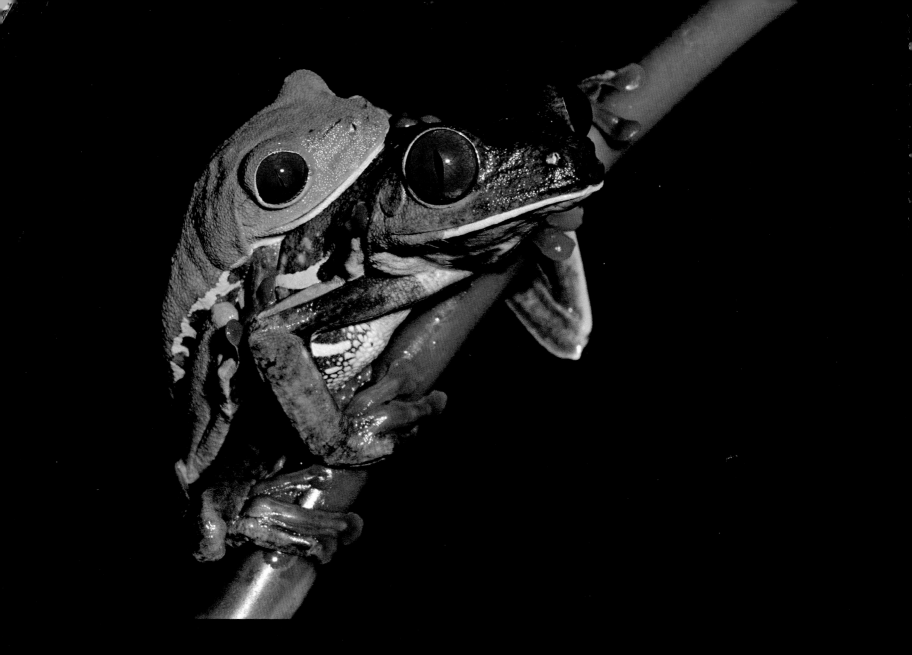

The rainy season in Costa Rica usually begins in April or May, and this marks the beginning of the red-eyed tree frogs' breeding season, when they venture down from the canopy to the lower levels of the forest. As darkness falls, males begin to call from vegetation near a pond or pool of water. The female's attraction to a male depends on her preference for his call. She will approach a male and allow him to climb onto her back (above). The female carries him to a pool, where she fills her bladder with water. She then climbs to a branch that overhangs still water and lays her eggs in a jelly-like mass (left), usually on the un-

derside of a leaf. The male immediately fertilizes the eggs, and the female releases the water from her bladder to prevent the eggs from drying out. The tadpoles develop inside the eggs; once they mature, they wriggle free and fall into the safety of the pond water below, where they will develop into adult frogs.

Above: Red-eyed tree frogs mating. Note that the male (on top) is smaller than the female.
Left: Red-eyed tree frog eggs on the underside of a leaf.
Right: Red-eyed tree frog on a heliconia

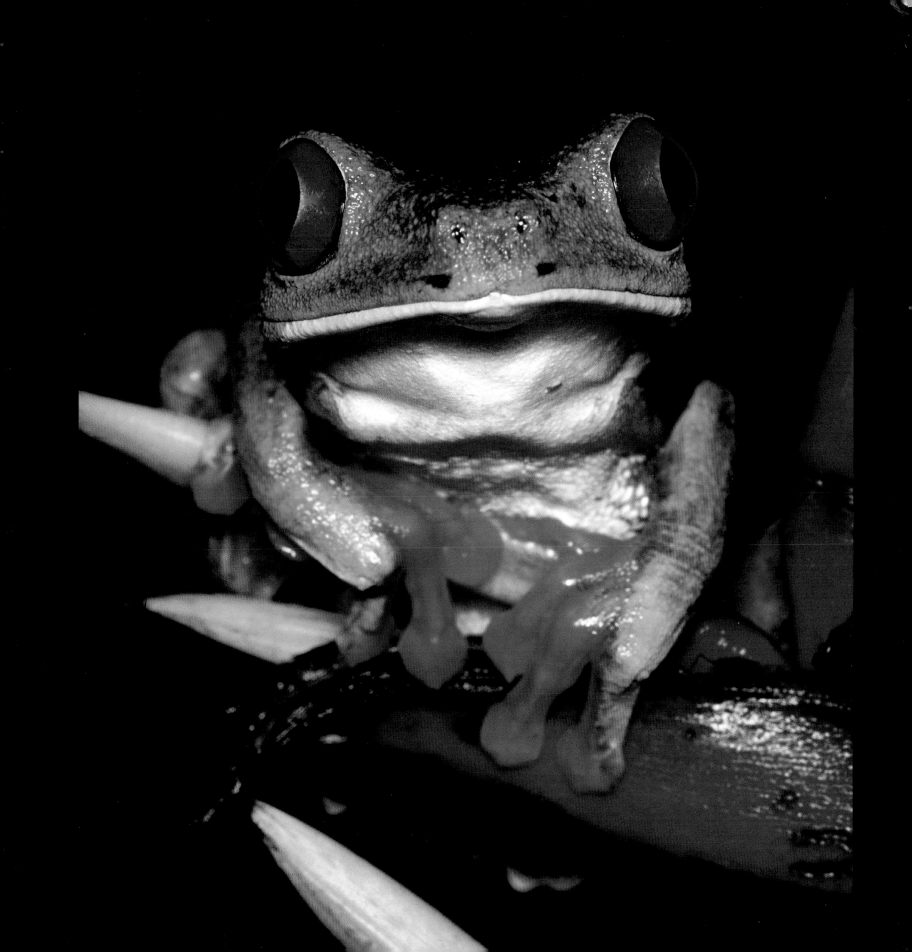

The South Caribbean
A Secluded Paradise

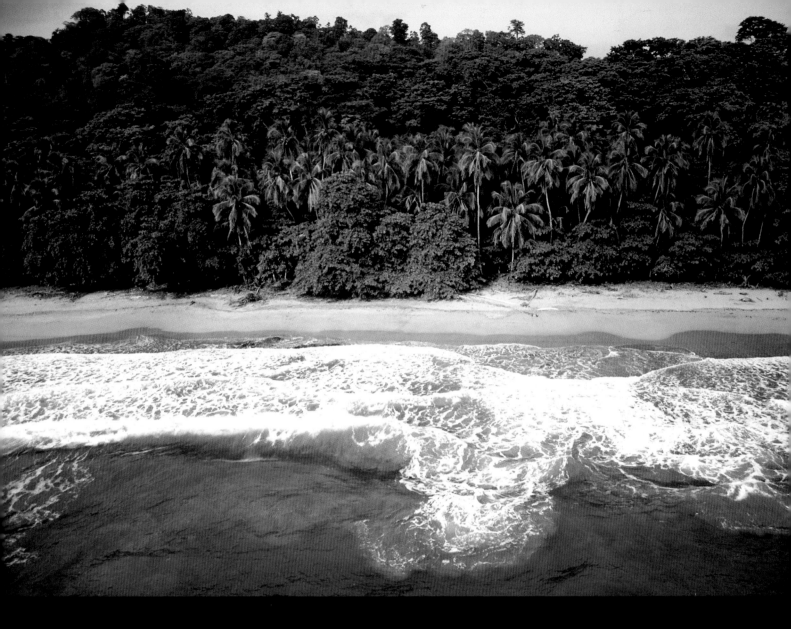

Meandering south from the city of Limón, the Caribbean coastline is fringed with palm-lined beaches, lowland rainforest, and coral reefs. The region encompasses two sizeable protected areas: Cahuita National Park and Gandoca-Manzanillo Wildlife Refuge. The former has the country's largest coral reef; even though much of the coral was damaged during an earthquake in 1991, life still flourishes in these waters. On and these protected areas teem with wild-

life. There are particularly large populations of sloths, howler monkeys, leaf-cutter ants, and snakes. Cahuita and Gandoca-Manzanillo serve as nesting sites for loggerhead, hawksbill, green, and leatherback sea turtles.

Previous pages: Early morning sunshine begins to warm the sand in Gandoca-Manzanillo Wildlife Refuge.

Above: Coastline near Cahuita National Park

During the first few months of the year, Costa Rica's Caribbean coast is visited by one of the world's largest reptiles. Sometimes weighing in excess of 1,100 pounds (500 kg) and measuring 6 feet (2 m) in length, the leatherback is the largest of all turtles. It is easily distinguished from other species by its large size and the prominent longitudinal ridges running down its back. It also differs from all other marine turtles in that its carapace is made of a very tough, leathery skin rather than bony plates.

Females nest every three to four years, coming ashore up to ten times over a period of weeks to lay eggs. The best condition for nesting is at high tide on a moonless or cloudy night, when darkness conceals the turtles from predators. As with all other marine turtles, the female leatherback uses her hind flippers to dig a deep hole in the sand, into which she deposits between 50 and 150 eggs. The hatchlings will emerge approximately sixty days later.

Leatherback turtles are most at home in the open oceans of the world and travel extensively during the year. Individuals that nest on the shores of Costa Rica are thought to migrate as far south as Argentina and as far north as Canada. Their preferred food is jellyfish, whose poisonous stings seem to have no adverse effect on the turtles. A common cause of death in leatherback turtles is suffocation or digestive disorders that result from swallowing floating plastic bags, which they mistake for jellyfish.

Right: Leatherback turtle returning to the sea after laying her eggs on Gandoca Beach.

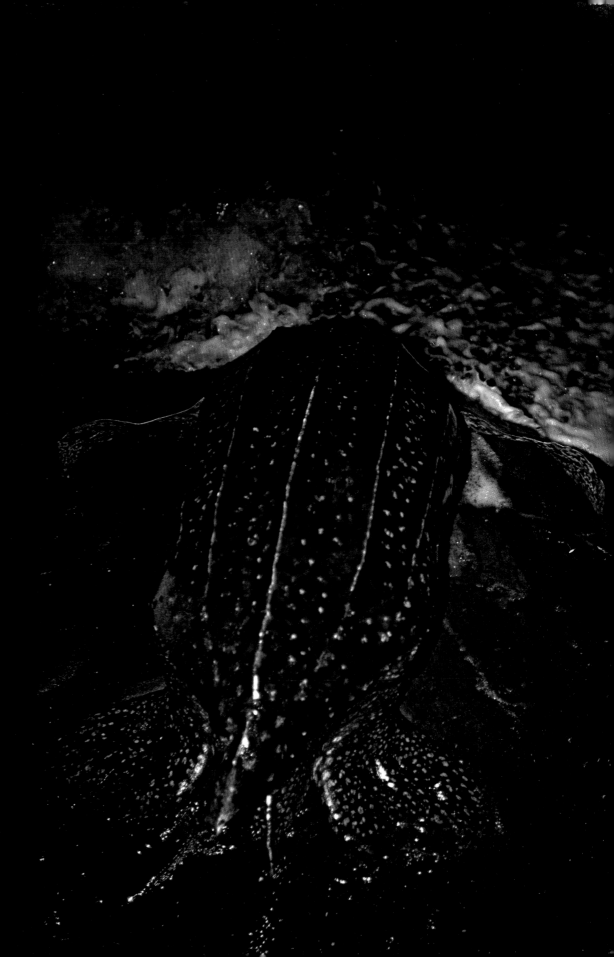

The beach morning glory is one of very few flowering plants in Costa Rica that can survive the harsh conditions of a tropical sandy beach. It has thick, waxy leaves to reduce water loss, and its flowers only open in the relatively cool early morning hours. Keeping close to the ground to protect itself from the wind, the creeping stem grows across the sand and can extend to lengths of several yards. When the stem tips detect that they are within a few yards of the high tide mark, they begin to bend up to 180 degrees and grow back away from the sea to prevent the plant from being immersed by the waves.

Left: Beach morning glory flower on Gandoca Beach.

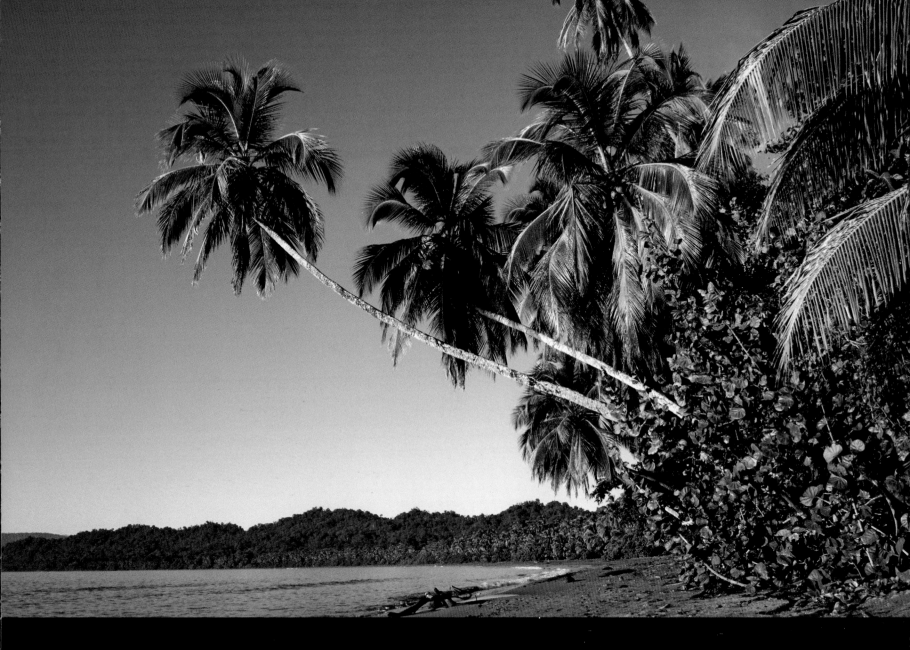

Since young coconut palms require a lot of sunlight for healthy development, they will rapidly grow out of the shade of a beach thicket toward the brightest available light source. Sometimes, the quickest route to direct sunlight is not upward but horizontally toward the sea—the water reflects a lot of light toward the beach. Coconut palms have extremely strong root systems that can support the weight of a trunk growing in this manner.

Coconuts are the seeds of the palm. If they fall into the ocean from one of these outstretched palms, they may float for thousands of miles before being washed up on a distant beach and germinating.

Above: Coconut palms arcing over the surf in Cahuita National Park.

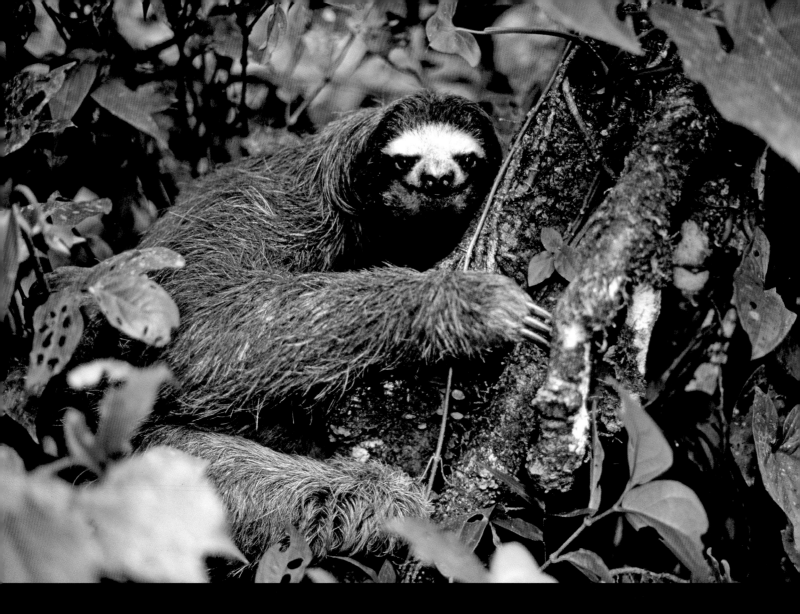

Sloths are tree-dwellers. Living in the forest canopy provides them with all their dietary requirements and keeps them at a safe distance from most predators. Sloths only venture down to the forest floor either to defecate or to move to another tree when there is no route via the canopy. The male three-toed sloth above was spotted in a small *Cecropia* tree isolated from other trees in a tiny clearing. After two days, he had consumed all of the

the trunk and then defecated at its base before proceeding to shinny up a nearby tree.

Sloths defecate approximately once a week. They climb down to the forest floor and deposit their droppings in a small hole that they dig at the base of a tree with their stubby tail. Two common theories exist as to why the animal does this. The first is that it is carefully fertilizing the soil around one of its favorite trees. The other suggests

tionship with the many moths, beetles, and mites that live in its fur; these insects spend the egg and larval stages of their life cycle in sloth feces. When they emerge as adults, the insects attach themselves to the sloth the next time it defecates at the base of that tree.

Above: Three-toed sloth defecating at the base of a tree in Cahuita National Park.

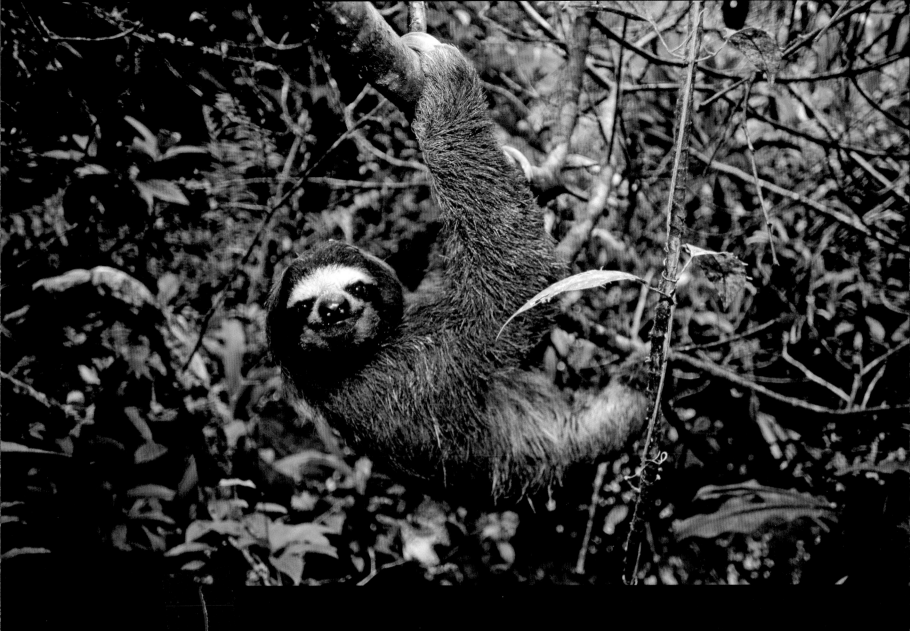

A sloth's body is well designed for climbing trees, since its long, curved claws hook perfectly around branches. The sloth's elongated neck, which has eight or nine vertebrae (as opposed to seven in most other mammals), allows it to rotate its head 180 degrees. This gives it the ability to look directly behind itself while hanging upside down.

Above: Three-toed sloth climbing between trees in Cahuita National Park.

As one would expect, the two-toed sloth has one less toe on each forelimb than its three-toed relatives.-However, its ability to defy gravity by hanging and clinging to branches for hours on end seems to be unaffected. All sloths have very well-developed retractor muscles in their limbs, which are used for pulling, and much smaller extensor muscles, used for pushing. To further improve their grip, their toes are joined to each other by ligaments, allowing the digits to work together as a very strong, single claw.

Right: While feeding, the two-toed sloth can support its whole body weight with the powerful claws on its back feet.

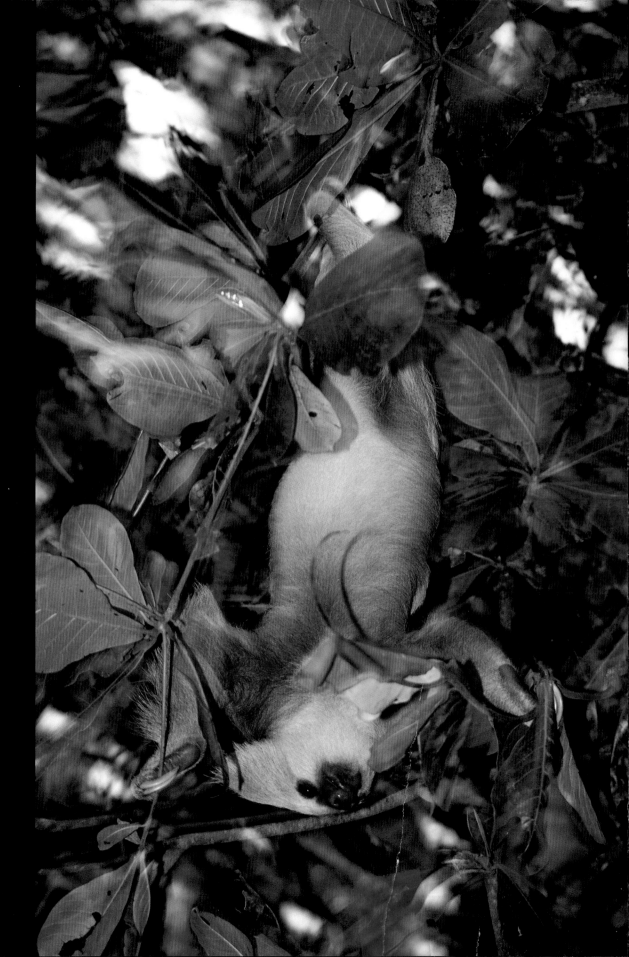

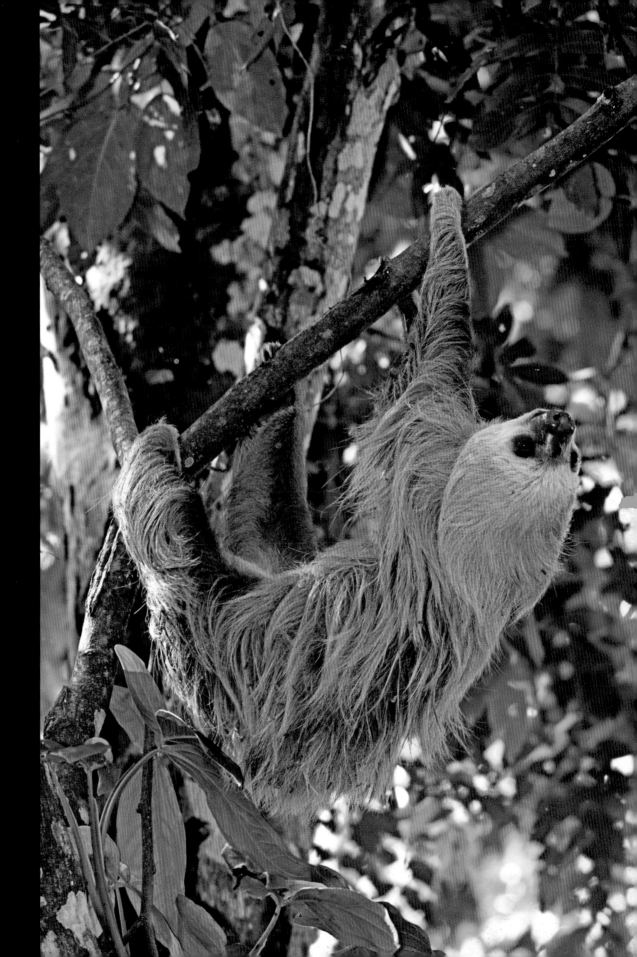

Sloths have very long and thick fur covering a large proportion of their body, which may seem strange for an animal inhabiting the tropics. But the sloth's metabolism produces relatively little heat, so insulation is essential for the animal to maintain a working body temperature, especially at night or on cool, cloudy days.

To prevent the fur from absorbing too much water when it rains, the hairs grow from its stomach toward its back. Since the sloth spends most of its time upside down, the direction of hair growth is therefore toward the ground. This allows water to run off the sloth's body more easily.

Right: The thick fur of a two-toed sloth helps conserve the small amount of heat that the animal produces from its slow metabolism.

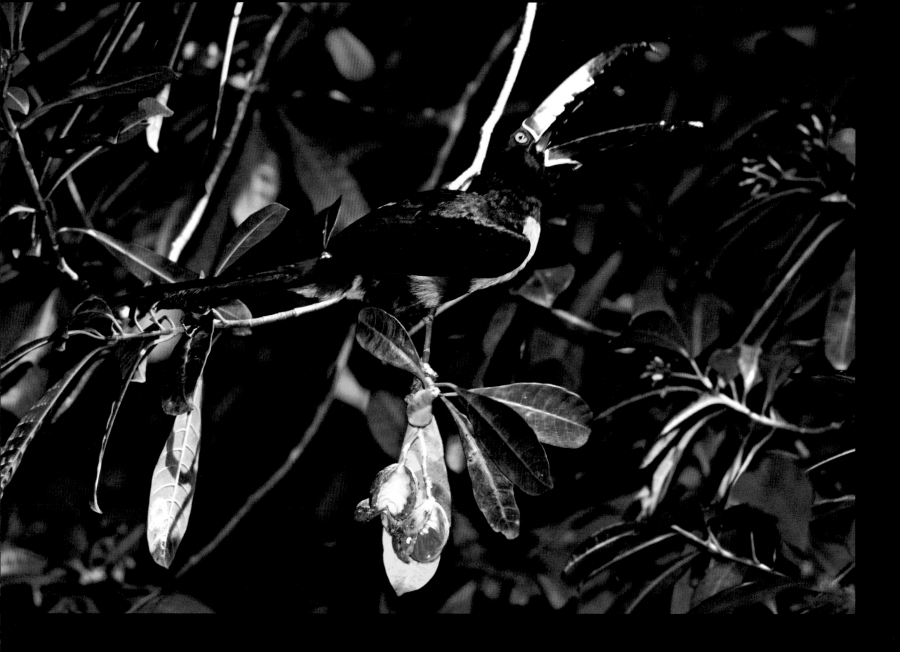

The sapote tree has no trouble attracting carriers to disperse its seeds. Its succulent, bright orange fruit, which stands out clearly against the green vegetation, is quickly spotted by birds as soon as the fruit opens. The collared araçari (above) can use its huge bill to skillfully bite off small pieces of the fruit. It eats these pieces by flicking them into the air and letting them drop into its throat.

The white-ringed flycatcher (right) is small and agile enough to hover briefly in midair in order to feed from this hanging sapote fruit. Flycatchers also eat insects, which they pluck from leaves or flowers without landing.

Above: Collared araçari feeding on sapote fruit.
Right: White-ringed flycatcher hovering to feed on sapote fruit.

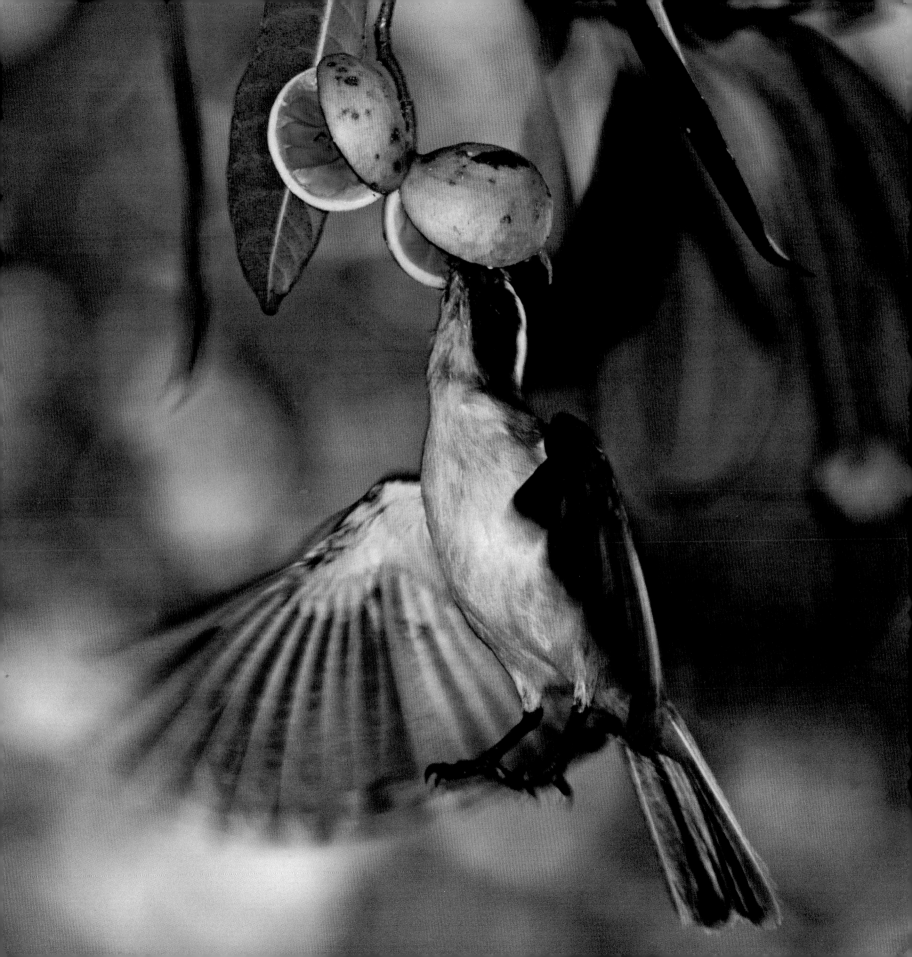

Howler monkeys occasionally feed on fruit and flowers, although they are predominantly leaf-eaters. As a result of this low-energy diet they are much less active than the other three species of monkey native to Costa Rica. They spend many hours during the day resting and sleeping, often draped comically across the boughs of trees with their limbs hanging limply. Because it is so easy for them to find leaves, howler monkeys have little need to travel far in search of food. Indeed, having encountered a troop of howler monkeys in the morning, it is not uncommon to come across them again in the afternoon in the very same place. Because they need less area in which to forage compared to other mammals their size, they can live successfully in regions of disturbed forest or partially forested farmland.

Left: Female howler monkey resting in Cahuita National Park.

The most characteristic aspect of howler monkey behavior is the roaring howl the males make (above). This howl warns of the group's whereabouts, enabling other and hollow, acting as a resonating chamber. The sound produced by the vocal cords is amplified in this chamber, resulting in a booming call.

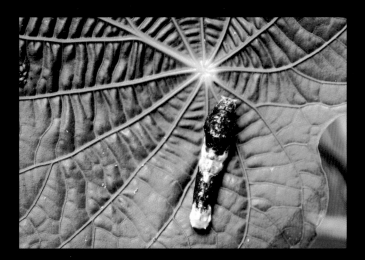

Animals near the bottom of a rainforest food chain face a constant struggle to survive. Most insects, for example, are surrounded by potential predators. Many use a fast getaway or chemical defenses to avoid being eaten, others opt for stealth.

A huge number of insect species rely on camouflage to remain hidden from the searching eyes of their predators. The swallowtail butterfly larva (left) closely resembles a bird dropping, and this stick insect (below) mimics a fallen mossy twig.

The better disguised an individual is, the more likely it is to survive long enough to reproduce and pass on its genes. This is how, over the course of thousands of years, an insect species can develop an almost exact resemblance to its surroundings.

Left: The form of a swallowtail butterfly larva is almost identical to that of a bird dropping.
Below: A mossy walking stick blends perfectly into a background of moss and bark.

This lobster claw heliconia is native to Costa Rica. It usually grows in dense populations within disturbed areas of rainforest. Its reproductive structures are cupped inside the plant's enlarged pink and yellow horn-shaped bracts. Except during very dry periods, these bracts are filled with rainwater and a liquid that the plant secretes. This aqueous solution surrounds the reproductive structures and makes them inaccessible to crawling, herbivorous insect pests.

Right: The lobster claw heliconia is common throughout the Caribbean lowlands of Costa Rica.

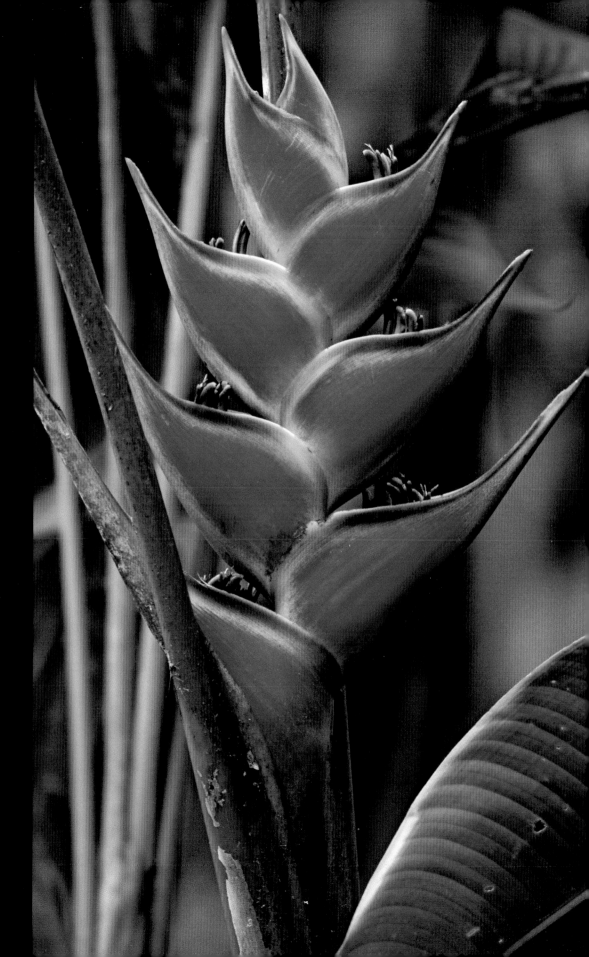

Leaf-cutter ants are highly industrious insects. Each individual is programmed to perform its tasks for the benefit of the colony as a whole. Workers scour the forest for suitable leaves and flowers that they cut into pieces with their powerful jaws and bring back to the nest.

Above: Worker leaf-cutter ants sawing through a leaf with their powerful mouthparts.

It is quite easy to find a column of leaf-cutter ants in Cahuita National Park. Dozens of small trails cross the main path, over which hundreds of thousands of ant feet have marched.

Upon arriving back at their nest, worker ants deposit their leaf fragments inside, where slightly smaller workers collect them and chop them into smaller pieces. These are then passed on to another caste that chews the pieces into a pulp and fertilizes it with an enzyme-rich fecal fluid. A new group of ants then spreads the pulp over dried leaves in a separate chamber, where a fungus is planted on top and left to grow. Even smaller gardener ants keep these chambers clean and later harvest the fungus to feed the colony.

Right: Bodyguard leaf-cutter ants ride on the leaf fragment of a worker to protect the worker from parasitic flies as it carries its load to the nest.

Below: Worker leaf-cutter ants carrying leaf fragments into their nest hole in Cahuita National Park.

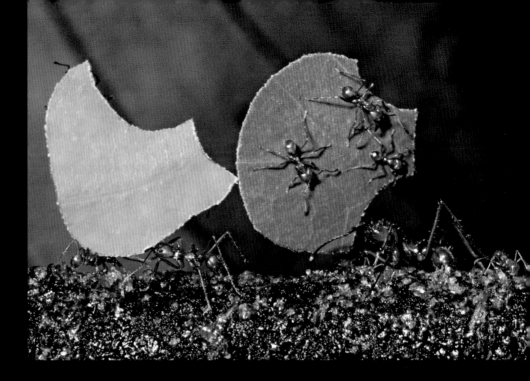

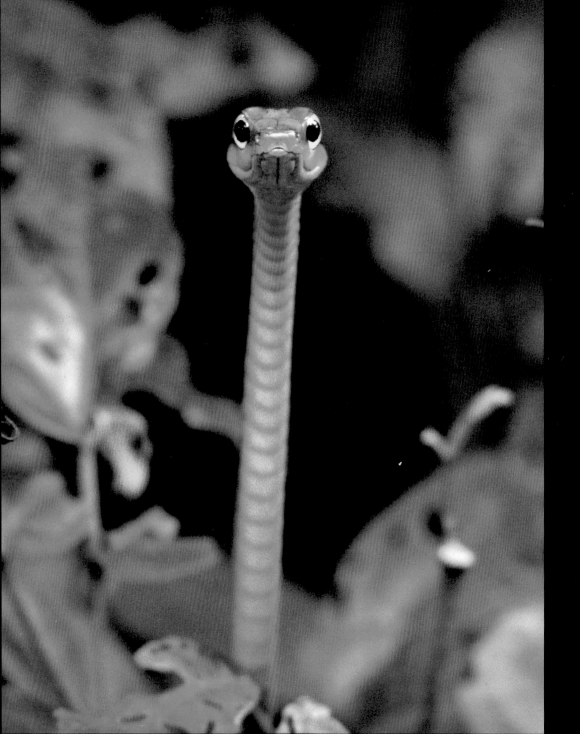

It is unnerving to be alone in the jungle and suddenly realize that you are being watched. While photographing a column of leaf-cutter ants, the author glanced up and met the steady, almost hypnotic, gaze of this parrot snake (left), only a couple of yards away in the undergrowth.

This snake hunts small lizards and frogs and often remains frozen in an upright posture while carefully searching for prey. When a breeze blows through the forest, the snake will typically sway from side to side, perhaps to mimic a moving branch. This habit may help it to remain unnoticed by its predators. Parrot snakes do not inject venom, but have enlarged teeth with which to grip an animal tightly before swallowing it whole.

Left: Parrot snakes can remain upright and perfectly still while studying the undergrowth for prey.

Few snake species in the world have such an extensive distribution as the brown vine snake. Its habitats range from dry forests in Arizona to the Amazonian rainforest of Brazil. This highly adaptable reptile hunts in a similar way to that of the parrot snake (left). Unlike the parrot snake, however, the brown vine snake injects a mild venom that helps to immobilize its prey. As with most snakes, the brown vine snake monitors its surroundings by "tasting" chemicals in the air, using a tongue lined with highly sensitive chemosensory cells that can detect prey from several feet away.

Above: Brown vine snake weaving its way through the undergrowth in Cahuita National Park.

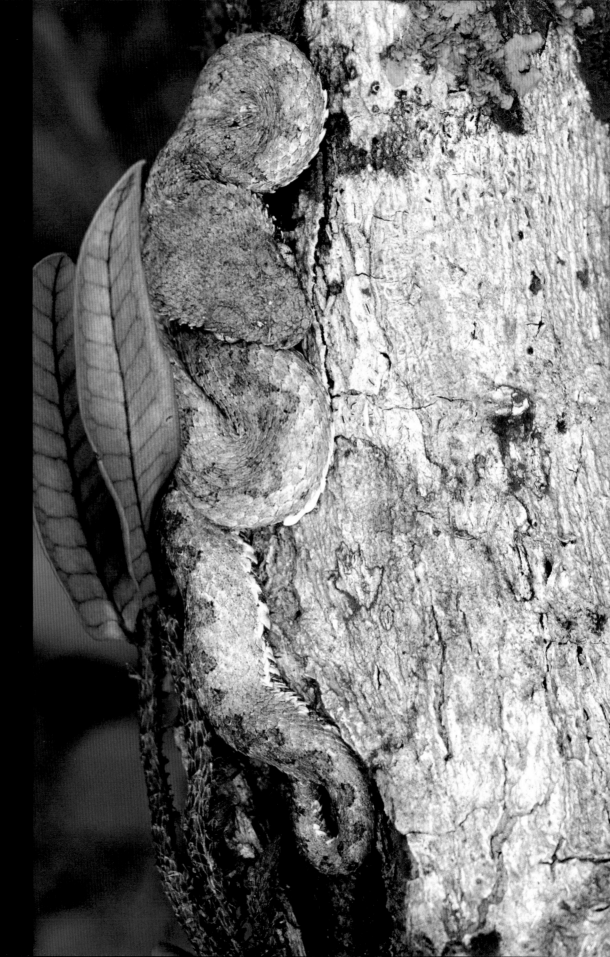

The eyelash viper derives its name from the two pointed scales that protrude above each of its eyes like huge eyelashes. The common belief is that these scales protect the animal's eyes as it moves through the undergrowth.

Highly efficient sit-and-wait predators, these snakes can spend many days in one place patiently waiting for a lizard, frog, bird, or small mammal to pass by. Heat-sensitive pits behind each nostril alert the snake to the presence of another animal. If the snake is hungry, it will strike once the prey is close enough and inject highly toxic venom into its blood. It then swallows the dead animal whole.

Right: Remarkable camouflage helps eyelash vipers to sit and wait for unsuspecting prey without being spotted.

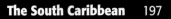

Individual eyelash vipers differ greatly in color. Some have gray, green, or brown skin that camouflages them against the bark of a tree or a leafy branch. Others are bright yellow, which may allow them to be fatally mistaken for flowers by the lizards and birds that they feed on.

Left: The most conspicuous morph of the eyelash viper species is bright yellow.

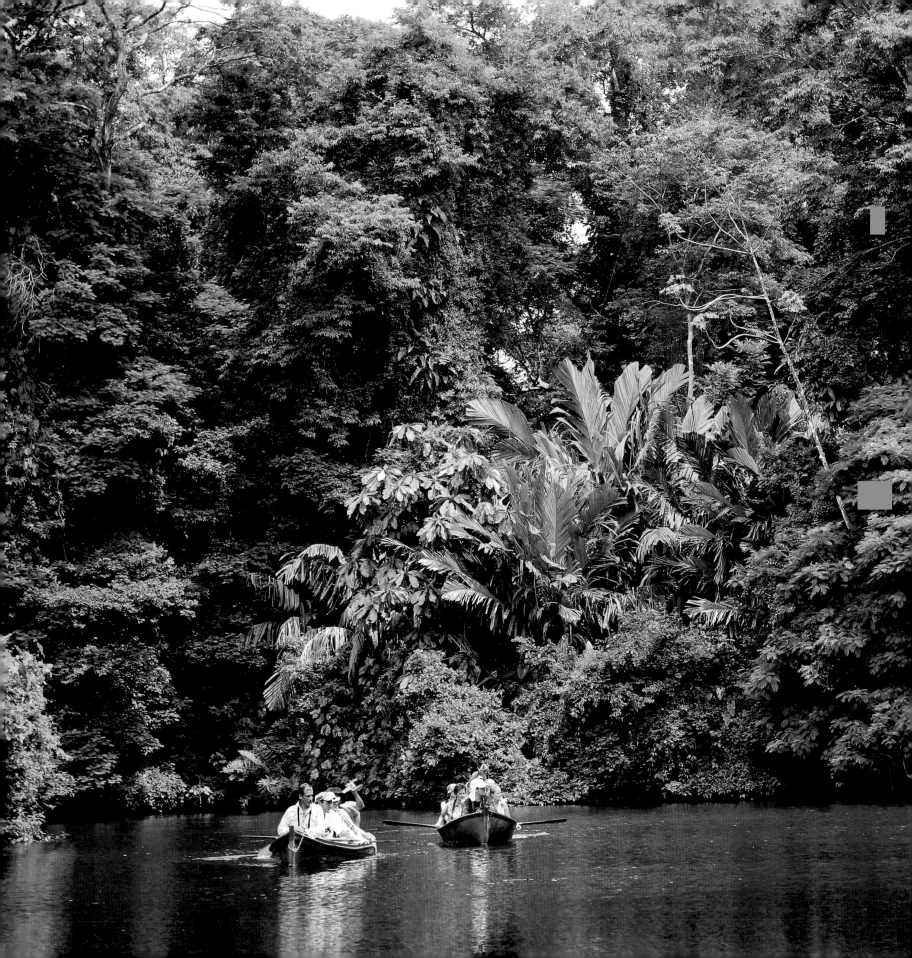

Conservation and Responsible Tourism

As a tourist in Costa Rica, your very presence can play a significant role in helping to conserve the country's natural beauty. Below are a few suggestions for how to choose an ecologically friendly hotel or tour operator, along with advice on environmentally responsible travel.

There are a number of excellent green hotels and lodges in Costa Rica. These businesses attempt to preserve the forest on their property in order to minimize fragmentation of biological corridors; they control and limit waste products; they make a practice of educating their guests about wildlife and about local environmental issues; and, very importantly, they provide jobs for members of the local community who otherwise might have been motivated to earn a living through illegal hunting or other destructive means.

Unfortunately, many large resorts and hotels place the environment low on their list of priorities. Among these hotels, some of the worse offenders—perhaps not surprisingly—carry names that suggest a strong commitment to the environment and rely on advertising slogans that suggest the same. In order to steer clear of these hotels, you can consult your guidebook—many of the best books now include information about which hotels are environmentally friendly or not. Finally, common sense goes a long way toward helping you decide where to stay and where to spend your money.

A good nature guide is invaluable. He or she will enable you to identify animals you might not have noticed otherwise, and will do so without disturbing or mistreating those animals. Costa Rica abounds with experienced, educated guides who either work independently or for a tour operator. You can, on the other hand, also come across tourist guides (and tour operators) who have less regard for how they negatively affect the natural world and its creatures. These guides howl at monkeys, whistle at sloths, chase whales and dolphins in boats, lure wildlife with food, and engage in other antics, all with a view to entertaining customers and thus increasing the size of their tip. In addition to being bad for the environment, these guides are also more likely to not know what they're talking about.

Most parks and other protected areas in Costa Rica don't have the resources to effectively recycle garbage. Instead, garbage is either simply buried on site or it is transported out at considerable effort. When you leave a park, you can lend a helping hand by carrying out all the nonbiodegradable materials that you took in. Plastic bags, bottles, batteries, and other garbage spoil nature's beauty and can take more than four hundred years to decompose.

Should you encounter hotels or tour operators in Costa Rica that conduct business in an environmentally destructive manner, don't hesitate to complain to the Costa Rican tourist board, either by e-mail (quejas@ict.go.cr) or telephone (506 299-5811).

The following national and international agencies, along with other institutions too numerous to list here, are dedicated to protecting wilderness areas and wildlife in Costa Rica. Your contributions to these organizations, whether through donations or volunteer activities, is a necessary and important source of support.

Association for the Preservation of Wild Flora and Fauna	www.apreflofas.or.cr
Caribbean Conservation Corporation	www.cccturtle.org
The Corcovado Foundation	www.corcovadofoundation.org
Friends of the Monteverde Cloud Forest	www.friendsofmonteverde.org
Greenpeace	www.greenpeace.org
The Jane Goodall Institute	www.janegoodall.org
The Leatherback Trust	www.leatherback.org
The Nature Conservancy	www.nature.org
The Rainforest Alliance	www.rainforest-alliance.org
The Rainmaker Foundation (The Guanacaste Dry Forest Conservation Fund)	www.rainmakerfoundation.org
The Tropical Science Center	www.cct.or.cr
The Volunteer Association for Protected Areas	www.asvocr.org
World Conservation Union (IUCN)	www.iucn.org
World Wildlife Fund (WWF)	www.wwf.org
Zoo Ave	www.zooave.org

Left: Tourists kayaking through Tortuguero National Park.

Acknowledgments

I am deeply grateful to Patricia Alpízar at the Ministry of the Environment and Energy (MINAE) for helping coordinate many of my trips into Costa Rica's national parks and reserves over the last 13 years. Once there, I was always able to rely on park rangers for a welcoming attitude and a helping hand. I owe them my thanks and would like to express my great admiration for the difficult work they do on the front line of nature conservation. Gratitude is also owed to Mariana Mora at the Organization for Tropical Studies (OTS) for her assistance during my visits to the OTS biological research stations at La Selva, Palo Verde, and Las Cruces.

I extend my appreciation to Mathias Black, Marc Roegiers, and John McCuen, at Zona Tropical Publishing, for their encouragement and suggestions, and for their unwavering dedication to this project. I would like to thank editors Philip Davison and David Featherstone for their valuable work on my original drafts of this book.

Tim Harris, from the Natural History Photo Agency (NHPA), kindly allowed me to use the high-quality scans of my slides that NHPA has on file. The graphic design expertise of Gabriela Wattson of Zona Creativa S.A. transformed my photographs and text into the elegant pages you see before you.

The following people provided invaluable assistance, and to all of them I am extremely grateful: Willow Zuchowski, author of *Tropical Plants of Costa Rica*; Twan Leenders, author of *Amphibians and Reptiles of Costa Rica*; Fabian Michelangeli, Robbin C. Moran, and Amanda Neill, of The New York Botanical Garden; Federico Guillén, whose valuable work in Costa Rican wildlife conservation merits an important mention; Alvaro Ugalde, former director of the National Parks Service; Eliécer Arce Guevara, director of Corcovado National Park; Alejandra Monge, executive director of the Corcovado Foundation; Randal García, director of Conservation at INBio; Piotr Naskrecki at Conservation International; Thomas Loáisiga at Canon in San José; Elmi Molina in Ostional; and artist Deidre Hyde for her useful advice at the very beginning of the project.

This book would be far from complete without mentioning my family and friends, who have always helped and supported me. The encouragement of my parents has been a major driving force behind this book project since the start; for this, as well as their eternal patience and faith, I offer them my deepest gratitude and love.

My profound thanks also go to my dear wife Cindy and our fabulous sons Pablo and Benjamin, to my brother Pete and my sister Sarah, and to life-long friends Matt, Andy, and Jamie; and also to Chloe, Jim (the original adventurer in Central America) and Jean Beale, Ron and Muriel Harvey, Chris Sewell, Victor and María, José Wabe, Toni Gordon, and Paul Mills.

The Images in this Book

Sadly, when we see a photograph that impresses us nowadays we often ask ourselves "Is that real?" Due to the digital photography revolution and huge advances in computer software technology, it is now very easy to manipulate the appearance and content of photographs.

All of the images in this book are a true reproduction of their original slides or digital photographs. No superimposed images, no computer-generated content, and no filters were used to produce colors or effects that didn't exist. All of the animals were wild and photographed in their natural habitats with the exception of those on pages 84 and 135, which were photographed in animal rescue centers, and those on pages 112, 113, and 200, which were taken in butterfly gardens.

I hope that this knowledge allows you to enjoy the images in this book just that little bit more.

Left: *Ithomia* butterfly feeding on *Ageratum* flowers.